complete
drawing course

complete
drawing course

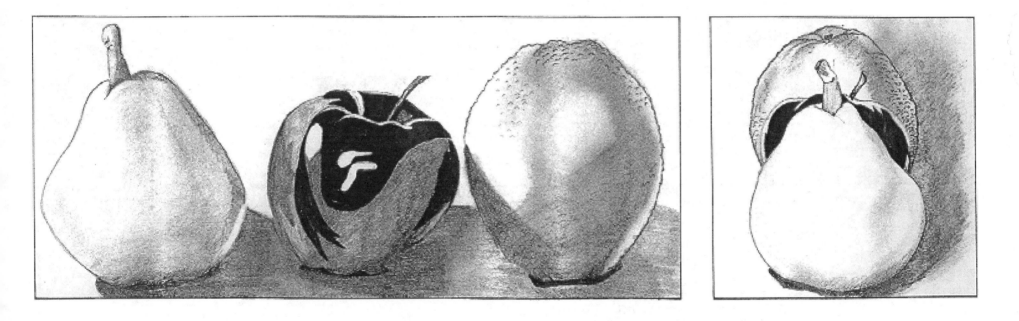

Sterling Publishing Co., Inc.
New York

Dedication
To Frank Wood –
unique art teacher

Acknowledgement
Many of the drawings are by students or members of the Diagram Group. Wherever possible they have been acknowledged in the captions. The following are acknowledgements to libraries and museums who own the works of famous artists.

Section 1
p27 Vincent Van Gogh: National Museum, Amsterdam

Section 2
p91 Cesare da Sesto: Royal Library, Windsor Castle, England
p119 Vincent Van Gogh: Art Institute of Chicago, Chicago
p128 Albrecht Dürer: Graphische Sammlung Albertina, Vienna

Section 3
p179 Vincent Van Gogh: National Museum, Amsterdam

Section 4
p194 Henry Fuseli: Victoria and Albert Museum, London
p208 Albrecht Dürer: Staatliche Museum, West Berlin
p220 Vincent Van Gogh: I V W Van Gogh
p221 Rembrandt: British Museum, London
p225 Juan Gris: Museum of Modern Art, New York
p227 Albrecht Dürer: Museum of Fine Art, Boston
p230 Vincent Van Gogh: Fogg Museum, Harvard University, Massachusetts
p236 William Blake: Tate Gallery, London
p244 William Hogarth: Mansell Collection, London
p246 Kathy Kollwitz: Fogg Museum, Harvard University, Massachusetts
p247 Ben Shahn: Museum of Modern Art, New York
p247 Hans Holbein: Royal Library, Windsor Castle, England

Artists
Joe Bonello
Alastair Burnside
Alison Chapman
Henrietta Chapman
Rebecca Chapman
Robert Chapman
Richard Czapnik
Stephen Dhanraj
David Gormley
Brian Hewson
Richard Hummerstone
Mark Jamil
Paul McCauley
Lee Lawrence
Victoria Ortiz
Kathleen Percy
Anne Robertson
Jane Robertson
Michael Robertson
Paul Robertson
Graham Rosewarne
Guy S. R. Ryman
Ivy Smith
Mik Williams
Robin Williams
Marlene Williamson
Martin Woodward
Zoe Ullstein

Editors
Carole Dease
Damian Grint
Denis Kennedy

Typographer
Philip Patenall

Library of Congress Cataloging-in-Publication Data Available

10 9 8 7 6

Published by Sterling Publishing Company, Inc.
387 Park Avenue South, New York, N.Y. 10016
First published in Great Britain by Macdonald & Co (Publishers) Ltd
as a four volume series: Drawing Workbooks
People, Places, Objects, and Trees & Plants
© 1987, 1999 by Diagram Visual Information Ltd
195 Kentish Town Road, London, NW5 2JU, England
Distributed in Canada by Sterling Publishing
C/o Canadian Manda Group, One Atlantic Avenue, Suite 105
Toronto, Ontario, Canada M6K 3E7
Printed in China
All rights reserved

Sterling ISBN 0-8069-4838-8

The publishers have made every possible effort to contact the copyright owners of the illustrations reproduced, but apologize in advance for any omissions from the above Acknowledgement.

FOREWORD

THIS BOOK IS WRITTEN TO BE USED.
It is not meant to be simply read and enjoyed. Like a course in physical exercises, or any study area, YOU MUST CARRY OUT THE TASKS TO GAIN BENEFIT FROM THE INSTRUCTIONS.

1. READ THE BOOK THROUGH ONCE.
2. BEGIN AGAIN, READING TWO PAGES AT A TIME AND CARRY OUT THE TASKS SET BEFORE YOU GO ON TO THE NEXT TWO PAGES.
3. REVIEW EACH CHAPTER BY RE-EXAMINING YOUR PREVIOUS RESULTS AND CARRYING OUT THE REVIEW TASKS.
4. COLLECT ALL YOUR WORK AND STORE IT IN A PORTFOLIO, HAVING WRITTEN IN PENCIL THE DATE WHEN YOU DID THE DRAWINGS.

Do not rush the tasks. Time spent studying is an investment for which the returns are well rewarded.

LEARNING HOW TO DO THE TASKS IS NOT THE OBJECT OF THE BOOK, IT IS TO LEARN TO DRAW, BY PRACTICING THE TASKS.

COMPLETE DRAWING COURSE is:
1. A program of art instruction.
2. A practical account of understanding what you see when you draw.
3. Like a language course, the success of your efforts depends upon HOW MUCH YOU PUT IN. YOU DO THE WORK.

- Drawing is magical, it captures and holds your view of the world. Once produced, the drawing is eternal: it says 'This is how I see the world at this place in this time.' It tells of your abilities and your circumstances.
- Drawing is a self-renewing means of discovering the world, and its practice is self-instructive. You learn as you go along and you improve with practice.
- Drawing is a universal language understood by everyone. It is also a concise and economical way of expressing reality and ideas.

- Drawing is a state of consciousness. You lose yourself in the drawing as you become involved in your responses to what you see. It has a calming effect when you feel depressed, agitated, ill or dissatisfied. You are outside yourself. Everyone can learn to draw. Be patient and try hard to master the skills.

CONTENTS

SECTION 3 PLACES

SECTION 4 PEOPLE

OBJECTS
LOOKING AND SEEING

Drawing objects is the easiest of subject areas to study when you first begin to draw. You can control the selection of objects, their surroundings and the lighting. But, most importantly, you can judge the time you have available for the study and can even return at a later date and complete or make revisions to your drawing.

Remember, when first doing a drawing of an object, that it is your personal view of the object. Your drawings are not copies of nature – they are interpretations. It is what you record, and what you miss out, that makes the drawing interesting.

Twenty-eight Tasks will help you judge more accurately what you see. Good drawing is 90 percent good observation. Look carefully, record accurately and interpret what you see intelligently.

The first chapter directs your attention to the two main questions of your studies: what is this object really like and how do I record what I see accurately?

● Pages 10 and 11 contain the most important idea in this section. Namely, how do you capture the three-dimensional world onto a two-dimensional surface.
● The next two pages, 12 and 13, direct your attention to the outstanding characteristics of each object – its unique features.
● Six pages, 14 to 19, deal with how we can portray the observable world more accurately. Firstly, by

looking at the positions of objects in space, one to another. Secondly, by looking at the shapes made by space. Thirdly, by the effects of light and shade on an object.
● Pages 20 and 21 illustrate with examples how your drawing is the result of three main influences: the object's special features; its context; your response to it – how you see it. Remember that no two people see the world the same way, and ten people drawing the same subject would produce ten different views of the subject.
● Finally, page 22 offers you a challenge to test your accuracy.

Flat or solid

Drawing reality is the process of converting solid objects to the flat surface of the drawing paper. Drawing is not copying reality, it is interpreting it. Objects have form – their solid qualities; they have texture – their surface qualities; they have color – their pigmentation of surface; and they have shades of light and dark. The first three properties are unchangable when studying an object, the last is the result of light falling on the subject. This feature may be varied both with the type and source of light and with the reflective qualities of the surrounding objects and surfaces. Because most objects we draw are familiar to us, we understand their actual qualities fairly easily from even quite simple drawn statements. It is only when we draw unfamiliar objects or objects from an unfamiliar view-point that we must pay careful attention to explain whether the object protrudes from or recedes into the flat surface of the page.

Lines
Left, we use lines to divide up areas to give the appearance of surfaces on an object. How we interpret these shapes depends partly on what we expect the object to look like from the position from which we view it.
1. The first three shapes are flat, parallel to the surface on to which they are drawn.
2. The second two are identical squares each standing on one of its corners and positioned side by side, parallel to the picture.
3. The next row is a group of four squares each one turned slightly more away from the position from which we view it.
4. The fourth row has two squares locked into one another like two clasping hands, both are turned at an angle to one another and at an angle to the surface of the page on to which they are drawn.
5. Finally one twisted surface, parts of which bend away from us and other parts of which bend toward us.

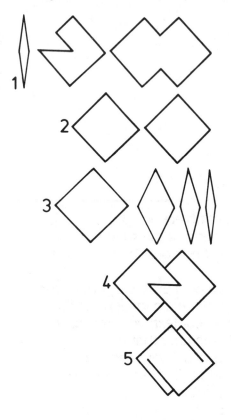

Impossible objects
Left and below, these simple drawings of a frame of square- sectioned limbs which can be turned from an open sided box seen from above (**A**). The same box (**B**) seen from below, or the interaction of a group of bars meeting in the center (**C**).

Understanding reality
Left,this drawing is not so easily explained. Each corner area makes sense as a drawing of part of a frame in space, but together, the parts imply an impossible construction.

Four Tasks

Four Tasks for you to explore the qualities of reality. Do each Task on a sheet of paper approximately 10 in (25cm) square using any drawing instrument that you feel comfortable with.

TASK 1
Form

Draw two objects of completely different forms, side by side on a table: a potato and a beer can; scissors and string; coins and leaves.

TASK 2
Tone

Draw an object with a single light source, then move the light to a new position and redraw.

TASK 3
Color

Draw two objects of different colors. Some grapes and a lemon, orange juice in a glass alongside tea in a mug, tomatoes and an egg.

TASK 4
Texture

Draw any two objects of differing texture. A wooly glove and a knife, a bowl and breakfast cereal, soap and a facecloth.

©DIAGRAM

Examining reality

Above, left to right, the first drawing of the apple is an outline, and it is hard to guess its color or the direction of the light. The second drawing more clearly describes the volume of the apple – its roundness. By peeling the apple, flat surfaces can be more easily drawn. The next drawing shows a solid object because the cutaway section helps us to interpret the object as being carved out of space.

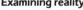

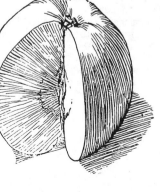

Four ways

Above, this drawing by Lee, aged 17, shows the four main features of reality: the form, texture, tone and color.

Whenever you do a drawing you improve your skill and commit the subject to memory. Whether you draw from observation, from photographs or from other artists' work. Each drawing is inscribed in your memory for later use. We all learn more about the physical world by examining it carefully and recording our impressions.

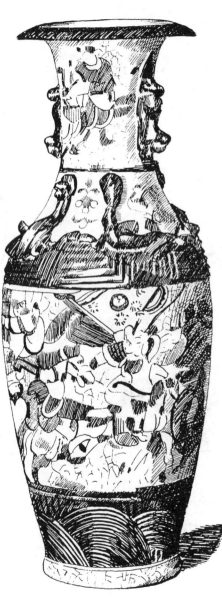

TASK 5

Capturing surfaces

Draw an object with at least two different features.
For example:
1. Colored surfaces: draw a hanging dress or patterned garment and try, in black and white, to describe the colors.
2. Textured surfaces: draw a toothbrush and try to distinguish between the smooth plastic handle and the bristles of the brush.

Object drawing

Left, a pen drawing of a vase in which the artist has indicated form, color, texture and lighting.

TASK 6

Interpreting subjects

Copy this drawing using colored pencils to capture the qualities of the subject. You could also copy a colored photograph of objects using black and white pencil marks to describe the colors.

Remembering reality

Top right, a drawing by Mark, aged 16 years, of his bike. Although the drawing lacks a correct sense of construction, the remembered details of individual parts are very well described. Drawings from memory without the opportunity to cheat and peep at the real object are an excellent test of a retentive memory. Such drawings are more likely to be successful with objects you see very frequently, rather than objects only rarely seen. When you try Task 7, you will see how this is demonstrated.

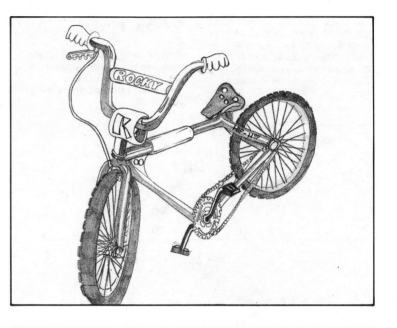

Copied reality

Right, the same student copied a similar bike from a mail order catalog. Having an interest in the subject matter of the objects you choose to draw from memory is often an additional help in remembering their details.

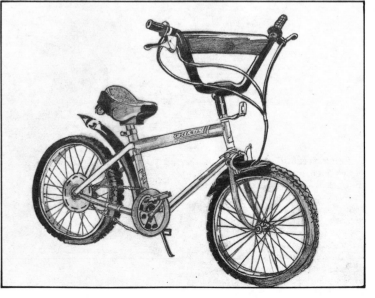

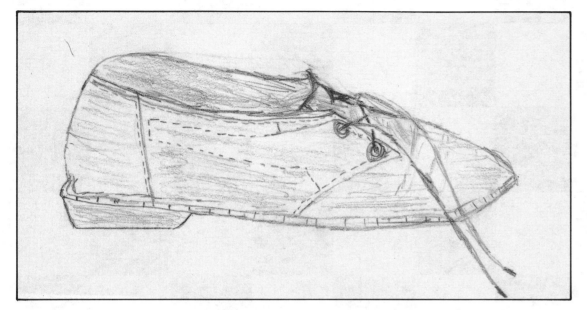

Observed reality

Granny's shoes are a wonderful study by a lady aged 75. Her shoes are very familiar objects, but when confronted with a problem of drawing for the first time, she has looked at the details with a fresh eye. We must all constantly practice drawing the objects around us so that they become committed to our memories.

Super-reality

Right, two drawings that do not record observed reality. They are very efficient descriptions of the surface qualities of the objects. This type of drawing is usually made from photographs and is used to describe the new, unused quality of an object.

©DIAGRAM

TASK 7

Memory studies

Draw from memory a small object from your kitchen, bedroom or bathroom. Try to do the drawing actual size. Leave half the page area free to add another drawing. Now fetch the object to your drawing area and carefully draw it alongside your memory attempt. Notice the differences between the two drawings. Familiar objects are easier to remember. To test this, do a detailed drawing of some object you may have seen only very briefly. For example, a Roman sandal, seen in movies, a play or reconstruction paintings. Can you do any of the following objects:

A. Red Indian feather headdress
B. Medieval crossbow
C. 1910 telephone

TASK 8

Object study

Draw one of your shoes, taking care you record every small detail of that shoe's unique qualities. Then draw a shoe from an illustration in a mail-order catalog or from a magazine. Notice the difference between the real world (your shoe) and the idealized world (magazine photograph).

Memory objects

Below, dozens of objects drawn from memory by Jane, aged 12 years. None is of objects in particular, all are generalizations of objects. In the sketch are a lamp, scissors, ruler, watches, etc.

Checking what you see

Beginners often have little confidence in their own ability to record accurately what they see. They struggle over making the objects 'look right.' The simplest way to achieve this is to relate the positions of objects to a regular pattern of straight lines. Try to imagine the object's 'footprint' on a surface – the shape it would cover if seen from directly above.

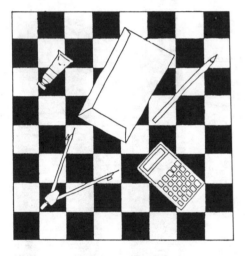

TASK 9

Objects in space

1. Select a group of thin objects such as a book, pen, ticket, clips, ruler or envelope.

2. Place these on a checkerboard or a grid you have drawn containing sixty-four squares.

3. Place tracing paper over the large grid on this page and copy on to it the exact shapes each object makes on the surface.

4. This pattern of outlines creates the 'footprint' of the objects.

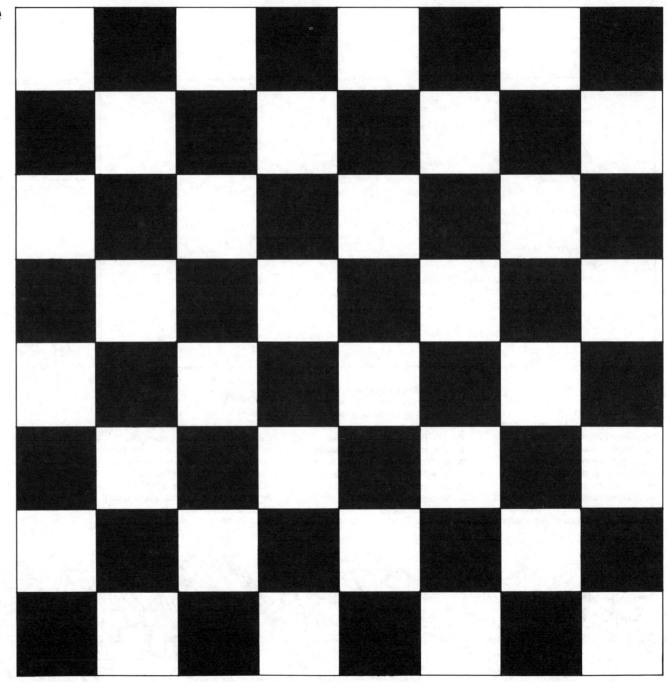

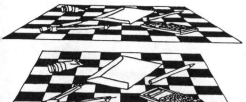

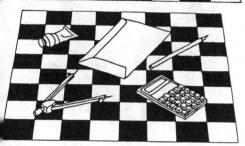

TASK 10
Plotting space 1

Sit on a chair looking at the objects you set up in Task 9 with the front edge of your grid or checkerboard parallel to your sketch pad. You can change your view of the group by moving closer or further away, or by raising or lowering the plan on which you have the grid. Establish a view similar to one of the drawings (left) and plot the arrangement of objects on to tracing paper over the grids (right).

TASK 11
Plotting space 2

Draw the same group of objects set up in Task 9 from the same point of view, only this time placing them on a sheet of white paper. Try to judge their relationships in the light of the knowledge gained when they were on a grid.

TASK 12
Plotting space 3

Sit in a different position, viewing the objects from the side. Or carefully turn the board on which they are placed around to offer a different view. Do a drawing and compare the way this view produces different spatial relationships for the objects.

Some points to note
(**A**) A pencil set across the grid at 45 degrees (pointing to the corners of the square), when drawn from a low vantage point appears almost horizontal (**C**).
(**B**) Objects that are apart and not touching may appear much closer together when viewed from a low position.

©DIAGRAM

Outside and inside shapes

Remember that as well as the shapes of forms there are also the shapes of space. These are the areas in and around the objects. Studying these helps check the accuracy of your record of the object's features, and it directs your attention to seeing the negative values of shapes. On the object itself, you should also examine the shapes made by colors and tones.

Basic shape as pattern
One usual way to maintain an accurate record of an object is to see first its basic shape — then the shapes in and around the object. Try to see the view of the object as a flat pattern, which often creates very unfamiliar outlines to the object.

TASK 13
Shapes
First copy a photograph of an object in a magazine. Then place tracing paper over the photograph and, using a felt-tipped pen, fill in the spaces around the object. Cover your drawing with more tracing paper and fill in the same areas and compare the two shapes. Repeat the Task with new overlays, filling in the shapes of the object.

TASK 14
The shape of form
Objects change their shapes as you change the position from which you view them. This is because the edges are surfaces seen side on. You can explore the variety of shapes produced by an object by doing a series of studies of a chair or similar open-framed object.

Seeing shapes

One very useful way of checking your ability to see shapes accurately is to place the object in front of a grid, then carefully record the irregular shapes of the outline against the regular shapes of the grid.

TASK 15

Testing shapes

1. Copy the grid on page 14 onto tracing paper.

2. Stand the book open at page 14 and place a standing object in front of it.

3. Carefully copy the shapes of the object set against the grid onto your tracing paper grid.

TASK 16

The shape of light

A very simple method of converting a picture to its basic elements is to draw lines along the edges of all the dark areas, then to fill these in to form blocks of tone. A good exercise or practice is to place tracing paper over photographs and shade in the colored areas or tonal areas. Although this produces flat patterned solutions, it is still useful as a means of seeing the basic elements of a subject.

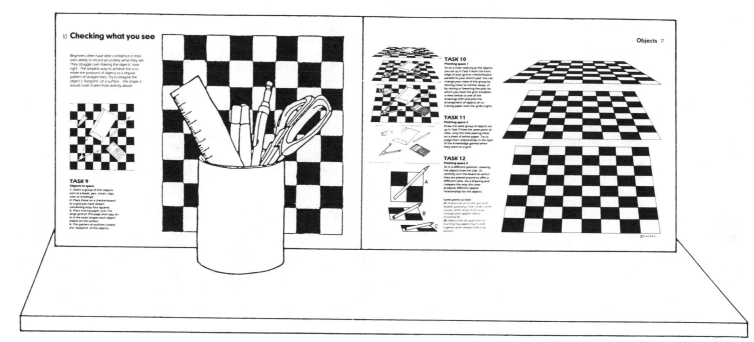

©DIAGRAM

Light and shade

The appearance of an object is very often the result of the direction and strength of the light source. Simple direct light produces very dark shadows with sharp edges. Numerous light sources produce soft edges and reflected light areas in the dark parts. As the shadows are the result of the forms, understanding the source of the light is one way to help describe the solid qualities of an object.

Remember when drawing a complex group of objects to keep the directions of the light sources constant. A frequent mistake of beginners is to draw each object as if independently lit. A simple method of avoiding this is to squint with half-closed eyes at your subject. This blurs the tones and simplifies the overall pattern of light and shadows.

TASK 17
Box

Do a series of shadow studies from changing light sources. Use any small available box such as a matchbox square-sided packet, or tin box. Light the subject with a small desk lamp which can be moved to a variety of positions. Record each shadow carefully.

TASK 18
Egg

Place an egg on a sheet of white paper in natural light. Do a pencil study with soft pencils, paying special attention to the reflected source of light on the underside of the egg.

Light sources
Right, a simple open box illustrates the changing effects of different light sources. These shadows are caused by light falling from the front, back, sides and above.

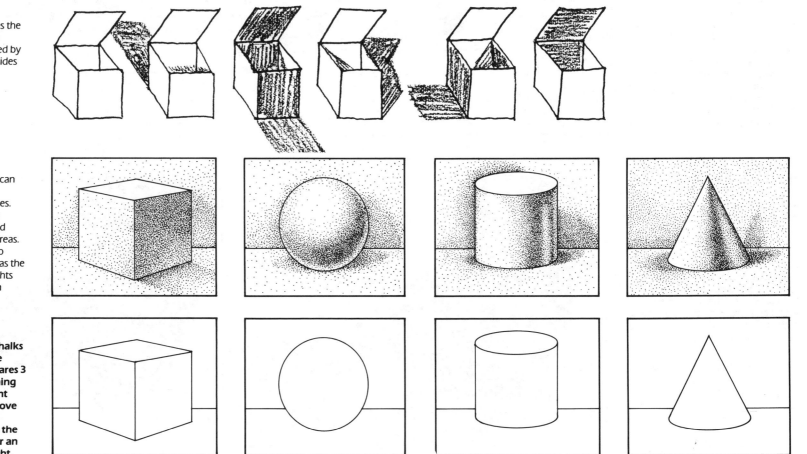

Regular solids
The individual facets of an object can capture in their dark areas light reflected from surrounding surfaces. This light has been bounced from nearby planes on to the object and produces a thinning of the dark areas. These are very useful in helping to describe the volume of an object as the darker areas between the highlights and reflected lights push the form forward.

TASK 19
Reflected light

Working with soft pencils or chalks on cartridge paper, copy these regular solids (right) on to squares 3 in (7.6cm) square. Then imagining the light falling from a different source from the illustration above it, build up the tones on these regular solids. Work back into the dark areas with white chalk or an eraser to produce reflected light.

Ball and bowl
Below, this drawing uses shadows and highlights to describe a ball in a shallow bowl. The basic information of three concentric circles can be described in a variety of ways.

TASK 20

Interpretation
Make three separate drawings on cartridge paper, each one to show three circles with similar spacing to those shown below right. Using a soft pencil or chalks, build up the tones on each to describe the three different solids drawn, right.

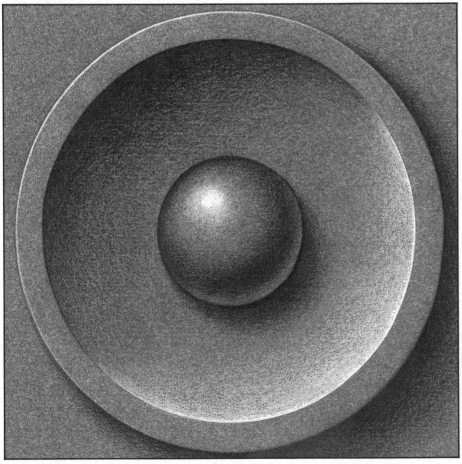

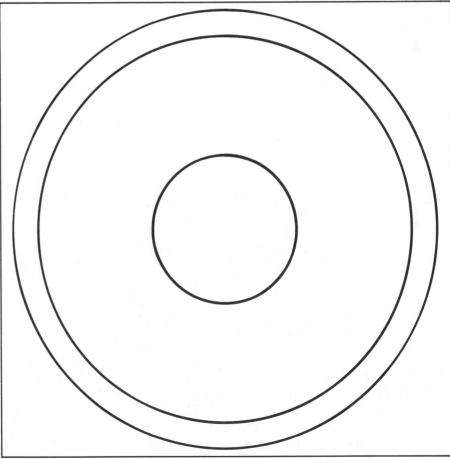

The object you draw is capable of many interpretations. Unlike a circle, which is a line circumnavigating a center point and is always constant, each drawing is a record of a particular study. The quality of the drawing is the result of your cultural origins, your experience and your point of view. The type of tool and surface you work with also influences the results. A pen study is not like a brush study.

Artistic intentions
Below, this drawing of a crane was drawn to present an accurate description of the working parts.

Variety
A chair has a simple function – to support a seated figure, but designers offer an enormous range of shapes and decorations. The examples, right, are collected from different historic and cultural sources.

Emotional study
Below, this drawing is a fantasy sketch using a beer can as the source of inspiration.

Subjective study
Below, this drawing by Philip, aged 21, explores the effects of cross-line drawing and uses the can only as a reference for supplying shapes and tones.

Objective study
Right, this drawing in pencil by Lee, aged 17, is an accurate description of the reflections and colors of the object.

©DIAGRAM

TASK 21
Collecting themes
Make a collection taken from books and magazines of studies of the same object. Try to maintain an interest in one particular object so that you can build a file of examples such as shoes, knives, glasses, and collect examples from every period and culture.

TASK 22
Familiarity
Draw a familiar object from an unusual angle. Try turning it into a tall building or a space station. Impose on the subject an element of fantasy.

TASK 23
Subjective study
Choose a drawing tool unfamiliar to you, such as a technical pen, or a brush and redraw one of your earlier studies. Give more attention to the style of drawing than to the examination of the surfaces of the object.

TASK 24
Objective study
Do a very careful pencil drawing of an object. Make it a very small one, such as a key or watch, and try to draw the maximum detail. Record the surface details and all the tiny individual features to make the drawing as detailed and truthful a study as possible. Do your drawing the same size as the object.

Accurate observation
The previous 12 pages were directing your attention to looking and seeing – learning to record as carefully as possible the qualities of the objects you study. One key element of a drawing is the amount of concentrated thought you give to examining what you see. Drawing is a thought with a line round it.

TASK 25
Judging proportions
Stand this book open on the table so that the back half supports the upright front cover. Sit opposite, facing the cover straight on. Draw the cover as accurately as you can, making the base approximately 5 in (12.7cm) long. When the drawing is complete, draw a fine diagonal line through two opposite corners. This diagonal line should be the same as one on the book, so if you place the lower left corner of your drawing on the lower left corner of the book cover, the diagonal line should extend and meet the upper right hand corner of the book. This is to check that your judgement of the proportions of your drawing matches the proportions of the book.

TASK 26
Testing accuracy
Place five coins in a row, each touching its neighbors. Do a drawing as accurately as possible of the plan of this row, trying to draw the coins actual size. Do not trace the coins, judge their size by eye. When your drawing is complete, place the coins on your drawing to judge the accuracy of the overall length of the row.

TASK 27
Unusual views
This drawing of a spoon in a glass of water by Henrietta, aged 15 years, is an excellent study. Many objects offer the opportunity of an exciting drawing, if you first think about how best to view them. Select a comb, cup, hat, keys, or kitchen implement, and draw it from an unusual viewpoint.

TASK 28
Memory drawing
Five drawings by Jane, aged 11, of fruit and vegetables, drawn from memory. Try to draw the following objects from memory:
1. Your own or friend's bicycle.
2. Your bedside lamp.
3. Your winter shoes.
4. The hat of a friend.
When you have completed the drawing, obtain the real object and make a second study and compare the two drawings.

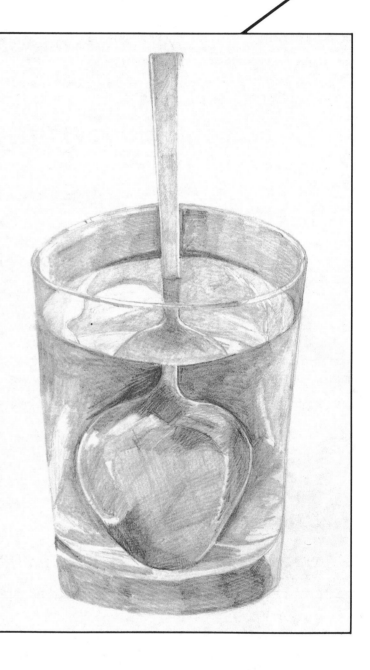

UNDERSTANDING WHAT YOU SEE

Most beginners are inhibited by the results of their work. 'It just doesn't look like the object' is their response to their early attempts. In this chapter there are forty-one Tasks set to explain how you record what you see by understanding the situation of an object in relation to your drawing surface.

Each of your studies is an invitation to whoever observes your work to step into the same space as that surrounding the objects you have drawn. Your primary task in learning to draw is to be able to describe the three-dimensional world using only two dimensions.

- The first two pages, 24 and 25, describe the solid world of each object – the space they fill.
- Pages 26 to 29 help you consider the area around each object – the space objects stand in and how their surfaces appear in relation to your view.
- Pages 30 to 35 are essential to an understanding of how the appearance of an object is very often the result of our viewpoint. Where we stand when we observe the object influences what we see of it.
- The subject of perspective has always been a fearsome one for beginners, yet its secrets are easily revealed if you rely upon observations and not what you think an object should look like. Draw what you can see and check, not what you imagine.
- Pages 36 to 41 describe how to think of an object as having fundamental features that you can use to your advantage when studying it: its form; its symmetry; its irregularity; its surface qualities; and its inner qualities of hardness or softness.
- The review page, 42, returns to that most common fault of beginners – the failure to maintain accurate powers of observation. You will find guidelines on how to avoid some of the main pitfalls that prevent you getting satisfaction from your drawing.

All objects fill space, even thin objects like envelopes or tickets. Remembering the volume of an object helps you record its three-dimensional properties. Try to think of the object packed up in a box, whose sides touch exactly the top and bottom, sides and front and back of the object. This container is the extent of the object's three dimensions and, although it may not appear in your drawing, the viewer must not be left in doubt as to where it would appear on the drawing.

Tracking surfaces

Outline line drawings do not offer clues to the three dimensions as clearly as ones drawn with shadows and textures. It is often very revealing to imagine tracks made by a snail traveling across the surface in a straight line.

TASK 30

Tracking

Begin with lines that travel over the surface cutting the shapes clearly into halves or quarters (**a** and **b**). Then draw tracking lines from a variety of directions (**c**). Apply this on an overlay of tracing paper to the drawing below, and to photographs of objects in magazines.

Height, width and depth

Objects viewed from the front appear to have only height and width, but objects seen with three adjacent sides, have height, width and depth. Your drawing must always make this clear.

A Height
B Width
C Depth

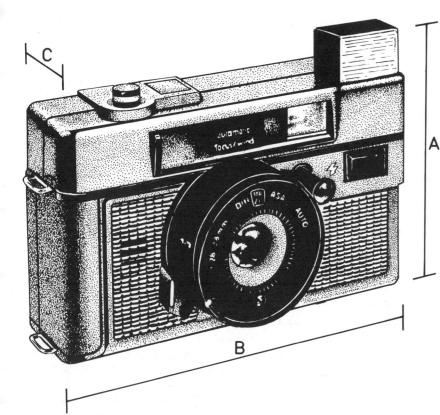

TASK 29

Three dimensions

Select any simple object viewed with three sides and do a very accurate pencil study, taking care to record the proportions of its three dimensions carefully.

Viewing all round
When drawing it is useful to keep in mind the plan and elevations of the object. How each would look if the object was looked at from directly above or from a side position.

TASK 31
All-round views
The drawings of a boot (below), show the top, side, front and back. We have all the information to describe a boot, but presented individually from each side. Do an invented drawing showing the boot from three sides – a three-dimensional view. It will help you if you draw a box (a sort of shoe box) into which the boot fits on each view. Then draw the box in three dimensions and construct the boot within the space.

TASK 32
Elevation
Draw this unfamiliar musical instrument from a view seen from the side, then from above, then from one end.

Outline and form
The outline drawing of a kettle does not describe the form very clearly. The lines can only use overlap to indicate position. By adding shadows the solidity of the kettle becomes clearer.

TASK 33
Form
Do an outline drawing of a domestic object, then shine a strong light from a single source on-to the drawing and redraw, adding the shadows on your drawing. Redraw with a new light source.

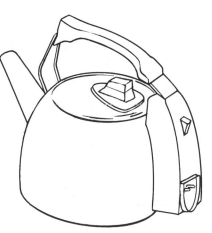

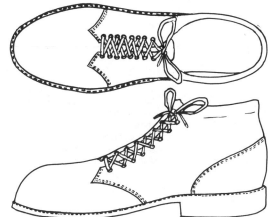

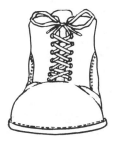

©DIAGRAM

The space they stand in

Objects not only occupy space (their volume), they also stand in space in relationship to one another and their surroundings. They leave a 'footprint' on the surface they occupy. Drawing this spatial arrangement is often very difficult for a beginner. Placing the objects in space requires you to think around the object to its full three-dimensional form, and its nearest neighbors.

TASK 34
Chair

The feet of a chair are in a constant relationship to one another. They usually occupy four corners of a square. The placing of the four legs firmly on the ground can prove very difficult for beginners. It helps if you simplify the relationships to vertical and horizontal points (the dotted lines on this drawing). To test your ability to understand the 'footprint' of a chair, place it on a white sheet or clean, smooth, light-colored surface and do a drawing of the four legs. Move the chair to other positions and redraw the legs. Each time link the feet with connecting lines on your drawings. Notice how, although the legs never get closer to one another, their relationship in your drawing varies.

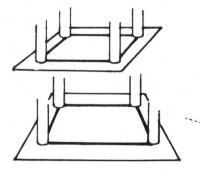

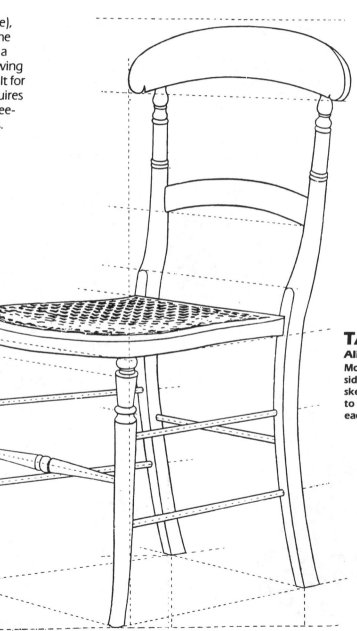

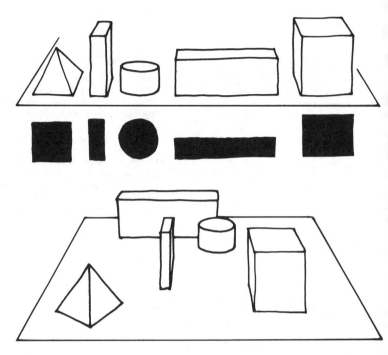

TASK 35
Alignment

Most objects are not seen in flat side view. The position in this sketch of five regular solids is simple to understand. The front edge of each touches a common front line.

The positions of the groups in the second sketch is not so easily established. Can you indicate on a tracing overlay where you think each stands on the base drawing below.

Thinking space

Below, this drawing of part of an art-school painting studio illustrates the problem of placing objects in space. Here are four easels, each with three legs, and each at a different angle to the picture and to each other.

TASK 36

Thinking space

Draw three chairs placed at different angles to one another. Plot the feet positions very carefully.

TASK 37

Floor guides

The position of the objects in this drawing by Vincent Van Gogh are more easily understood because of the texture of the carpet. Draw objects that are standing on a tiled or striped floor. If this is not available, place a group of small objects on a checkered cloth on a table and do a series of studies from a variety of different positions.

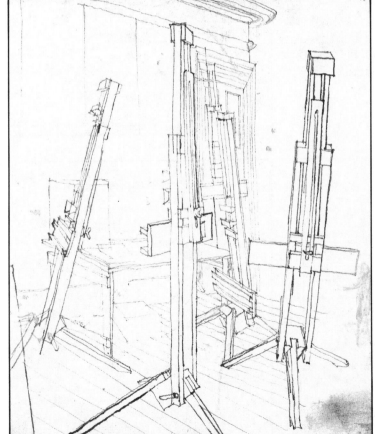

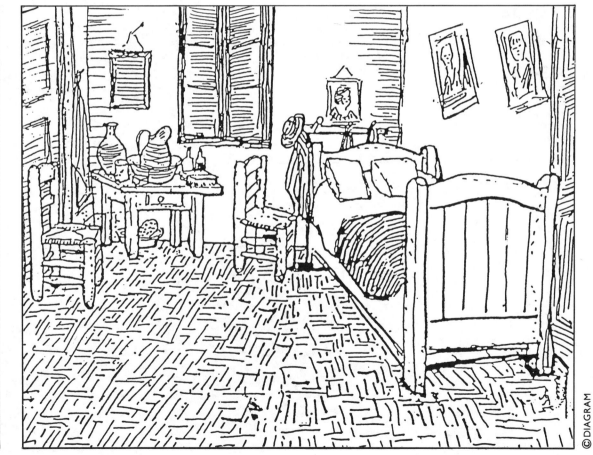

© DIAGRAM

Plane surfaces

Not only are objects seldom seen flat on to your position when studying them, but their surfaces are also turned away or toward you. Very few objects have vertical sides and a horizontal top surface. Most have irregular facets set at angles to one another. These surfaces give clues as to their direction if you look carefully at the lighting on the surface texture, or at the point where the edges occur. Remember that edges are usually surfaces seen from the side.

TASK 38
Surface clues
Draw an object with a strong textural surface.

TASK 39
Overlap
Draw an object with strong overlapping qualities, such as a cabbage, a discarded coat, or a crumpled bed.

Three studies of fruit
Bottom left, the pear offers only clues at the top and in the shadows.
The apple offers clues at the top and in the reflections of light and color.
The orange offers clues at the top and on the texture of its surface.

Right and below right, these two drawings viewed from either end of the row are understandable by the overlap of the surfaces one in front of the other.

Four ways to understand surface angles.
1. The overlap at the edges.
2. The overlap of other objects.
3. The surface textures.
4. The lighting effects.

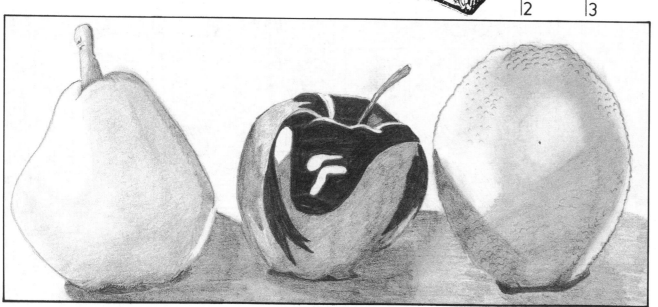

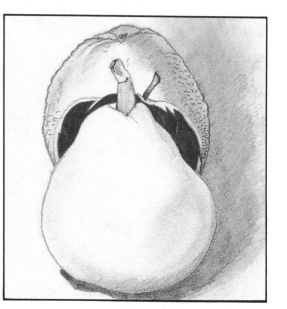

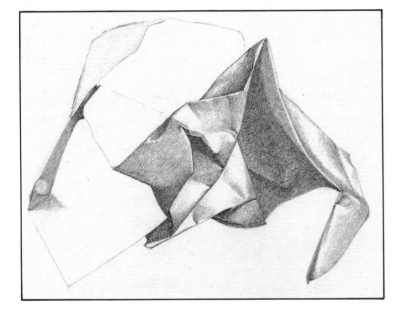

Surface patterns
Left, this drawing is of a crumpled wrapping paper. The artist records its form by the shading and the overlap of areas. The drawing below is of the same paper, in the same position, but only the stripes are drawn. Studying objects requires you to record the lighting, overlapping and surface characteristics.

TASK 40
Surface patterns
Draw a striped blanket, a jacket with strong patterns, and a patterned tablecloth.

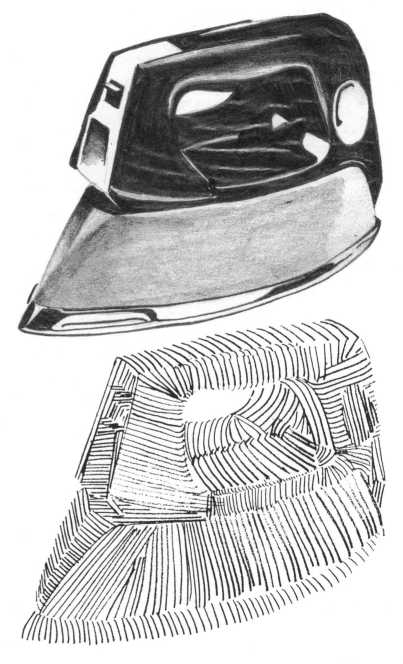

Surface directions
Top right, the very complex angles of the surfaces of this iron are described by carefully observing the lighting and the overlapping along the edges. One way to achieve this description of form is to think of directional lines that would travel all over the object. The drawing below attempts this solution. Even if you do not draw these directional patterns, it helps to think constantly of them when describing the form.

TASK 41
Directional lines
Place tracing paper over the drawing of the camera on page 24 and draw a pattern of directional lines following the surface planes.

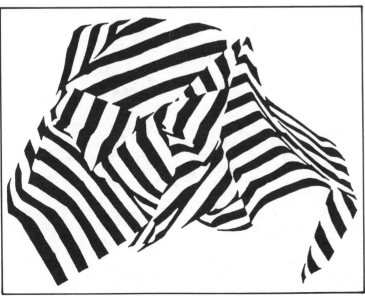

©DIAGRAM

The subject of perspective usually causes some anxiety in beginners. They feel they will lose themselves in the mysteries of geometry, mathematics and recessional space, which all seem to combine in a web of lines. This is quite unnecessary. Perspective is simply a method of checking what you see. Understanding how space appears from a single point of view helps you confirm your discoveries when you examine reality.

Three viewing positions
Below, center and right, standing, you see on to the top of a table. Sitting low on the ground, you see only the side view, and if viewed from below the base of the legs, you see the underside.

Simple principles
There are some simple facts to remember:
1. If you view objects straight on, horizontals are drawn straight across your vision.
2. If you move your position to view the object at an angle, then horizontal lines recede into the picture to meet in 'vanishing points.'
3. These distant groupings always occur level with your head, at a line running horizontally across your view – your eye level.
4. Wherever you stand, you always see the tops of objects placed below your eye level, and the underside of objects that are above your eye level.
5. Verticals are drawn straight up and down in all cases except when you stand close to objects and look up or down at them.
6. The closer you are to an object, the more you see of its top surfaces.
Remember, when your drawing does not 'look right,' try a simple test: extend into the picture the parallel edges of objects and these should meet at a common vanishing point.

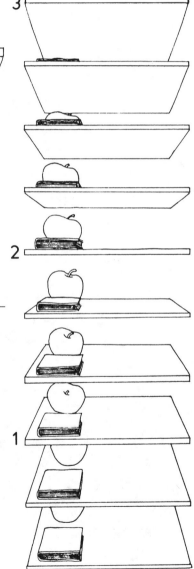

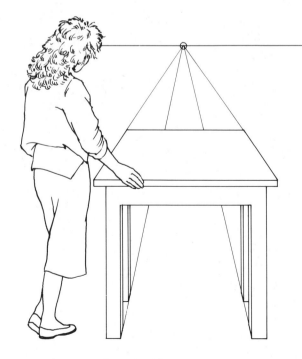

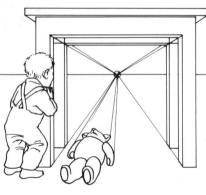

TASK 42

Position of an object
Sit on a chair and do three drawings of a small object, such as a vase, box or cooking utensil. First, look down on it (place it on the floor), then look at it from the side (place it on a table), finally, look up at it (place it on a high shelf).

Shelves
A good test of your understanding of the changing shapes of an object is to draw an object with a series of levels, like a cupboard. You will notice the following changes to the surfaces:
1. The lower shelves reveal a full view of their surfaces and objects on them.
2. The middle shelves show only their front edges and the objects are overlapping.
3. The upper shelves show only their undersides and obscure the objects on them.

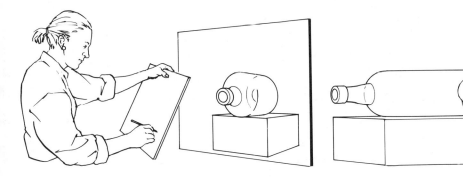

The picture plane
All images are seen and drawn as if projected on to a flat surface between you and the object. This is the picture plane. This imaginary surface flattens the object as if it were on a glass plate. The object seen closest to the picture plane is recorded larger than that seen in the distance. This is because the image of the object is a projected form from its origins in your eye.

Right, top surface objects show more of their top surface the closer they are to your position. Note the gap between the two boxes (**a**) on the foreground tables, and the overlap of the boxes on the distant tables (**b**).

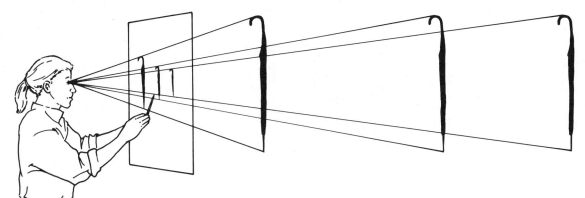

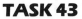

TASK 43
Position of the viewer
Place an object halfway up a staircase. Draw it from a position at the bottom of the staircase. Draw it from a position at the top of the staircase. Compare the two drawings.

TASK 44
Reducing scale
Place this book on a table and, sitting 2 ft (60cm) away, do a careful drawing of the table top and the book. Then move your position to a point 10ft (3m) away and repeat the drawing. Note that although your eye level has not changed, you will see less of the top surface of the book and table in the second drawing.

TASK 45
Surface views
Sit comfortably in a chair and do a drawing of a stepladder. Place this book on the lowest step and include it in the drawing. Then place the book on the middle step and include it, then place it on the top step and include it. Note the changing shape of the book in your drawings.

©DIAGRAM

The edges of an object that is not seen parallel or front view recede to two vanishing points, one at either side of the object. The distance they are from one another and the object is the consequence of how close you sit to the subject, and at how much of an angle its surfaces are turned away from you.

Parallel perspective
This drawing of a cupboard is made according to the idea of reality instead of how it actually is. All the front parallel edges should converge to a common vanishing point. This drawing records the idea of parallel edges and not the observed facts. Always draw carefully what you see and not what you think.

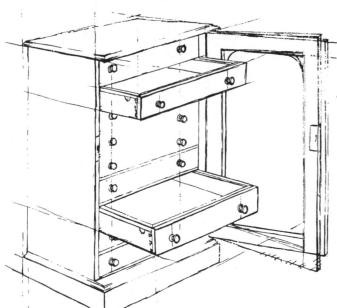

Disappearing edges
A Eye level below table: all horizontals slope downward.
B Eye level on floor: feet horizontal, all others slope downward.
C Eye level at table top: edge of top horizontal, all others slope upward.
D Eye level above table: all lines slope upward.

TASK 46
Cupboard door

To discover how top and bottom edges change with your view of the surfaces, do a series of drawings of a door, opening it in stages from a position where you can see its front, to one where you see the back. Keep your position constant and notice the changing angles of the top and bottom.

TASK 47
Recessional edges

Stand this book on the edge of the table with its spine pointing toward you. Do a drawing from very close to it, with your eye level at the table edge, and notice how both top edges appear to slope away from you.

TASK 48
Recessional surfaces

Judging recessional surfaces by placing this book in any position on a checkerboard. View the board from the same angle as the drawing below and, on a tracing overlay, plot the edges of the book against the squares. Repeat, moving the book to other positions.

TASK 49
Angles of recession

To test your ability to judge recessional angles, do a drawing of a checkerboard viewed from one corner. Then fold a strip of paper into an angled wing, matching the angle of your drawing (diagram, bottom right). Now view the checkerboard through the center 'V' and compare the angles of recession.

Horizontal recession

Right, this drawing of a checkerboard viewed from one corner clearly shows that the distant lines are more horizontal than those in the foreground. Compare the shapes of the nearest (**A**) and furthest (**B**) squares.

A

B

Drawing objects with circular surfaces often causes a beginner problems. Remember that all circles fit exactly into squares, with the center of each of four sides touching four points on a circle. This very important feature is the key to constructing circles seen in oblique angles.

TASK 50

Mastering circles

This group of circular objects clearly shows the construction lines. Do a drawing of a similar group of cups, saucers and plates, beginning each object by constructing the ovals around a central axis.

TASK 51

Seeing inside shapes

Draw a group of different shaped glasses. Place some in front of others so that you have the additional difficulty of seeing their shapes through the distortion of foreground glasses.

Surface areas of horizontal circles

Only circles seen directly from on top are circular. Others retain their common width but change their depth, depending on your point of view. To help you draw accurately an unfamiliar view of a circle, first construct a recessional square, cross the corners to establish the center points on the edges, then draw an oval that touches the center point on each side of the square.

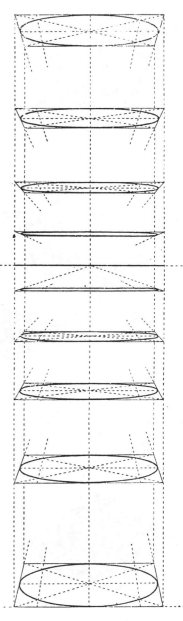

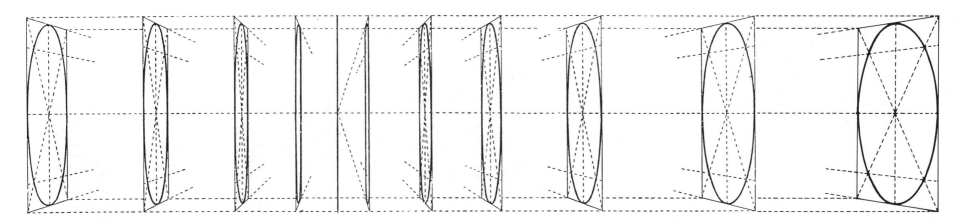

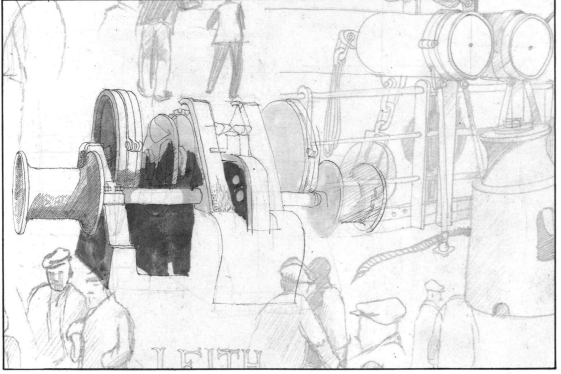

Surface areas of vertical circles
Just as with horizontal circles, the distortion of circles is only in one direction. The height of a circle seen from the side is constant, only the width changes with your point of view.

TASK 52
Horizontal circles
Do a drawing on location of pipes, tubes, logs, machinery or objects that have different sized circular ends.

TASK 53
Extended circles
A very good exercise to help you master circular shapes is to draw a telephone cable or coil of wire. Although concentrating on the circular features, remember to keep in mind the overall shape of the object.

©DIAGRAM

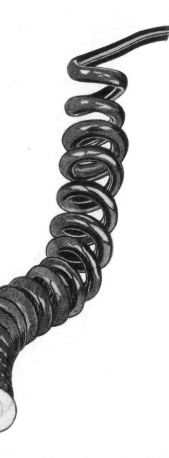

Many objects have an inner geometry. They are assemblies of parts that have a regular form. Their sides are mirror images or their top is like their bottom, or their front like their back. Many objects may not at first glance appear to have these features, but in constructing your drawing, it is useful to begin with center lines and build outward to balance shapes.

Three regular solids
A. Top is as bottom
B. Front is as back
C. One side is as the other
These three axes, which create similar halves, can be combined to form symmetrical objects.
D. Left is to right
E. Top is to bottom and left to right
F. Back is to front and top is to bottom and left is to right.

Simplified solids
Wherever possible, reduce the object you are studying to a group of basic shapes. Turn it into blocks of forms. This helps you judge the overall shapes and you can then work into your drawing the incidental smaller features.

TASK 54
Three-dimensional symmetry
Draw an object with three-way symmetry – a brick, a golf ball, a box of breakfast cereal.

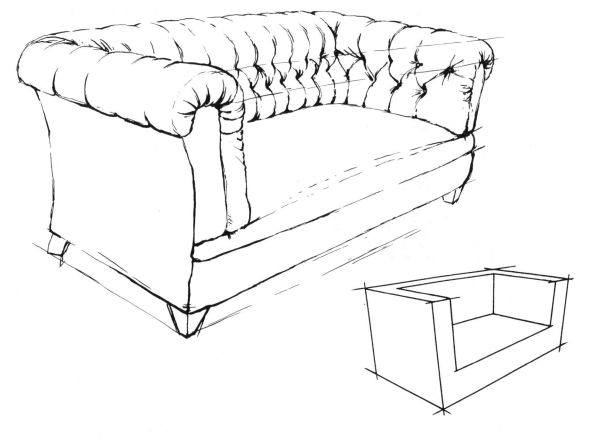

Different objects

At first glance, many objects can offer a very complex group of shapes. A spoon, a cane chair, spectacles, all seem very difficult to draw. But if seen as symmetrical objects, half the problem is solved as each object reflects the shapes of its other side.

TASK 55

Discovering symmetry

Draw center lines on to photographs of objects in magazines and catalogs.

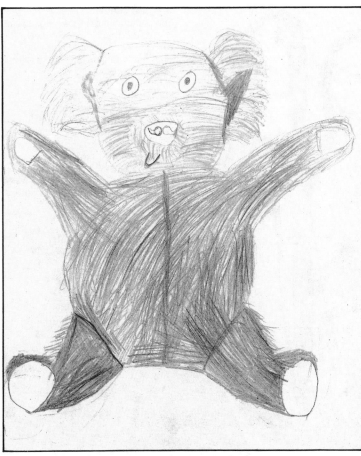

TASK 56

Simplifying objects

Do simple blocklike sketches of the main elements in the drawing of the camera on page 24. Notice how this block drawing helps you see the three-dimensional elements of the drawing. Apply this simplification to your own earlier studies.

TASK 57

Mastering symmetry

Draw a pair of spectacles, a man's hat, a fork. Begin with a center line and build up the two equal sides.

Unexpected symmetry

Right, this teddy bear drawn by Paul, aged 10, had a strong central line down its tummy. This helped Paul see that the left side is the same as the right on his toy.

© DIAGRAM

Because most objects we draw are familiar to us, we understand their actual qualities fairly easily from a simple drawing. It is only when we draw unfamiliar objects that we must pay careful attention to explaining whether the object protrudes into or recedes from the flat surface of the page. Think of the plan of an irregular object when you are struggling with its unique shape.

Natural objects
Right and below, the nuts and the shell may appear to be irregular but are, in fact, the result of natural geometry. As they grow they form their shapes. This development is often hinted at in the surface textures, so study carefully the small detail to be able to draw the object more accurately.

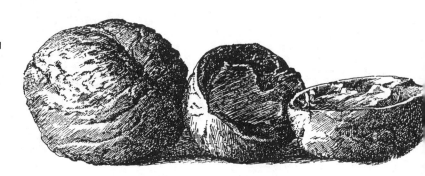

Irregular objects
The gloves and scissors are examples of objects with a real symmetry. Seen from the top they are easy to understand. Drawn from the side, they present difficulties.

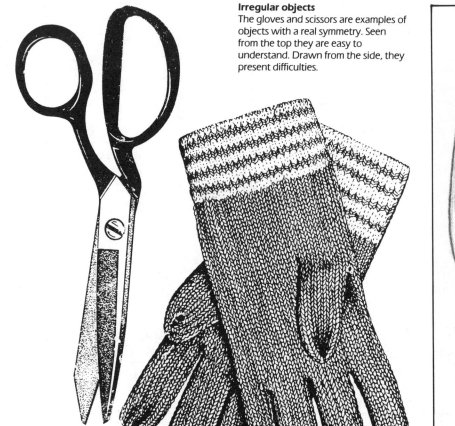

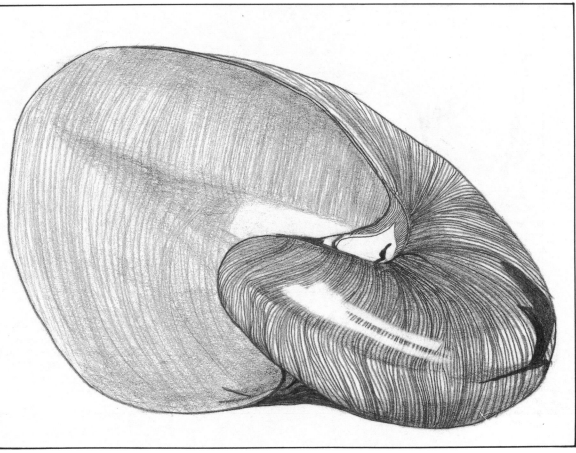

Irregular objects
Right, these two drawings by Philip, aged 18, capture very beautifully the sense of old worn material. The care with which the detail has been observed gives us the feeling we would know the bag if ever we were to see it.

TASK 58
Infinitely variable objects
Draw a coat lying over the arm of a chair, or a cushion, or a discarded crumpled newspaper.

TASK 59
Natural objects
Do a series of studies of vegetables, fruit, shells or stones. Take special care to record their surface textures.

TASK 60
Irregular objects
Draw a pair of scissors, a pocket knife, a shoe, or any available object that is irregularly shaped.

TASK 61
Exploring irregular shapes
Collect examples of small objects, such as keys, and do drawings actual size.

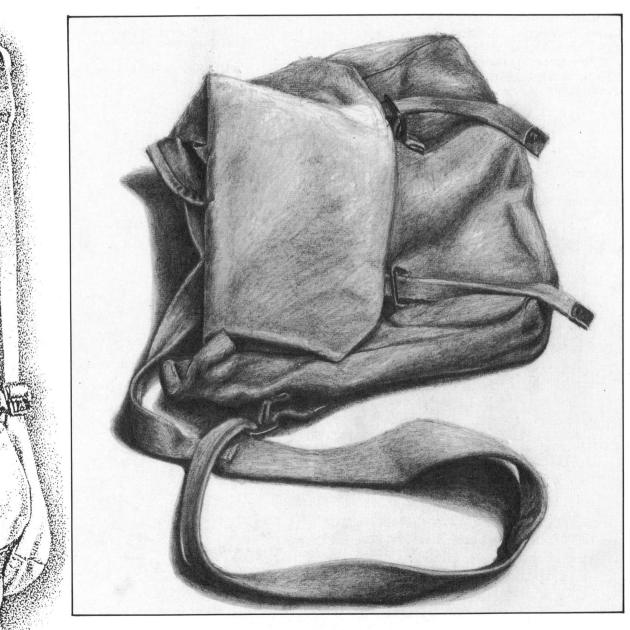

©DIAGRAM

The surface of an object is very often a good guide to its character – as hard as nails; as soft as silk; as stiff as a poker. Your drawing should capture these surface qualities and you should make a practice of collecting examples with strong textural qualities.

Textures
Below, a clear way to observe textures is to study colorless objects. A pencil drawing by Jane of a group of white objects: cup, egg, cloth, bread, soap.

Reflective surfaces
Below, a silver coffee pot drawn by Lee, aged 17. This modern replica has a very highly polished surface which Lee has successfully described by using a soft, sharp-pointed pencil.

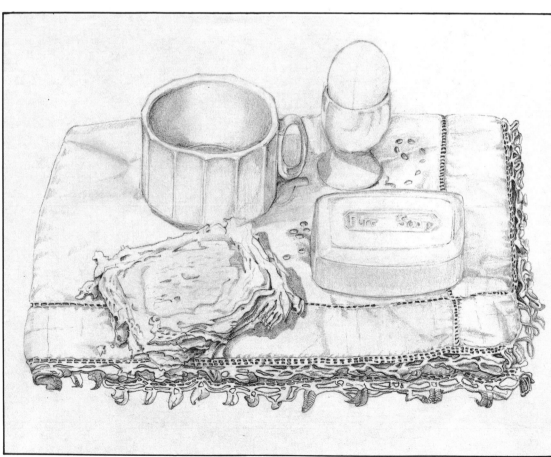

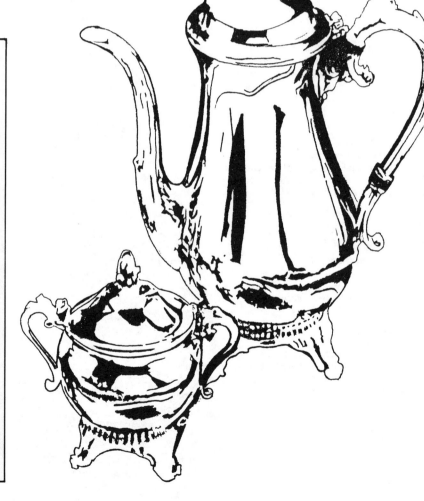

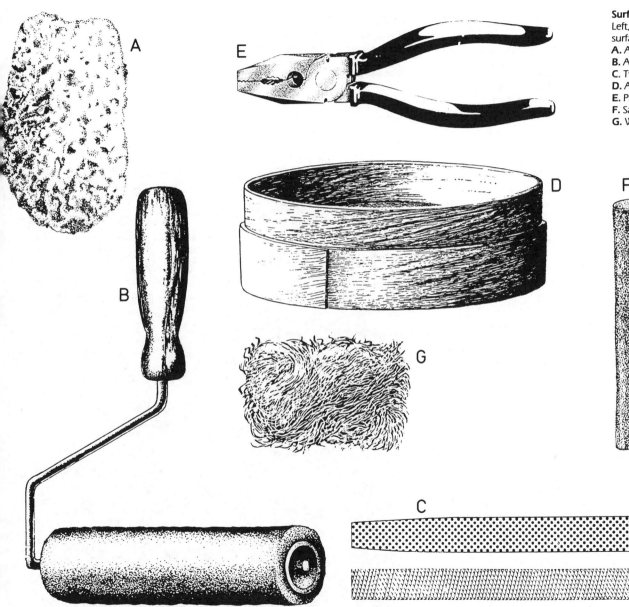

Surface qualities
Left, eight objects with different surface qualities:
A. A sponge
B. A soft-fabric paint roller
C. Two metal files
D. An old wooden sieve
E. Pliers
F. Sandpaper
G. Wire wool

TASK 62
Surfaces
Begin to collect examples of pronounced surface textures such as rocks, sea-worn wood, old sack-cloth or rusty iron. Do drawings to capture these qualities.

TASK 63
Rubbings
One very good method of recording surface texture is to keep a notebook of thin paper into which you add wax-crayon rubbings of interesting surfaces.

TASK 64
Reflective surfaces
Draw objects that have a very polished surface, such as new shoes, new kitchenware or garden tools, bathroom objects.

TASK 65
Comparing textures
To help you judge surface qualities, select two objects with strongly contrasting textures. Do a drawing using pencils in which you concentrate on capturing the rough, smooth, dull, reflective features. Possibilities are.
A sponge and soap
Polished floor and wooly rug
Brick and glass
Breakfast cereal and bowl
Egg and potato.

©DIAGRAM

Examine reality

The previous thirty-six Tasks were designed to set you studying what you saw and understood of your observation. Remember, always rely on what you see and not what you think is there. Examine reality very carefully and it will yield its secrets.

TASK 66

Reappraising your drawings

Check all your previous drawings for construction faults and if now you feel you could do better, redraw a previous exercise.

Three Tasks

Three Tasks set to test your powers of imagination. Imagine that the camera and the telephone on page 24 were standing side by side. Then try the following exercises. If you feel inclined, you can select other objects than those on page 24.

TASK 68

Common unusual view

Do a drawing in which you imagine that you are looking down on to the top of both objects.

TASK 69

Common light source

Invent a light source that is falling from above left. Then redraw the two objects with the shadows common to both.

TASK 67

Common space

Do a drawing in which both views in the original are adjusted to a common point of view.

Understanding circles

Right, a very good drawing by Henrietta, aged 15, in which the final overall impression is marred by a simple mistake. She failed to realize that the circles on the objects should all be consistent. The table is seen almost directly from the top but the bottle and glass are seen almost from the side.

Some common faults

1. Failing to draw ovals correctly. The circular parts of objects must all be consistent with one another.
2. Failing to observe simple recessional features of parallel lines.
3. Failing to place the objects correctly in space.
4. Failing to construct correctly a regular proportional object.
5. Failing to maintain a common light source.
6. Failing to relate objects to a common space.

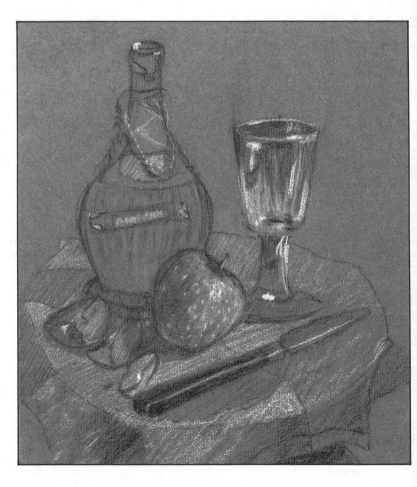

MASTERING TOOLS CHAPTER 3

Although the most popular beginner's drawing implement is a pencil, very many more tools are available and they can be mastered. This chapter contains twenty-four Tasks to involve you in the opportunities of exploring the marks made by different tools.

Begin with the tools that you feel are most comfortable. Then, when the opportunity arises, explore the use of other tools with which you have had little experience.

Remember that whatever tool you use and however interesting the marks are on the page, it is more important to care for what you say than how you say it. Clever effects are impressive, but often of little real value.

- The first two pages, 44 and 45, contain twelve examples of the same subject recorded by a student using a variety of drawing tools. These clearly reveal the way marks influence the appearance of the drawing.
- Pages 46 to 49 are examples of marks made by the most popular drawing tool applications – the dry-medium pencils and chalks. These offer such a wide variety of effects and can be easily corrected. Therefore, they are by far the best choice when you begin your earlier drawings.
- Pages 50 and 51 describe the less familiar wet-medium tools. Beginners usually find it harder to work with pens and brushes as they can be difficult to handle confidently at first. Their marks are hard to remove or modify.
- Pages 52 and 53 describe some of the types of drawing surfaces available and how these influence your choice of drawing tool.
- The final page of the chapter sets you the Task of reviewing your understanding of the quality of marks made by different tools.

Marks made by tools

Three factors combine to create the quality of the drawing. The tool, the paper surface and your experience and confidence. These pages illustrate the effects of different tools and the confidence with which different students handle them. Some are more suitable than others for your Tasks, and some you will feel more comfortable with than others. In addition to your most favorite drawing tool, try on occasions to explore the effects of using less familiar tools.

Changing tools
Below and opposite, twelve examples of the same subject study drawn with a variety of tools.

1. Soft pencil on rough paper.
2. Hard pencil on tracing paper.
3. Charcoal on rough paper.
4. Crayons on white paper.
5. Crayons on dark paper.
6. Pen on smooth paper.
7. Ball-point pen on smooth paper.
8. Brush on smooth paper.
9. Felt-tipped pen on smooth paper.
10. Technical pen on smooth paper.
11. Mixed media.
12. Colored pencils on dark paper.

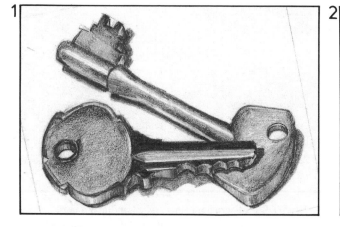

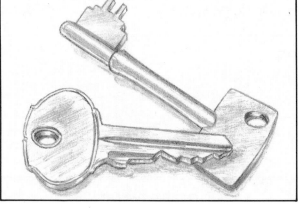

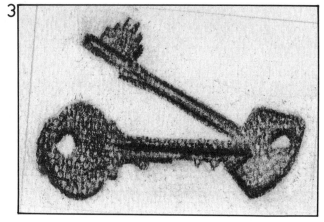

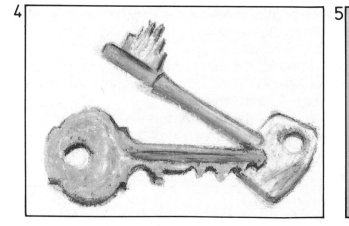

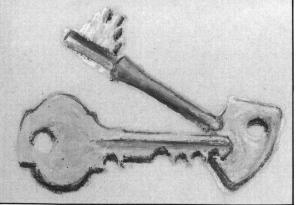

TASK 70
Judging originals
Visit the local art galleries and try to see examples of artists' original drawings. Take care to examine the method by which they were drawn.

TASK 71
Judging reproductions
Collect examples of drawings in magazines and books and make a note on them of how you think they were produced. Be careful, as many are reproduced smaller than when originally drawn.

TASK 72
Paper surfaces
Collect whenever possible examples of different types of paper. Keeping a portfolio of types of paper means you can always experiment on new surfaces with familiar or unfamiliar tools.

TASK 73
Exploring techniques
Redraw one of your earlier drawings or copy a photograph from a magazine using a tool you have never used before. It might be a technical pen or wax and waterolor.

7

8

9

©DIAGRAM

10

11

12

Dry tool marks

Pencils, chalks, charcoal and crayons are all dry-medium tools. They are convenient to use as they offer a wide range of tones and can produce fine or broad marks, depending on the condition of the point. In addition, they can more easily be corrected so a beginner feels less inhibited using a pencil than a pen.

Pencils
There are a variety of pencil- like objects. Wooden-bodied are the most common, but fine leads mounted in a holder are also handy as the lead can be retracted when not in use and they do not require sharpening. All pencils are graded for 'hardness' – this is the quality of the graphite 'lead' base. Softer leads make darker marks, harder leads make lighter marks. Softer leads wear down quickly so you must resharpen the point frequently. Harder leads are only suitable on strong fine-grained paper. The softer the lead, the more likely the drawing is to smudge.

TASK 74
Pencils
Collect together all your pencils, check you have sharpened the right end of each. You should have left untouched the end with the grade mark. Any pencil that constantly produces broken leads, should be discarded.

TASK 75
Sharpeners and erasers
Keep one small drawer of your work cabinet for sharpeners and erasers. You should have: scalpel holder and blades, sharp penknife, oil stone, sandpaper and a variety of erasers.

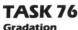

9H 8H 7H 6H 5H 4H 3H 2H H HB B 2B 3B 4B 5B 6B 7B 8B

Grades of pencil
9H is the hardest in common use and 8B the softest.

Tone and shades
Pencils are excellent at creating an even tone. By gently rubbing the pencil regularly across the surface you can achieve a tone that does not show the individual marks.

TASK 76
Gradation
Draw a series of 1 in (2.5cm) squares. Begin one side as a solid black line and gently shade the white area to produce a regular, even-graded tone from black to white.

TASK 77
Tones
Practice building up areas of tone that have an allover even quality. Select one of the values on this drawing (left), and shade an area of equal value. Then fold over the edge of your paper to place the tonal patch you have drawn on the folded edge so that you can visually match it to the examples here.

Tones and shades
Right, detail (actual size) of an excellent study by Henrietta, aged 15, which shows the advantage of working in pencil. She has used fine soft lines to plot the subject. Then she strengthened the edges she felt confident with and, finally, used the side of the pencil to shade large areas.

Sharpening pencils
Always sharpen your pencils with a tool that cuts away the wood in a direction away from your work, usually over a dust bin. Remove carefully thin slices of wood, working gradually to expose an even round point. Complete the sharpening of the point by gently filing it down on a strip of sandpaper. Store your sandpaper or sandpaper blocks in an old envelope.

Points
Hard pencils should have long sharp points. Soft pencils should have short exposed points.

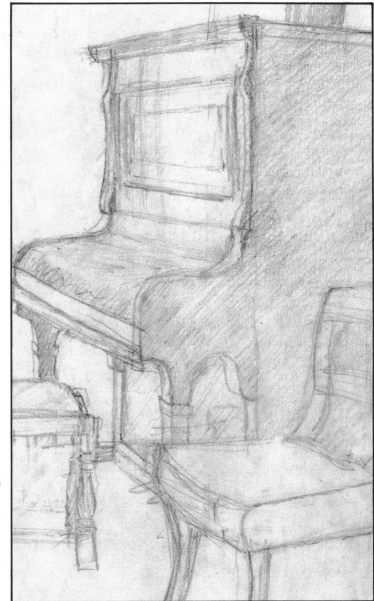

Working with charcoal sticks, crayons and chalks, offers you the opportunity to build up areas of tone as well as vary the line thickness qualities. The major advantage of these tools is the wide variety of tones and marks available, some created by blurring with your finger, or highlighting with an eraser. The most common practice is to use a tone-colored paper, either light brown or blue. You must always work on surfaces that have a texture rough enough for the fine particle of charcoal, wax or chalk to stick to.

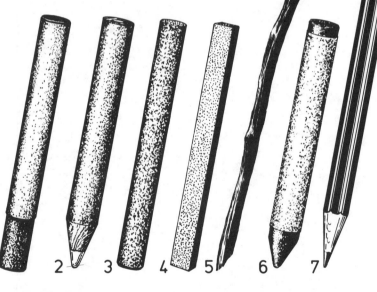

TASK 78

Storage

Collect all your chalks, crayons, charcoal sticks in one small drawer or box. Take care to keep them wrapped in tissue paper and separate from one another.

TASK 79

Exploring techniques

Redraw one of your earlier studies using an unfamiliar tool. Possibly colored chalks on brown paper.

Types of tool

There are two main types of drawing stick – those based on water adhesive and those with an oil base. Beginners should use the water-based sticks as these allow you to make changes to the marks.

Water-based

1. Pastel sticks with protective paper cover.
2. Pastel pencils.
3. Chalks.
4. Graphite stick.
5. Charcoal.

Oil-based

6. Wax crayons.
7. Colored pencils.

Working the tones

Below, when using water-based chalks, it is possible to alter the tonal effects by techniques other than drawing lines:

A. Broad areas of tone can be produced by using the side of the chalk.
B. Fingers can be used to smudge edges.
C. Lighter areas can be obtained by removing the chalk with a putty eraser. If you do a charcoal drawing, you can use a ball of soft bread to the same effect.
D. Highlights can be achieved with lighter colored chalks working over the dark areas.
E. Areas can be softened with an eraser.

TASK 80

Artists' drawings

Obtain books with examples of reproductions of chalk and charcoal by famous artists. Remember that most illustrations in books are not the size of the original drawing. Examine how they achieved the tonal effects and how they used chalks and charcoal. Copy one of their drawings.

A

B

C

D

E

Light to dark
Right, this chalk drawing by Rebecca, aged 8 years, makes excellent use of the opportunity of working back into the drawing with light chalks. The original was on colored paper and was drawn with a variety of colored chalks. This drawing is greatly reduced but a section, actual size (left), shows how the chalks hold to the surface.

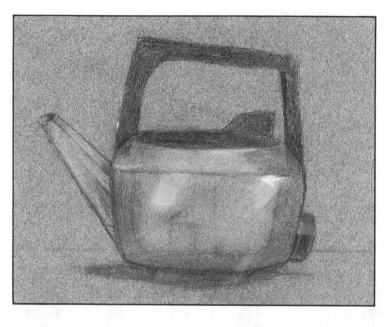

Working
Left, very often it is advisable to rest your hand on a small sheet of paper laid over your drawing. This prevents the texture, moisture and temperature of your hand from smudging your drawing.

Fixing
Right, all dry-medium drawings should be fixed with a spray of artists fixative. Do not use pressurized canisters as these are harmful to your health and damage the earth's atmosphere.

TASK 81
Fixing
Check that all your drawings have been fixed, and are stored so that no two drawings face and touch one another.

© DIAGRAM

Using tools that produce a mark made by ink has a major disadvantage for beginners. Once you have made the mark on the paper with brush or pen, you cannot easily lighten or remove it. Inks are usually water-based which means they are absorbed into the paper.

The advantages of wet-medium tools are that if you work confidently, they can produce a wide range of beautiful marks. Creating tone requires either a slow build-up of fine lines and dots, or the application of layers of ink washed on by brush.

Mixed media
Below, this drawing of a statue uses a mixture of pen and ink and finger smudging. Note the fuzzy lines (lower right), due to drawing on a wet surface. The shadow on the leg is a smudge of the knee.

TASK 83
Mixed media

Do a drawing on strong smooth paper and while working with a pen and ink, smudge the lines to produce tones. This may spoil your drawing but if you work lightly with water-based inks, you can produce attractive results.

The most popular wet-marker tools are:
1. Brush.
2. Writing pen.
3. Technical pen.
4. Ball-point pen.
5. Felt-tipped pen.
6. Broad-tipped felt pen.

TASK 82
Technical pen
Redraw one of your earlier drawings using a technical pen. Work on strong tracing paper over your drawing.

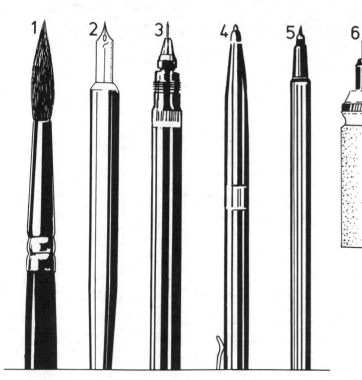

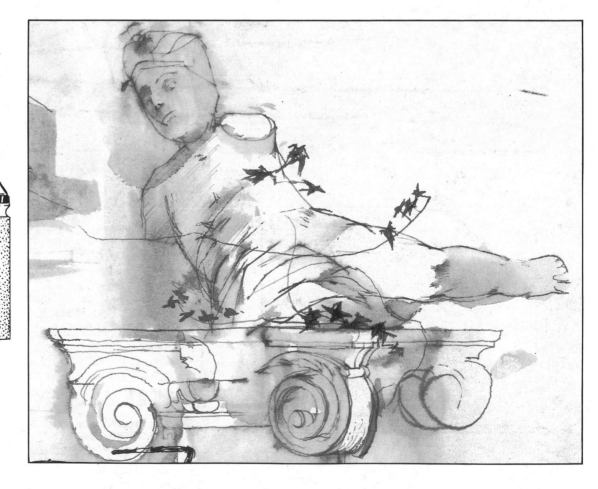

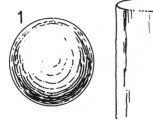

Tonal values
Left, achieving an even range of tone is a matter of practice. You can create the illusion of darkening areas by:
1. Varying the thickness of lines.
2. Varying the space between equal-thickness lines.
3. Criss-crossing lines.
4. Building up areas of tiny dots.

Building up tones
Pens produce a line and not a tone. To achieve an area of tone, the pen must be used to produce multiple marks either as lines or dots.

Building a line drawing
Below, four drawings using pens. These examples have been considerably reduced. First begin with a fine pencil study of the construction of the object.
Each subsequent drawing was produced on tracing paper placed over the base construction. Working this way enables you to carry out a free and confident study without revealing the earlier construction.

TASK 84
Tonal values
Build up a series of tube-like objects, practicing achieving an even range of tone. First try by lines, then dots, then cross-hatching.

TASK 85
Building a drawing
Do a very accurate pencil construction of an object. Then place tracing paper over your construction and do a free rendering in pen.

© DIAGRAM

When beginning to learn to draw, use the basic tools and surfaces available in the local art supply store. It is always possible to do interesting drawings with any tool on any surface, but when beginning some tools can prove difficult to handle on some surfaces. Avoid working with fine pens on rough-textured paper, or with brushes on thin paper.

Factors
You should consider three qualities of the material you draw on. 1. The texture of the surface, rough or smooth. 2. The strength of the paper (usually its thickness). 3. The paper's color.

TASK 86
Unfamiliar surfaces
Do a drawing on brown craft paper or rough-textured paper, using a range of tools, pencils, pens, brushes – to experience the different effects of the marks on the surface.

TASK 87
Collecting examples
Store examples of the different types of paper you discover in a portfolio so that you have as wide a range as possible of papers to experiment on.

Surface qualities
It is not possible to include in this book surfaces other than the one on to which the text is printed. Nevertheless, you can see the consequences of working on different surfaces by details from four drawings reproduced actual size.

A. Plastic
Drawing reproduced actual size done with a technical pen and ink on plastic material.

B. Newsprint
Felt-tipped pen on newsprint, actual size.

C. Cartridge
Pencil on a rough-surfaced cartridge, actual size.

D. Tracing paper
Hard pencil on a good-quality tracing paper.

TASK 88
Plastic surfaces
Purchase a small piece of technical drawing plastic-surfaced material and do a very detailed pen drawing, having first planned the subject study on paper.

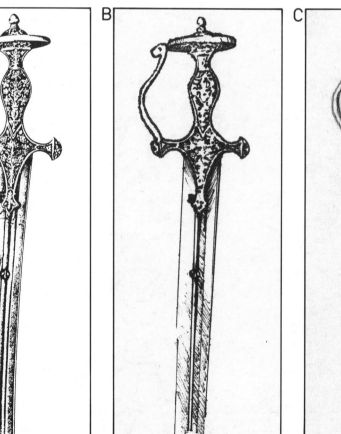

A

B

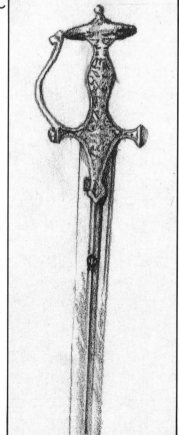

C

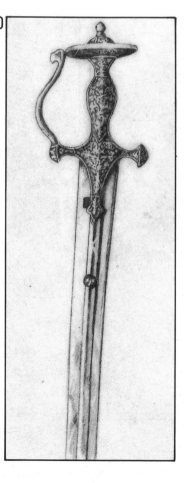

D

Paper types

There are a wide variety of papers but normally you are limited to those available in the local art stores. Below is a list in order of cost and quality.

Newsprint paper	Very cheap, poor-quality paper, usually cream colored. Not suitable for pen and ink or brush drawing.
Tracing paper	Very useful to explore with as you can place a second sheet over your first drawing and redraw, preserving the successful parts and changing other parts.
Stationery paper	The type used in typewriters. Very cheap, usually a standard size, good for pen drawings. Usually not rough enough for pencil or chalks.
Cartridge papers	These are the traditional artist's cream-colored papers. Good-quality papers have a fine-textured surface for pencil and chalk drawing.
Ingres paper	Expensive, good quality. Often in pale colors, not suitable for pen drawing.
Water-color papers	Often handmade, expensive, have a strong thick quality. Not suitable for pen work unless with a fine surface grain.
Bristol board or card	Fine-surfaced white paper mounted on board or smooth surface card. Very good for pen work, but not suitable for pencil drawing.
Plastic	Used by professional illustrators for pen work. Not suitable for pencil. Gray opaque surface enables you to work over a previous drawing.

Judging reproduction

Right, this drawing by Philip was done on a sheet of stationery paper with a soft black pencil. The reproduction here is a reduction from the actual size. The detail, above, is actual size. The quality of a reproduction is affected by the scale of the illustration to the original.

TASK 89
Sketch pads

Begin to carry a sketch pad with you on your outings and always have a pencil ready for drawing objects of interest.

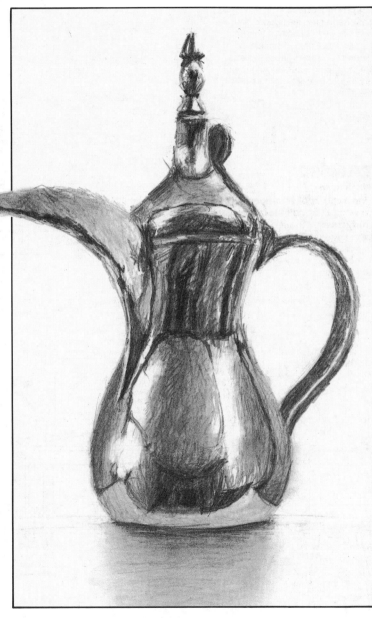

Graphic qualities
This chapter has introduced you to
qualities of drawing that are the
consequence of marks made by
different tools on various surfaces.
These graphic qualities can provide
additional aspects to a drawing's
merits.

TASK 90

Work area
Find a corner of your home where
you can set up still-life subjects and
study them without risk of them
being moved. This is particularly
important if you want to do the
same subject study in a variety of
techniques.

TASK 91

Conversion techniques
Redraw any of your earlier Tasks or
any drawing in this book, using a
technique other than the original.
This is a pencil study of the
illustration on page 24. Can you
identify the tool used to do the
original drawing?

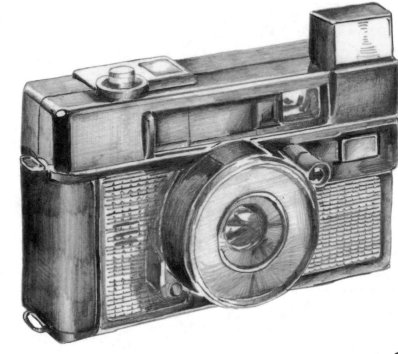

TASK 92

Understanding techniques
Can you identify the drawing
method of the following
illustrations:
The apples on page 11
The shell on page 38
The gloves on page 38

TASK 93

Soft pencil study
The scissors by Lee, aged 17,
were drawn with a pencil on
stationery paper. He first
constructed the study very carefully
with a light plotting of shapes. He
then built up the tones using a soft
pencil. Do a study of a reflective
object using a soft, sharp-pointed
pencil.

CONSIDERING DESIGN CHAPTER 4

Having fun with your drawing skills is really the purpose of this chapter – seeing the drawing as independent of the subject and then looking at the end result as the product of how you approached the problems of selection and composition.

This chapter is concerned with how you enjoy and exploit the graphic qualities of your work, with Tasks to help you explore the style of your drawings.

There are four main factors to consider before you begin a study: the choice of objects – some rare, some common, some familiar and some strange; the grouping – how subjects stand beside each other; the lighting; and, finally, the position of objects within the frame of your picture.

The more subjects you study, the more tools you explore and the more adventures you begin, so your confidence increases and you become capable of producing drawings that reveal a unique view of the world and produce results that will impress your friends.

- The first four pages, 56 to 59, are about the way beginners hesitate when selecting objects to draw. What do you draw? How do you select a subject? The world has millions of objects and how do you find one that you can use in your drawings?
- The subject of pages 60 and 61 is one most enjoyed by beginners – how to make their drawings look real. Adding detail is looked at as well as building a technique that produces admiration in the observer.
- Pages 62 to 65 are on how to view the subject from within the edges of your frame – composing the subject.

- Pages 66 and 67 have examples of drawings that go beyond reality. Drawings where the artists have had a particular reason for their point of view, and this has influenced the results.
- Finally, page 68 has an example of a single study to illustrate the charm and beauty that can be obtained from working in pencil and looking very carefully at the subject.

What do you draw? How do you make the subject interesting? These two questions often inhibit a beginner. Every object offers you a challenge: how to make it an interesting subject to study. A simple shape such as a pencil can be turned into a fascinating drawing if you view it imaginatively. Most homes contain hundreds of small objects of a wide variety of shapes, materials and conditions. Some are new, some are old, some common, some unfamiliar.

The unusual
Left, these joke replica plastic flies offered the opportunity to do a quick ball-point pen sketch.

Found objects
A pen, brush and ink study of an old broken bird cage. Even if incomplete, sketches made on location often contain items of interest due to their uniqueness.

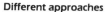

Different approaches
Below left, this drawing by Lee, aged 17, is a very careful pencil study of an office paper punch. In contrast, the line drawing below was constructed using a brush and ink technique.

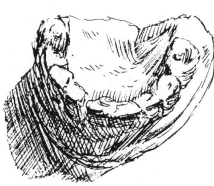

TASK 94
Subject studies
Keep a sketch book devoted to variants of one narrow subject study. For example:
Sea shells
Worn stones
Jewelry
Antique furniture
Ornaments
Ceramics
Any subject you find personally interesting.

Fish
Below, a very careful pen and ink drawing of a fish.

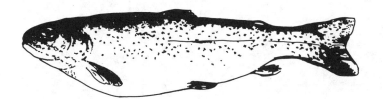

Unusual objects
Above, a plaster cast of a child's teeth — a ball-point pen study reproduced actual size.
Examine old magazines and books for photographs and drawings of unusual objects. Trade catalogs, mail order catalogs all offer a very wide range of subjects.

Compositional factors
When selecting and arranging objects, think of their comparative qualities, their shape, size, color, texture condition and use. Choose objects whose contrasts are:
round and square
smooth and rough
bright and dull
large and small
common and rare

Interesting objects
Below right, the interest in these old shoes rewards Henrietta, aged 14 years, with the good results she gets from a careful pencil study.

TASK 95
Exploring details
Looking closely at small objects can produce interesting studies. Do a drawing larger than the subject taking good care to study all the tiny details. Objects could be a tiny dead beetle, the inside of a watch, or an old worn small object.

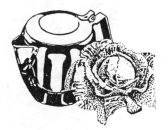

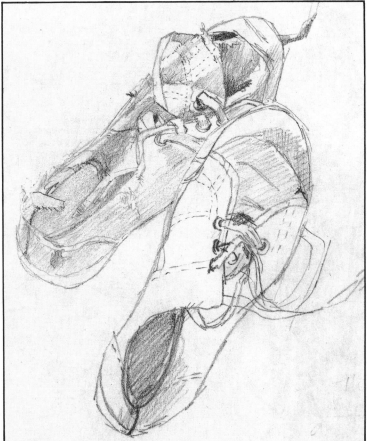

TASK 96
Common objects
Begin with this list of ideas and select one available in your home. Do a variety of studies from different points of view.
Hats
Shoes
Bottles
Vegetables
Fruit
Shells
Kitchen utensils

TASK 97
Unusual objects
Begin with this list of ideas and select one available in your home. Do a variety of studies from different points of view.
Broken toys
Discarded crumpled papers
Driftwood
Worn furniture
Old tools
Old weapons or musical instruments
Old shoes

©DIAGRAM

Drawing the unfamiliar

Your home may provide you with subjects to study, but going out on location, or collecting unusual objects, widens your source of ideas. Museums, antique shops, beaches, forests, scrap yards, all provide opportunities to discover subjects to study. Many famous artists had a private collection of odd objects that they could study for ideas. Rembrandt had a collection of skulls, armor, classical sculpture, plaster casts, furs, fabrics and jewelry, all of which he used as props in his paintings.

Museums
Left and below, a pencil study of a suit of armor and a pen study of a crab, both drawn in a museum.

TASK 98

Museums

Go to your local museum and sit in a corner away from the main avenues of the public. Do a very detailed study of some unusual object.

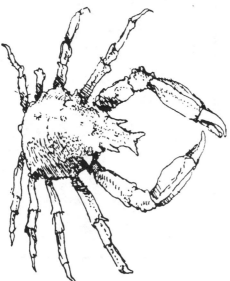

Exploration
Below, this pencil drawing of half a cabbage illustrates the opportunities available for finding interesting subjects among ordinary household objects.

TASK 99

Exploring the unfamiliar

Cut open a fruit or vegetable and do a very detailed drawing of the unusual shapes revealed.

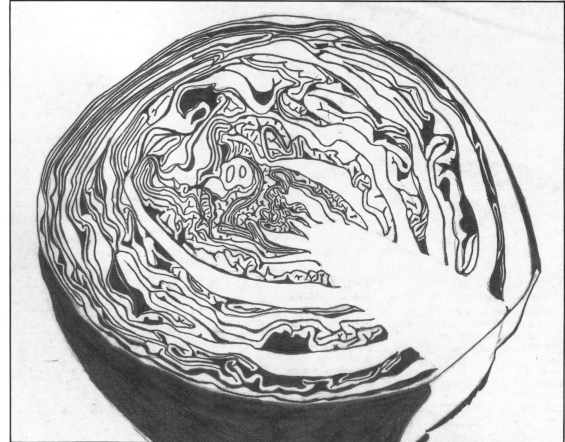

Outdoor objects
Left, a pen study of old railway signals and, right, a pen study of a 19th-century steam engine. Both illustrate the interest you can discover in outdoor objects.

TASK 100
Outdoor objects
Make a long-term study of some common object that has a large variety of forms – possibly city street lights, park benches or fire hydrants.

TASK 101
On-location studies
Keep a sketch book devoted to one narrow subject study made on location. For example:
Street furniture
Vehicles
Graves
Iron-work
Select a subject to which you have access – possibly boats, trains, cars, plants, trees, houses.

TASK 102
Sketch pad work
Collect small objects and commit them to memory in a small sketch pad. Elastic bands, wrapping paper, broken containers, keys, the contents of a small boy's pockets – all offer opportunities for a careful, actual-size pencil study.

Themes
A collection of studies of small architectural details observed in a 19th-century cemetery.

an old steam engine in a scrape yard.

Drawing objects as carefully as possible so that you can record every tiny detail is not to copy reality but to enhance it by careful exaggeration. Most successful drawings are built up from carefully drawn understudies, usually made in pencil and very often finished with a sharp dark pencil or technical pen.

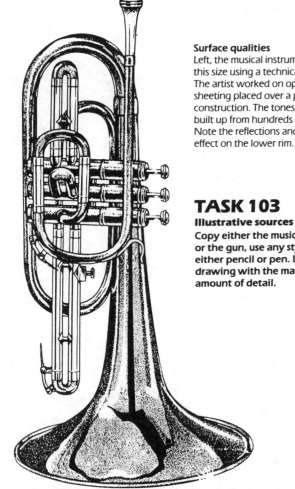

Surface qualities

Left, the musical instrument was drawn this size using a technical drawing pen. The artist worked on opaque plastic sheeting placed over a predrawn construction. The tones are carefully built up from hundreds of tiny dots. Note the reflections and the dazzle effect on the lower rim.

TASK 103
Illustrative sources

Copy either the musical instrument or the gun, use any style you prefer, either pencil or pen. Do the drawing with the maximum amount of detail.

1

2

3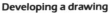

Developing a drawing

1. Begin with a hard pencil on tracing paper. Sort out all the complex construction at this stage.
2. Build up the main dark areas using Indian ink and brush, or pen.
3. Continue developing the drawing. Work very carefully to build up tonal values. Look for the tiny unique features, such as dullness, reflections, worn surfaces.

TASK 104
Photographic sources

Do a very careful study of an object from a photograph in an industrial catalog, sports goods catalogs, musical instrument manufacturers catalog, or a source of good clear photographs.

Notice board

Successful drawing depends greatly on your powers of observation. Graham's pencil study of the objects collected on his notice board are all drawn actual size and reproduced here the same size.

TASK 105

Natural size

Collect a group of thin objects, such as tickets, notices, envelopes, keys, jewelry and pin them to a board. Do a very careful study of them to the same size as reality.

TASK 106

Surface detail

Look at the drawing of a hammer on page 13 and then draw a similar study of an object that has a variety of surface qualities – part dull, bright, rough, smooth, soft and hard. Try to describe all the surfaces as accurately as you can.

© DIAGRAM

Arranging objects

For still-life studies, two aspects greatly influence the drawing's possibilities: what you draw and then how you view it. The choice is often a very personal one and remember that anything can be interesting. First do a series of sketches of the arrangement of the objects. Do not settle for the first solution, explore other groupings and viewpoints.

Lighting
Right, when setting up a still-life try a variety of lighting arrangements. Even with a simple cup, the changing directions of lighting produce quite different effects on it and on our understanding of the subject.

TASK 108
Lighting
Select an object that you feel you can draw carefully. Next do a series of drawings each with a different light source.

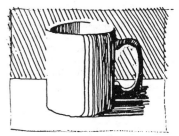

Arrangements
A group of objects can be arranged in a variety of ways.
A. They can be displayed facing the picture plane — a series of overlapping, flat, front-facing objects.
B. They can be displayed receding into the picture area — usually lying down and pointing into the page.
C. They can be arranged in a more complex way with some set at odd angles to the picture.

TASK 107
Grouping
Do three studies of the same group of objects: first arranged flat upright, square to the picture; secondly, all laid down receding into the picture; then in a disorganized arrangement.

A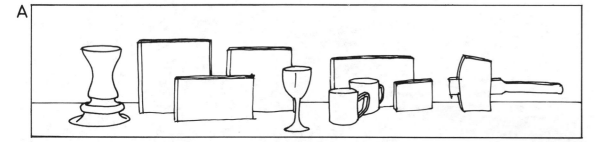

B

C

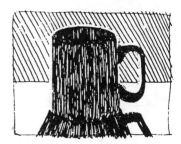

Composition

The possibilities for the positioning of a subject within a frame is the result of four factors:

1. Your position when you view the subject.
2. The subject's position in the frame.
3. The size of the subject in the frame.
4. The proportions of the frame.

Factors influencing the composition

A. Your position. When beginning a study choose a simple view if the objects are complex. Complicated views can be hard to draw.
B. The subject's position. Usually, your drawing should be within the central area of the paper, so that you can compose a framed view later.
C. The subject's size. Normally draw the subject with a minimum of 2 in (5cm) around it. It is usual to draw the subject smaller than actual size.
D. Frame proportions. Sketch pads, artist's paper sizes, commercial papers are usually rectangular and your drawing should be centered to enable you to apply a variety of formats to the rectangle.

A

B
 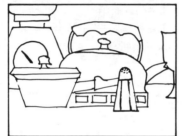

C

D

TASK 109
Composition

Do an analysis of the basic composition of still-life paintings in your local art gallery.

TASK 110
Framing

Make an adjustable pair of L-shaped frames so that you can sketch a variety of compositions within changing frame shapes.

Your view of objects

Simple objects can be the source of interesting drawings if you consider the point of view you select when examining them. Never begin a study without first doing a few very quick sketches of the object from a variety of view-points. Begin with simple views and later, when you feel more confident, select unusual ones.

TASK 112
Positioning

The drawing of a book is made interesting by the view in which its open pages fan out and in the way it is lit. Do a similar drawing of this book by standing it open on the table.

Unusual view
Looking down on the subject can be interesting as it offers a visual interest to what could otherwise be a dull subject study.

TASK 113
Unusual view

Try viewing your composition looking down on the subject or selecting a corner of the grouping.

TASK 111
Viewing

Select two objects and stand them side-by-side on the table.
1. Do a front view of them, then a side view.
2. Do another view looking directly at them, then do a view from on top.

3. Do two studies from oblique angles, either from above and the side, or from close up with a distortion.

1

2
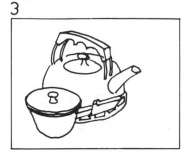

3

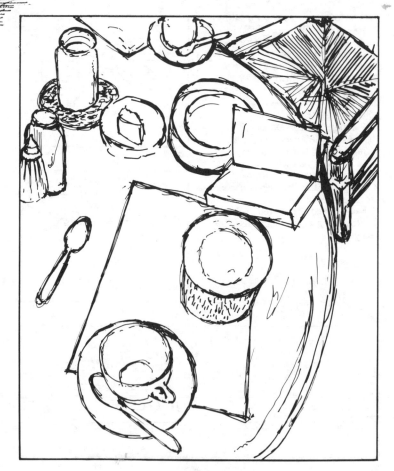

TASK 114
Drama
This is a simple paper stapler but the view creates a dramatic scene. Select an object such as a cooking implement, or carpentry or gardening tool and do a study which has a strong sense of drama.

TASK 115
Pattern
The simple silhouette of the chair is interesting because we seldom see the chair from this position. Do a drawing of a chair in your home viewing it from an unusual angle.

TASK 116
Subject
This drawing of a human skull is interesting for two reasons. The subject is strange, and the view is unusual. Try to obtain unusual objects which you draw from unusual angles.

©DIAGRAM

Beyond observation

Objects can be seen as representing ideas. They have an interpretation other than what they look like — they represent what we think of them. You may have personal views of an object which, if successfully described, add more to our understanding than straight recording of what you see. Your drawing can open our eyes to new ways of seeing reality.

TASK 117
Ideas
The drawing of a clock is not a description of what it looks like, it is more: it is a drawing of the idea of time. Select an object that represents an idea and describe the thoughts through the drawing. Try perhaps a knife, a shell, or an old worn-out object.

TASK 118
Formalization
Two drawings of men's suspenders. The elastic irregular-shaped objects have been presented in a formal pattern in these drawings from a 19th-century catalog. Turn one of your subjects into a designed structure.

TASK 119
Information
Drawings of objects are often used to convey information. This transparent engine drawing shows all we may need to know about how the inside relates to the outside. Do a transparent-style drawing of your fridge, medicine cupboard, or larder.

TASK 120
Imagination
The drawing of a scallop has exaggerated its features. It has become a fantasy drawing. Select an object and find the most dramatic way of reinterpreting its forms.

TASK 121
Drawing style
This drawing by a 19th-century Chinese artist of a small rock relies upon the style of drawing for its interest. Do a study of a simple object but hold the drawing implement in the hand not normally used for drawing. Redraw the subject using your normal hand and compare the qualities of line.

TASK 122
Graphic possibilities
These drawings of the insides of fruit are experiments in interpreting the way in which the shapes can be transformed into exciting designs. Turn one of your earlier studies into a flat arrangement of shapes.

©DIAGRAM

Develop skills

Drawing objects is a study from which you can learn a great deal before you begin the more exacting tasks of drawing people and places. Many artists have used the accessibility of objects as a convenient way to develop their skills and powers of observation.

TASK 123
Research
Visit art galleries, collect books on art, cut illustrations from newspapers and magazines. From wherever possible copy other artists' work.

TASK 124
Records
Check that all your drawings are marked with the date and your signature. You must constantly re-examine your work, but you must have an inner pride in your achievements to spur you on to more studies.

TASK 125
Pride
Select your very best study. Spend money on a professional service and have your drawing mounted and framed. Display it in your home.

TASK 126
Collecting
Begin a lifelong collection of one type of small object – possibly a type of ornament, candlesticks, ashtrays, salt cellars, horse brasses.

TASK 127
Study
Begin a lifelong study of your favorite object. Start by doing studies from books, become a specialist in the study of one small object.

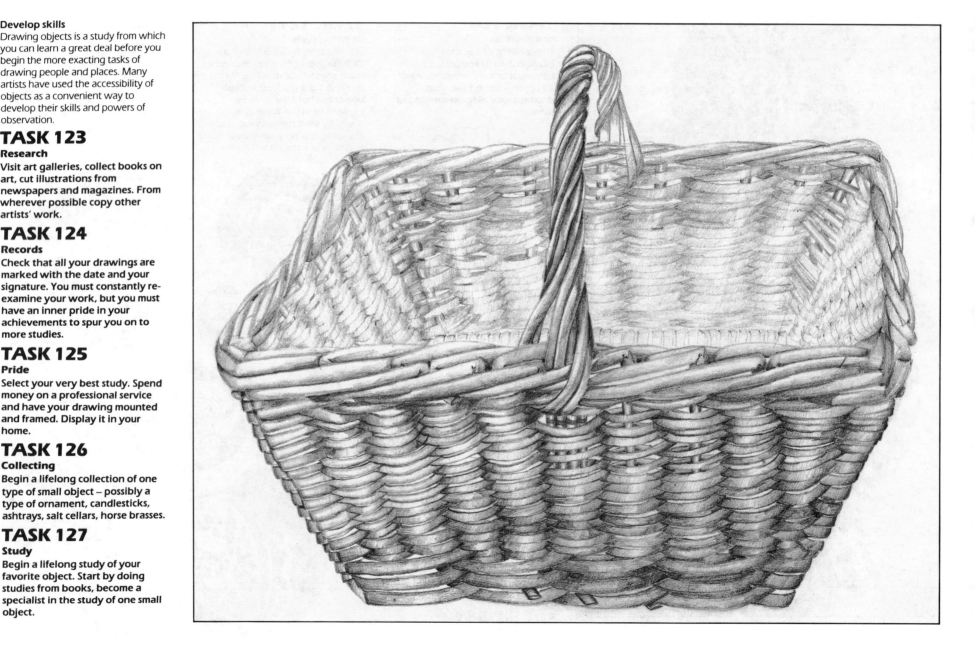

TREES AND PLANTS
LOOKING AND SEEING

Mastering plant drawing is not a simple skill. The qualities that make up a living plant are elusive. Drawings over which you spend a great deal of time may be accurate but lack life. Drawings done quickly after much practice may capture the very essence of the plant.

You will learn to produce a successful drawing by the combination of three factors: understanding what you see; mastering your tools; and seeing your drawing as an expression of a unique statement, independent of the original.

One certain way to develop your skill is to work carefully and slowly. Confidence comes with practice. You learn as you draw. Earlier drawings always reveal the innocence of your experience – this quality of innocence is the very element you should retain when trying to create a fresh and lively study.

Before you begin your drawing Tasks, Chapter one invites you to look more closely at plants or the landscape, and to study what you see.

Your earlier results will be very dependent upon your powers of observation. There are thirty-two Tasks to sharpen your judgement of what you see.

- The first two pages, 70 and 71, contain the most important idea in this section: places recede from you and contain solid objects – but you have only a two-dimensional surface on which to record them.
- Pages 72 to 75 help you check what you see and not to rely upon imagined shapes. They encourage you to examine the solid elements and the spaces between the parts.
- Pages 76 and 76 explain that all natural forms have a three-dimensional quality: they protrude from or recede into the picture.

- Pages 78 to 81 direct your attention to the surface qualities of trees and plants, their color, their shading, their individual and collective textures.
- Pages 82 and 83 show examples of the vast range of natural forms and the way each unique species can be interpreted to add interest to your drawings.
- The review, page 84, has examples of the way artists have looked at nature and how their view influences their drawing.

Drawings are flat objects, a surface with marks. The two-dimensional limitations must be overcome when trying to capture the three-dimensional reality of a plant or tree. Your drawing should attempt to describe the real world's features. Plants consist of shapes, tones, forms, textures and colors. Each of these characteristics can vary depending on your position and the conditions in which you view them. When drawing a subject from one view try to remember what it looks like from other points of view.

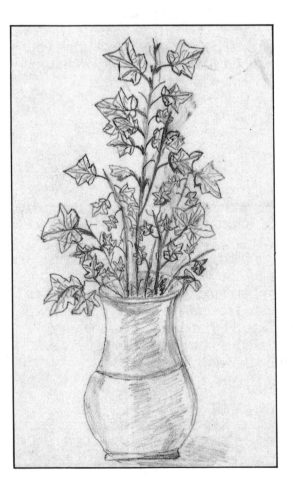

Granny's plant study
Left, the first-ever drawing of a plant by Granny, aged 76. Beginners see leaves, flowers and vases as flat shapes. When they draw subjects, they draw a net of lines with little regard for the spatial properties of the object.

TASK 1
Recording reality
Draw a bunch of flowers in a vase, or a small household plant. Take a long time over your drawing and record the maximum amount of detail. Pencils are usually best for beginners, but you can try any drawing implement.

Kathy's plant study
Right, a mature student's drawing of a plant. Education has taught her to vary line thickness to indicate changes of direction, to observe very carefully the details, and to consider the three-dimensional reality of the plant.

B

A

Seeing space

Edges are the forms of objects seen side on. Even the thinnest of leaves has thickness. Each plant has its own characteristic type of leaf and, although the individual leaves appear to you to be different, this is often because you see them twisted or turned.

TASK 2

Caged space

Another way to realize the space of plants is to imagine them in a cage. On a tracing paper overlay, draw a wire cage over Kathy's plant, left. Make the cage like a box with vertical sides and horizontal top.

TASK 3

Drawing plants

Place the plant or bunch of flowers you sketched in Task 1 on the floor and do another drawing of it viewed from directly above. Identify on this drawing the same leaves as in Task 1. Also, can you identify the leaves **A** and **B** (left) on Kathy's plan view (above)? The answer is on page 93.

TASK 4

Seeing Space

Do a plan drawing of the plant (above). Remember, each leaf is of similar shape, each leaf points away from the center, and each leaf may be directly above or below.

©DIAGRAM

Checking helps with accuracy. Take care to record the vertical, horizontal, and recessive relationships of fixed points on your plant study. The two-dimensional relationship is drawn vertically with a plumb-line and horizontally with a held-out pencil. Recessive relationships require you to maintain the same position throughout the study.

Recessive checking
You observe objects with two eyes – you are bifocal. This means that you see two images that are superimposed by your brain to produce an impression of a solid world.
You see a little of the opposite sides of objects close to you and again because you are bifocal, objects set in space have a displacement relationship between two points in space. Check this in Task 60.

TASK 6
Checking displacement
Sit with your head resting on a fixed point, and view two objects, one in front of the other, with one eye only. Mark a point on the first object which is in line with a point on the second. Close the first eye and repeat, and you will find that the point on the far object is different.

TASK 5
Framing your view
One simple method of checking the vertical and horizontal alignments of points is to make a frame through which you view the plant. Cut two L-shaped pieces of card and clip them together to form a frame. Check off the points which touch the edges in your view with similar points on your drawing.

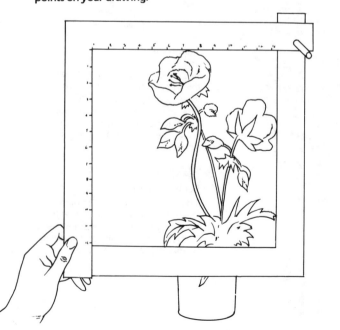

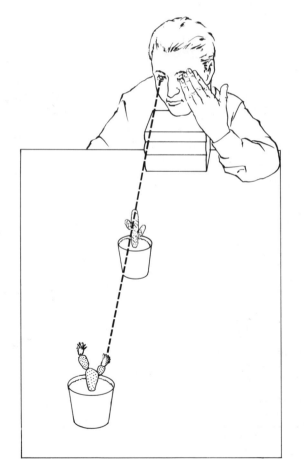

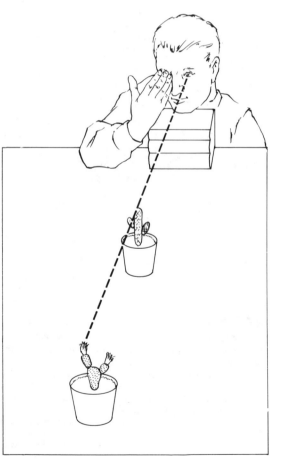

Vertical checking
This is achieved by holding a weighted line in front of the plant, sighted so that higher points can be checked against positions lower on the plant. Horizontal points can be sighted by viewing them across the edge of a pencil held at arm's length.

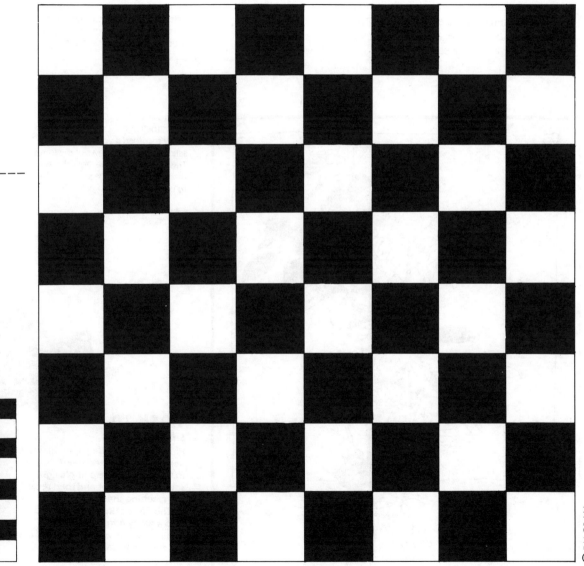

TASK 7

Vertical alignment
Make a hanging line from string or thread attached to a key. Fix two points, one above the other, on your plant study, and check them with your earlier drawing.

TASK 8

Horizontal checking
Place a plant in front of a checkerboard and draw the shapes carefully with a soft pencil on tracing paper placed over this grid (right). Pay particular attention to the places where the branches cross the dark squares and make sure your drawing records these points.

© DIAGRAM

Checking shapes

Often beginners are worried about their ability to draw accurately the complex and unique shapes of plants. Every plant seems different and there are no simple relationships between the parts. One method is to examine very carefully the shapes plants make, and the shapes of the space they leave exposed.

TASK 9
Helpful surroundings
When studying small plants, it is helpful to stand them in front of brickwork or trellis where the verticals and horizontals can be used to check their shapes.

Shadow shapes
Right, the complex shapes can be more easily recorded if you think of them as silhouettes, or shadows of the forms. This drawing by Jane, aged 12, was made by inking in the shadows, cast on to paper, of a garden plant.

TASK 10
Shadow shapes
Pin a sheet of white paper against a vertical surface, then stand a plant in front of it. Shine a single light source at the plant and then record the resulting shadows. Another method is to take a white board into a sunny garden, stand it behind a plant, and then record the shadows in your notebook.

The shape of space

Left, we tend to see the physical world, but not the shapes of space between the solid elements. This branch of blossom has two areas **a** and **b** which, when drawn separately from the plant, look quite different (below). Placing light plants against dark backgrounds, or viewing dark plants against the sky helps to expose these shapes.

Shapes in space

Right, each shape seen through branches is not bordered by sides which are touching one another. You are not looking at holes in a flat net of lines. They are the result of your position as much as the position of each to the other. The two shapes (**A** and **B**) are the consequence of crossing boughs which are spread well apart in the picture space. They belong to branches on trees about 10 ft (3m) apart.

TASK 11

Shape of space

Place tracing paper over photographs or drawings of plants and fill in with a felt-tipped pen the spaces between the foliage. Try this exercise on the drawings on pages 91 or 93, or do a drawing looking at the sky through a group of branches.

TASK 12

Changing shapes

Select a simple open tree or bush and draw the space between each group of branches on one part of the tree. Move your position to view the subject from another side and draw the same area, not the changing shapes.

Plotting points

Each end of a branch is located within the three-dimensional space of the tree. Linear subjects may look flat, but their open cage-like qualities are easily revealed if you walk around them and notice the changing relationships.

Transferring points
Right, keep your viewing position constant while you study a subject. This will help you to record the relationships accurately. Sit so that you can directly transfer your vision of the object on to paper (**A**) rather than turning your head through a wide arc (**B**).

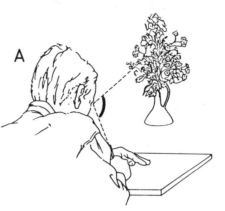

A

B

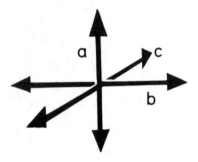

Spatial points
Left, branches reach out in three dimensions.
a. Upward and downward
b. Sideward from left to right
c. Inward and outward.
The end of branch at **b** may appear above a point at **c** but in fact is much deeper into the picture.

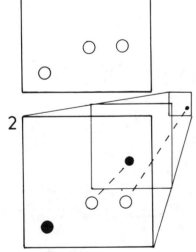

1

2

The Stars
Left below, the deceptive relationship is best illustrated by considering the stars in the sky. Each may appear to be alongside or above others (**1**), but within the vast depth of space they are often light years away from each other (**2**).

TASK 13
Radial points
Do a study of a tree that has fallen down so you can look down the central trunk and record the radial arms of the branches. Another way to study this effect is to draw a plant from a position above the top and looking down onto the group.

TASK 15
Relating points
Place tracing paper over a photograph or drawing of a linear plant and plot the ends of the branches in relationship to the central core.

TASK 16
Simplified structures
Do a study of a plant or tree. Ignore the individual features, just draw the main central group of branches as if they were a spreading collection of tubes.

Views of lines
Right, winter trees can look flat and thin, like the view of this leaf (above), but in fact they are the silhouettes of open, three-dimensional subjects.

TASK 14
Views of lines
Do a very careful study of a winter tree or a dead tree. Select one main branch that appears to be growing almost horizontally. Move your position to the side and redraw the subject, checking the new shape of the selected branch.

Linear plant
Left, this silhouette study of a plant suggests a view like a feather. In fact, all the leaves stick out from the central stem in every direction. The sketch along-side suggests some of the spatial relationships of some of the limbs.

© DIAGRAM

Light and shade

The ability to capture depth and space in a drawing, which is so vital to a good study, is often helped by the presence of light and shaded areas. Because we think of the source of light as usually falling from above, areas with dark tones indicate that they are beneath, behind or turned from the light source. This feature can be a great help to your drawing.

Branches
Left, the use of shading can help unravel the direction of branches. Dark areas can be used to indicate:
A. Areas turned away from the light source;
B. Areas beneath and shaded by foliage;
C. Areas carrying the shadows cast by other branches.

TASK 17
Branches
On a summer day with strong sunlight, do a pencil study of a group of thick-limbed branches. Take care to record the shadows of the foliage and twigs on the tubular structure of the branches.

Leaves
Left, in this pencil drawing the underside shading of the leaves helps describe the direction of each leaf on the main stem. Right, the pen drawing uses shading to indicate the surface character of the leaves and their direction.

TASK 18
Leaves
Draw a small plant with a single light source and record the shaded areas very carefully.

TASK 19
Textured volume
Choose a small bush and draw it as a single mass, describing the areas that overlap one another. Think of the bush as having been carved from a block and covered in the texture of the foliage, and draw the general bumps and hollows on the surface.

Light source

Right, this study uses the light source to describe which areas of the foliage are beneath other areas. The part of tree marked **A** is obviously in the foreground and the area marked **B** in the background.

Foliage

The overcast of a tree – its cover – helps you describe its bulk. With evergreens or trees in summer this overall texture of leaves is seen as a simple mass. The problem of how to set about drawing the tree becomes one of drawing a solid object and not a linear net.

Always think of the basic forms:

a. A ball
b. A canopy group
c. A cone
d. A tube
e. Irregular

TASK 20

Tree forms

Do a variety of basic shape studies of trees in the park or from photographs or drawings. Use a soft pencil and confine your drawing to describing the light and dark areas only, as in the study (far right).

©DIAGRAM

Using the overall surface qualities of a plant to suggest its shape, as on the previous pages, can be further helped if you consider the type of surface texture a plant has. There are an enormous variety of plant surface textures which, if recorded carefully, give your black and white drawing an appearance of color.

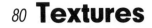

Foliage varieties
Below, the classic Chinese 17th-century work 'The Mustard Seed Garden' teaches artists to examine the varieties of texture on plants. This is a small section of the numerous styles of brush marks suggested to record plant varieties.

TASK 22
Drawing varieties
Practice with a brush the different types of marks you can make (see page 103) and convert the picture (opposite) of the imaginary garden to one of the brush marks.

Seeing character
Left and below, the whole is not the sum of the parts. Individual leaves do not necessarily indicate the overall character of a plant. These studies from leaf to apple tree, show the progressive change as you move further away from the subject.

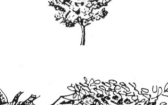

TASK 21
Natural character
Draw a complete tree, then a branch, then a cluster of leaves, then an individual leaf.

Wild varieties
Right, the 19th-century wood engraver Thomas Bewick was a master at rendering on a very small scale the individual types of plants in his landscape.

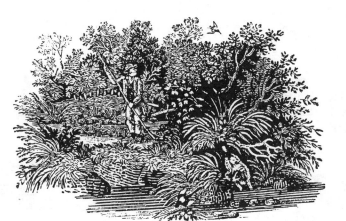

TASK 23
Texture
Do a very careful study of a section of a flower-bed in a park or garden, trying to record a large number of plant varieties.

TASK 24
Foliage
Keep a sketch book of a wide variety of foliage types. Develop a convenient way of using pencils, pens, or felt-tipped pens to capture the texture's main features simply. Apply your techniques of texture recording to studies from seed catalog photographs, or books containing photographs of the countryside. 19th-century artists very often exaggerated this feature when landscape painting.

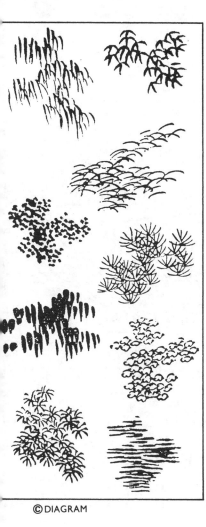

Imaginary garden
Above, this drawing is by a landscape architect who plans special feature gardens. His drawing is a collection of visual notes describing the different textures of plant varieties.

© DIAGRAM

Variety

There is a vast range of plants and trees. Each species has its own characteristic and its unique growing situation. Good drawings should leave you in no doubt as to the species, whether from the leaves, the size of the plant, its shape or the way the parts are arranged. Try to build up a knowledge of botany so that you can more easily recognize a species when you see it.

Japanese garden
Below, a wonderful drawing of the variety of plants in a Japanese garden. Most Japanese readers will be able to recognize the particular plants in the groups.

Leaves

Left, understanding the general shape of leaf species helps you draw more accurately the view of the particular leaf you are studying. Nearly all leaves have a symmetrical form, that is, the structure is divided down the center with either side mirroring the other. This must not be overlooked when drawing the leaf's attachment to its branches.

Structures

Plants grow in a regular way – their inner geometry directs them to develop particular forms. Most varieties have one of the following structures:

A. Clusters of stems from a common source.
B. One stem with alternating branches.
C. One stem with pairs of branches.
D. One stem with clusters of branches.
E. Each stem growing from the side of the preceding one.

TASK 25

Structures

Keep one section of your sketch book for plant structures and try to collect notes on the many ways the branches and stems are joined.

TASK 26

General appearance

Practice drawing the total tree in a way that indicates its general character. This is made easier if you study a distant tree that stands apart from all others.

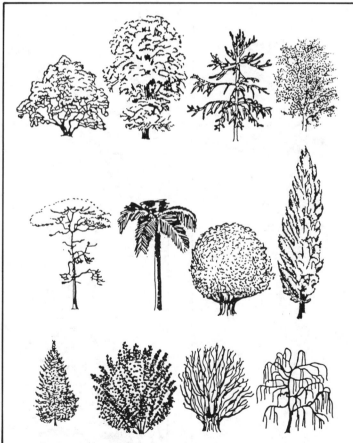

TASK 27

Leaf shapes

Keep a collection of dried leaves. Press examples of different shaped leaves in an old book, and perhaps keep a record by drawing around the edge of the different types you have been able to find.

General appearance

Left, because of their different structures, trees can be recognized by their overall appearance. They are often tall or short, thin or fat, heavy or light, upward pointing or downward pointing, straight or irregular.

TASK 28

Exotic forms

Use travel books or visits to a botanical gardens to sketch plants that do not grow locally. Draw palms, cacti, ferns, creepers. Often indoor garden plants have strange leaf shapes.

© DIAGRAM

Influencing factors
Not only are plants very varied, but each drawing has a number of influences on its appearance. It will be the result of your experience, the marks the tools make, the purpose of the study, and your cultural origins.

TASK 29
Variety
Study botanical books and learn to identify types of plants and trees.

TASK 30
Artistic diversity
Collect examples of artists' drawings of plants and trees that display decorative designs in books, magazines, and posters.

TASK 31
Artistic style
Copy the drawings of famous artists. Try to understand what tools they used and, if possible, identify the species of plant.

TASK 32
Presentation
Check that you signed and dated all the drawings you have done. Then make a notice board of hardboard or cardboard and pin up your most successful study for criticism by your friends and, most importantly, by you.

The previous 32 Tasks
Direct your attention to looking carefully at what you can see in the subject. Here are some examples of artists responses to their observations.
1. 16th-century drawing of a plant. This type of drawing is offered to enable you to identify a species you find.
2. 20th-century drawing of grass produced for the same reason.
3. Japanese brush drawing that captures the beauty of the plant.
4. Recreational study by child, aged 9 years, learning to record what she saw.

1

2

3 4

UNDERSTANDING WHAT YOU SEE

All plants and trees are three-dimensional – they exist in space. It is important to think of the space they fill and the space in which they stand.

Your drawing is an invitation to step into the same space as the subject and to experience its solid three-dimensional existence.

There are twenty-eight Tasks to help you achieve a special quality in your drawings.

- We start by considering what space looks like. Pages 86 to 89 describe the way plants and trees change their appearance, depending upon their location within your picture.
- Pages 90 to 93 examine branches and stems. A study of them will reveal their directional growth, and we look at how you must always locate them in the picture space.

- Pages 94 and 95 highlight the artist's traditional use of lines and tones to describe how leaves and branches overlap one another.
- Next, pages 96 and 97 set you four Tasks to enable you to understand that the thin flat qualities of a leaf may appear irregular, but are, in fact, distortions of simpler shapes.
- Finally, page 98 suggests how to apply your discoveries to a photograph.

The world is an open spacious environment.
When out on location, plants are identifiable in
the foreground, trees in the middle distance and
both combine to form shapes in the far distance.

Spatial properties
Your drawing of space is helped by five
techniques:
1. Haze – loss of detail in distant
objects.
2. Surface detail – foliage of plants and
trees.
3. Scale – size and detail of plants
diminish the further they are from you.
4. Base position – the position of
objects relative to each other.
5. Overlap – the amount by which
each plant obscures others.

The five features of space
1. Haze
Distant trees are seen as flat shapes.
The area between you and far
distances make them appear to have
less color than foreground objects, and
also to be simpler in form. In effect,
they merge into one another.

2. Surface detail
As foliage recedes into the distance, so
our ability to observe its tiny individual
features decreases. We see more
textures in foreground objects than in
distant ones.

3. Scale
Although plants grow to many
different heights, our knowledge of the
appearance of their adult size helps us
to locate them within the landscape.

4. Base position
By our observation of the heights, we
judge the location of the base of each
plant and tree. This fixes the object
within the receding surface of the
landscape.

5. Overlap
We understand positioning in space by
the amount one object overlaps and
obscures another. This is clear of each
object as well as its parts.

Spatial transfer

Right, you view the subject as if through a glass sheet. This imaginary surface, the picture plane, is set a right-angles between you and the subject. If you were to walk around a tree or plant, you would observe its three-dimensional properties, but when doing a drawing you have only two dimensions on to which to record these features.

Normally the following is true of your drawings:
Vertical (**A**) and horizontal (**B**) directions will be constant, and reduce proportionately into the distance. Recessional directions (**C** and **D**) will appear distorted so must be drawn to APPEAR to protrude and recede.

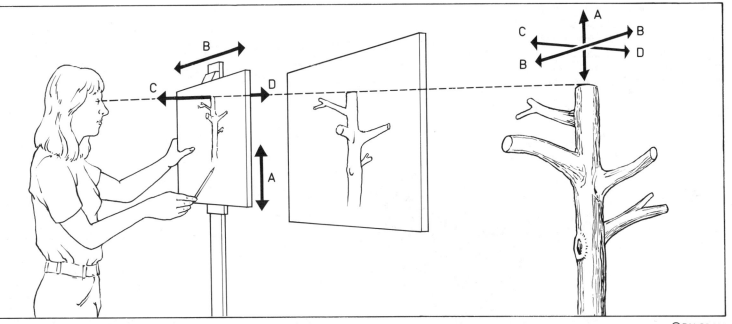

©DIAGRAM

Diminishing detail
Drawings of the same bush seen from varying distances. Each receding view of the object reduced its size. Although it appeared smaller the further it was away, the bush is reproduced the same size on each occasion so as to emphasize the change in detail.

TASK 33
Scale

Draw a landscape that contains a row of trees of similar height. Sit near one end so that they appear to diminish the further they are away from you.

TASK 34
Bases

Draw a group of trees or plant pots on a patio, and plot carefully their base points in relationship to one another. A street of trees is a good exercise as the sidewalk provides a clear guide to their base positions.

TASK 35
Overlap

Draw a group of trees in full foliage that overlap one another. Shade the near ones darker than those in the distance. Treat each tree as a cut out, flat shape.

TASK 36
Detail

Sit close to a small bush and draw as much of the detail as you can. If possible, draw every leaf! Move away and do another drawing, recording only the form and shadows of its foliage. Move even further away and draw its silhouette.

Although it may seem obvious that distant objects appear smaller than similar sized ones in the foreground, this is often unnoticed by beginners. When in doubt about the size of two objects, a distant one and a near one, check their heights one against the other.

Landscape scale
Below, the tree marked **A** on the distant horizon is considerably bigger than those in the foreground marked **B**. Even the tall tree **C** is smaller than **A**. The scale of objects is established by comparison with their surroundings.

Checking reducing scale
Above, hold out a pencil vertically at arm's length. Slide your finger up the pencil until the exposed end of your pencil is equal to the height of the distant object. Transfer this measurement by eye to an object near you and compare it with the first. Use these two measured lengths to make a similar proportional height on your drawing.

TASK 37
Judging size
Draw two trees with considerable distance between them into the composition. When drawn, try the measure test to judge how much one appears larger than the other.

TASK 38
Context

Place tracing paper over a landscape picture and, using a felt-tipped pen, draw a distant tree. Move the drawing to a foreground position and compare its new scale with surrounding objects.

TASK 39
Diminishing scale

A field of grass or wheat contains plants of similar height. Do a landscape drawing in which the foreground plants are drawn with bold, strong lines, and the distant tones with tiny fine lines.

TASK 40
Regular reduction

Draw an avenue of trees of similar height. Take special care to check their base positions and their heights.

Recessional objects

Right, objects of a similar height diminish on a regular scale. This is very apparent with an avenue of tall trees.

©DIAGRAM

The life of a plant shows in the strength and shape of its branches and stems. Its tensions are a key factor to capture in your drawing. Each branch is flexible yet firm, and the weight of the leaves acts to produce a curve on the lines of growth which you must portray in the lines of your drawing.

Life force
Right, this pencil drawing of a spring flower has a good sense of tension. The thrusting twist of the leaves and stem gives the drawing its vitality.

TASK 41

Life forces
Draw a young new branch or plant, trying to capture its springy, fresh, life force.

TASK 42

Understanding joints
Draw a branch and its stems taking care to study very carefully the joints between the branches and stems. Look for evidence on the branch of removed stems.

TASK 43

Surface clues
Draw a limb of an old tree, taking care to record the textures and changes of direction of the branches growing from the limb. Note that points on the edge appear closer together.

Branch types
Left, two silhouette studies of branches of trees. The top branch has paired stems, the bottom has individual stems.

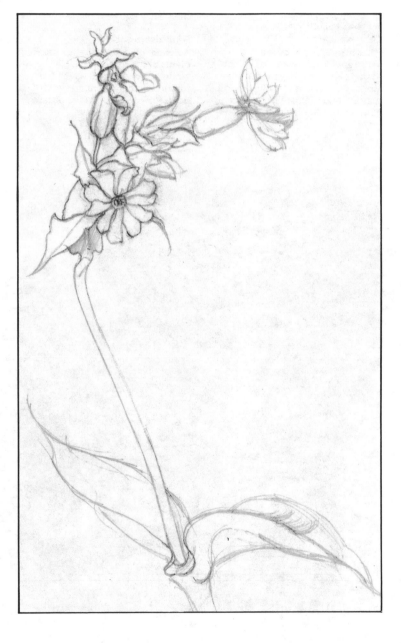

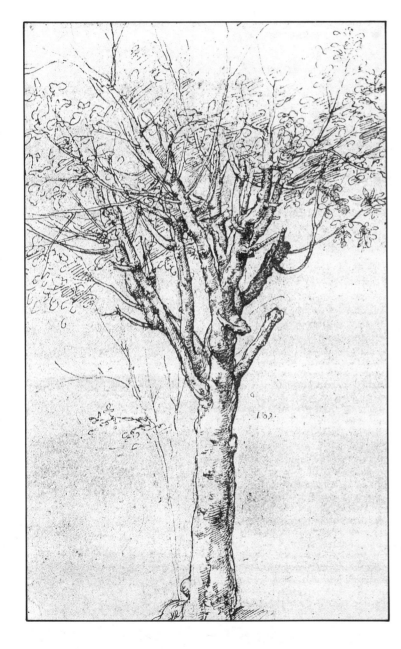

Tubular effects

Right, all limbs of plants are circular in section. Because the surface is curved round and away from you at the edges, points on the surface appear to become closer to one another as they approach the edges.

For example, **A**, **B**, **C**, **D** and **E** are all equal distance on the surface but appear to get closer on the outer edges.

Trunks

Left, studying the irregularities of an old tree helps you to record more accurately the volume and direction of the limbs. Each strut produces shadows on the surface of the bark and the texture of the bark will reveal tiny clues as to its direction.

Seeing tubes

Right, branches are tubes. A cluster of spreading branches can best be described by thinking of them as tubes pointing in a variety of directions. You can see this effect more clearly if you imagine the branches cut up into small logs. Each log should be separated at the point where it grows from another or from where it changes direction.

TASK 44

Volume

Draw a large branch as if it were sections cut into small logs, each rejoined at the branching point. Note very carefully the changing directions.

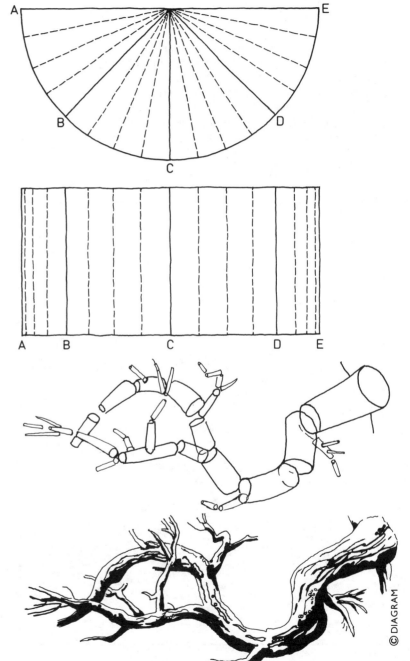

Base points

Studying the points at which plants grow from the earth can be very helpful in establishing their positions in space. The plotting of ground points and the construction of contours are often overlooked by beginners. While they may produce wonderful studies (such as the drawing below by Helen, aged 11), they lack any understanding of how the edges of the vase should be constructed.

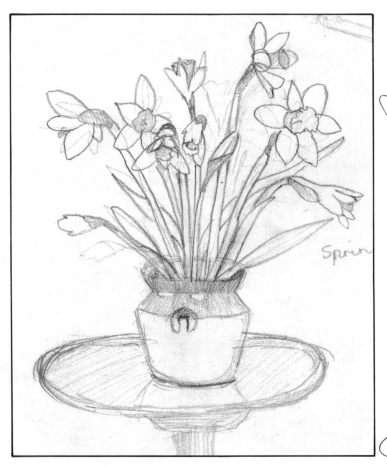

A

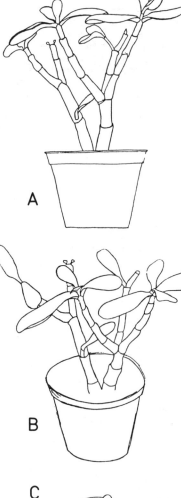

B

C

Drawing circles

Right, always remember some simple rules:

1. All circles fit into squares, touching the four sides at points on the center of each side.

2. All circles on vases and pots have their center points located on the central axis of the object, usually one above the other.

3. Usually circles describe horizontal discs, so these change depending on your viewpoint. Those level with your eye appear condensed and you see less of their surface (**a**). Those lower down (you are looking on to them) reveal a more circular form (**b**).

TASK 45

Understanding circles

Copy on tracing paper overlay the circular elements of vases and pots. Use trade catalogs and any photographs of objects where there is a variety of circular elements. Candlesticks, table legs, vases, all have horizontal circular elements.

TASK 46

Drawing circles

Left, draw a plant pot. Place it on a table and sit low down so that the pot's edge appears as a straight line (**A**). Do another drawing, placing the same pot on a chair located approximately 3ft (91.4cm) away from you. The rim of the pot will now appear as an oval (**B**). Finally, place the pot on the floor and do a drawing looking down on the subject. The rim should now look circular (**C**).

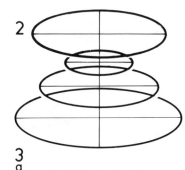

1

2

3
a

b

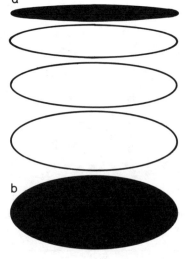

TASK 47

Comparing relationships

Below, push three sticks into the ground in the form of a triangle. Join their bases together with string to form a spatial net revealing this arrangement. Do a series of drawings from different distances from the group and notice how the triangle appears thin and shallow as you recede from the subject.

TASK 48

Winter roots

During winter the base points of plants can be more easily observed. The drawing (below) of a field of bare fruit bushes in snow clearly shows the position of the bases. Do a drawing in the park or countryside of a group of bare winter trees.

Understanding space

Right, the two views of the plant on pages 70 and 71 were to be compared to help you locate the positions in space of the leaves. Did you correctly identify the same leaves in both drawings?

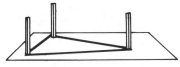

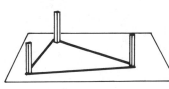

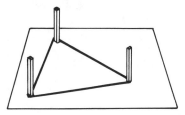

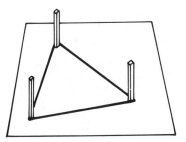

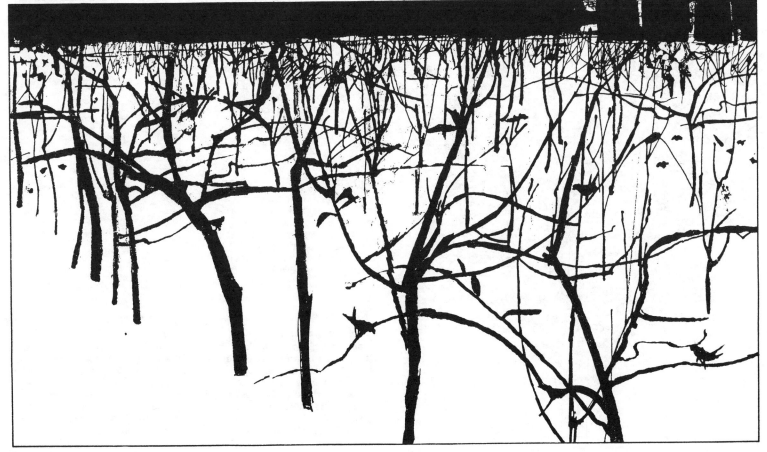

Overlap and haze

The two main techniques used by an artist to create an illusion of space are overlapping of lines and the softening and lightening of those lines meant to be more distant. Both are drawing conventions and if used carefully can give your drawing a greater sense of depth.

Drawing space
Three methods of obtaining a sense of space – overlap, line emphasis and tones.

Overlap (1)
Above right, tree **B** is clearly four trees behind tree **A** and although tree **B** is drawn the same height as tree **A**, it is clearly the tallest if set so far into the picture.

Line emphasis (2)
Far right, all the leaves are drawn the same size, but because of overlap and the increased thickness of lines some appear closer to the surface of the drawing than others.

Tone (3)
Below right, the branches appear behind or in front of one another because of overlapping lines, changing line thickness, and the addition of tone implying cast shadows.

Overlap
Left, a line drawing in which every element is recorded as if it were a flat surface parallel to the picture. This is a network of lines describing a three-dimensional object. The only concession to space is that some leaves overlap (so must be in front of others).

TASK 49
Explaining overlap
Place tracing paper over the drawing (left) and with a pen draw in thick lines all the leaves you think are nearest to you. Next, reduce the thickness of lines as you describe the leaves further from you. If you find this technique successful do a drawing from a study of a plant in this way.

TASK 50
Haze
Place tracing paper over the same drawing (left) and shade the leaves without drawing their outlines. Use light tones to describe leaves furthest from you and darker tones on the nearest leaves. If you find this technique successful, do a plant study from life.

Haze
Above, distant objects appear less detailed than those in the foreground. This is more true over greater distances, but the technique can be used when drawing an individual plant. This drawing uses haze to place the leaves in space.

Overlapping textures

Drawing the thin elements of a plant often presents only a silhouette of their volume and direction. Nevertheless, you must always be careful to draw in the overlapping features as these place each part in its correct spatial position. Below, four drawings of the same plant:

A. The edges give little clues telling you which leaves and branches are in front of others.
B. The same outline with details of overlap to explain positions.
C. Exactly the same outline, but with a completely different explanation within the shapes as to the positions of the leaves and branches.
D. A completed drawing with inner detail added to aid understanding.

TASK 51

Line overlap
Do an outline drawing of the illustration on page 71. Use the edges to carefully describe where the objects overlap.

TASK 52

Reading edges
Trace the outline of the plant (right) onto a sheet of tracing paper, then add inner details to explain which leaf you think overlaps others.

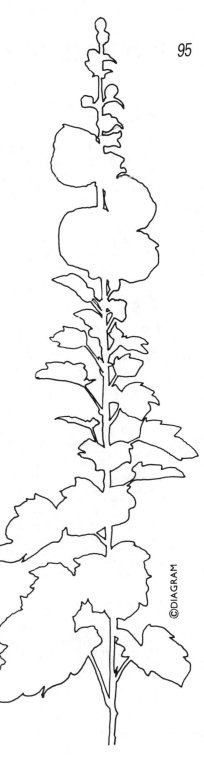

A

B

C

D

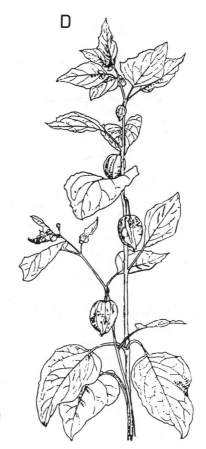

©DIAGRAM

All natural forms have a pattern of construction which is the result of their growth. However irregular a leaf or flower may appear, it is nevertheless conforming to nature's secret geometry. When drawing an individual flower or leaf it is useful to consider its basic shape.

Most flowers are circular with the petals radiating like the spokes of a wheel from the stem. Most leaves are symmetrical, one side being a mirror-image of the other, along a spine. The structure of a leaf radiates from the spine like a fan.

When drawing individual leaves or flowers three factors influence their appearance. Firstly, their natural species' characteristics, with the added tiny, unique variations of each object. Secondly, the way the object twists and turns as it grows. Finally, your view of the plant from where you are looking at it.

TASK 53
Twisting and curling
Draw a leaf shape within a rectangle, so that the edges of the box touch the tip, sides and stem of the leaf. Cut out the rectangle and place on a hard surface. Rub the paper with the back of a comb or ruler and the paper will curl. Draw the twisted shape and the new leaf shape.
Rubbing the paper in different directions or on the back produces different twists and curls.

Leaf form
Above, simple leaf shapes can appear very complex when they twist sideways and bend forward. It is always advisable to think of them as flat shapes, within a rectangle, then consider the distortions of the rectangle as indicating the unusual shapes of the leaf. Always keep in mind the idea of a center line running from the stem to the tip, and begin by sketching in the distortion of that line before plotting the outer edge.

Petaled flowers
Right, the wheel-like radials of petals can best be understood in plan view (**a**), but so often the flower appears in a different picture plane to the surface of our drawing (**b**).

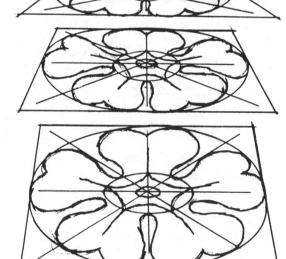

TASK 54
Flower shapes
Cut out a simple circular pattern of petals. Then draw the cutout from a variety of different views. First, a position directly over the shapes (a plan view). Next, one seen from above at a slight angle, and finally, one seen low down, almost from the side. Each time check that you have positioned the petals in the correct relationship to one another.

Grid distortion
Thinking of the leaf as a flat, regular, outlined shape that is twisted and curled by a regular grid helps to plot the edges more accurately.

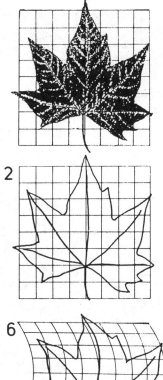

TASK 55

Grid distortion
Using tracing paper and a soft pencil, copy the squared grid on this page (1). Place your grid over a leaf of similar size and copy the outline (2). Trace off another distorted grid from this page (3, 4 & 5). Where the outline of your leaf cuts your grid, replot the inter-sections on to your new distortions (6). The resulting new leaf shape will create a drawing of a leaf bending in space.

TASK 56

Changing the shape
Working on a tracing paper overlay replot the leaf. Each time begin with the stem on an edge dot.

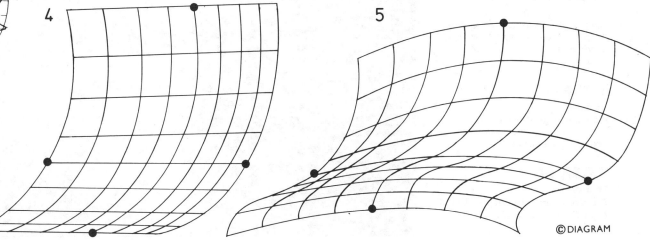

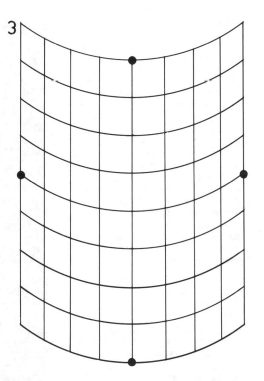

© DIAGRAM

Copying photographs

This chapter was concerned with explaining your impressions and how you recorded them accurately using conventional drawing methods. All drawing is explaining to yourself the space and form of reality, and for this reason working from nature is the best source of information. Nevertheless, photography can be of use in testing what you think you understand of the objects within your view.

When you first examine this photograph it appears normal but a little strange. When you try to copy what you see in the photograph it becomes less understandable. Before you begin the next four Tasks, turn the page around, viewing the picture upside-down and see what further sense it then makes.

TASK 57
Base points
Do a small sketch plan of the picture, locating the base points of the trees along the river bank.

TASK 58
Scale
Imagine you could walk away from the picture to obtain a full view of all the trees. Do a sketch of all their heights.

TASK 59
Texture
Do a drawing of the picture and carefully describe the various textures of trees, water and plants.

TASK 60
Shapes
The picture contains two types of trees. Draw an example of each, side by side.

MASTERING TOOLS CHAPTER 3

This chapter is about the marks you make when drawing, the surfaces you work on, and the tools you use. Every tool is useful but you will find some more convenient than others and, therefore, more comfortable to use. When working on location, take the tools which you most enjoy using. There will be opportunities at home to experiment with unusual tools or papers.

Twenty-five Tasks invite you to appreciate the qualities of the lines and tones of a drawing – the graphic qualities of your art.

- We start, on pages 100 and 101, with reviewing all the drawing tools normally used by beginners.
- The next two pages, 102 and 103, show the quality of lines achievable with pen and brushes – tools with which you may not be so comfortable.
- Pages 104 and 105 contain examples of working with tones. They show you how to build up the values of light and color with brush and pencil.

- Pages 106 to 109 encourage you to work out of doors, taking the knowledge acquired while studying indoor plants to the wild flowers and landscape of the countryside.
- Finally, page 110 reviews your working habits and needs. Do you have the correct equipment? Are your materials correctly sorted? Are your drawings preserved with care?

Whatever you choose as a drawing tool is of little relevance to the quality of your work if you feel comfortable using it. Normally beginners use pencils as these offer a wide range of marks and can be corrected with an eraser. In addition to the most familiar tools, use also those with which you have no experience when you have the time to explore their effects.

Types of tool
Right, there are four main groups of drawing implements:
a) Dry-medium tools: pencils, charcoal, chalks and crayons.
b) Wet-medium tools: ball-point pens, felt-tipped pens, technical drawing pens and brushes.

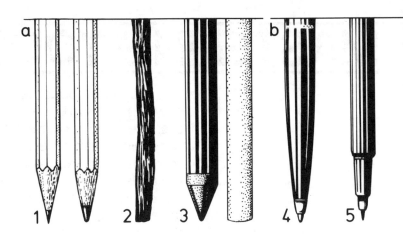

Types of tool
There are two main types of tool, dry-medium tools and wet-medium tools. Usually, the dry-medium tools work best on rough surface papers and the wet-medium tools on smooth surfaces. Brushes work on both smooth and rough surfaces, but are best on thick, strong paper as the dampness of inks can cause thin paper to buckle.

Dry-medium tools
Range:
1. Pencils; these are sold in a variety of strengths depending on the grade of the lead. H pencils are hard (thin faint lines), B pencils are soft (broad black lines).
2. Charcoal; this is not very suitable for plant drawing.
3. Chalks and crayons; these are good for landscape studies.

Pencils
The most popular, and easiest to use, tools are pencils. They produce a wide range of tones, and for most drawing surfaces their marks can be removed with a good clean eraser. They can be made to produce a wide variety of line thickness, or areas of tone that are built up into grays without showing the individual marks. The drawing (left) by Jane, aged 21, of spring buds uses the soft quality of the pencil to build shading and texture in the subject.

TASK 61
Caring for tools
Sort out your tool box or drawer. Make sure that all your pencils have sharp points and discard any that produce broken leads when sharpened. Make sure all your brushes have been washed clean of ink.

TASK 62
Judging tones
Draw a large leaf and, using a pencil, shade it in to try to capture its exact tonal value. Repeat the study using a pen and cross-hatching, and try to match the apparent effect of the pen lines with the built-up pencil tones.

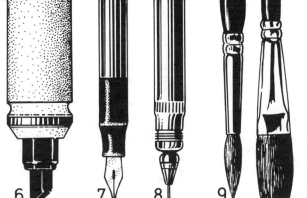

Wet-medium tools

Commercial writing tools are useful for drawing as they are convenient and can be replaced easily.
Range:

4. Ball-point pens; although usually not considered suitable, they are good for quick sketching.
5. Fine felt-tipped pens; these are good for studies of detail, but it is only possible to build line drawings with them.
6. Broad felt-tipped pens; good for solid areas.
7. Traditional writing pens; these give a good variety of line thickness, but are difficult to use on rough surfaces.
8. Technical pens; good for indoor studies of detail. They produce a consistent line without varying thickness or weights. Not suitable on rough surface paper.
9. Brushes of varying thickness; they produce an excellent quality of line, but are often inconvenient when working on location.
10. Oriental brushes; wonderful to use, but often difficult to acquire.

Commercial marking tools

Above, ball-point pens and felt-tipped pens with broad or narrow points are good for quick sketches. This drawing was made with two felt-tipped pens, one with a fine point for drawing the detail, and one with a broad point for filling in the darker areas. None of these tools allow you to alter the drawing once you have made the marks.

Drawing qualities

Above and right, these two studies of leaves show very clearly the different effects produced by tools. The drawing made with a pen (right) has the tonal areas described by layers of crossing thin lines. The drawing (above) is made with a pencil and here the tones are achieved by gently building up layers of marks with a soft pencil so that individually applied lines cannot be seen.

TASK 63

Line variety

Do a series of drawings of the same subject, such as a small plant in a pot. Make each drawing approximately 6 in (15cm) deep. Make each drawing of exactly the same view, but with each drawing try a different tool. Pens can offer greater detail than others, such as chalks.

TASK 64

Brush work

Collect together all your previously drawn Tasks and select one you think will convert to a brush study. Practice working quickly and freely, and do not worry too much about following the subject in detail. Use the pen to capture the gesture of the plant.

©DIAGRAM

Pens and brushes

Pens and brushes are good for capturing the spring and bounce of plants – their life force. The varying thickness of pen and brush lines means that you can use them to express the tensions and slackness of a fine branch. Both tools require you to work with speed to achieve a sense of energy, so it is often a good idea to do a pencil study first, then when you have committed the subject to memory, quickly produce a brush study.

Building tones
Left, pens are not suitable for drawing tonal values and Task 63 on the previous page will have revealed this. This drawing has successfully captured the gloss of the leaf but has a very laborious way of indicating shadows.

TASK 65

Exploration
Don't be afraid to have fun with your tools. It frees you from your inhibitions. The drawing (left), made with a pen, was produced by a method that usually does not create attractive results but can help you see subjects more clearly.
1. Select a simple plant.
2. Sit facing the plant with your drawing pad and pen on your knee.
3. Focus your attention on one point on the plant and trace carefully with your eye the contours of the plant, starting along the edge of a leaf.
4. Follow very slowly and carefully with the pen on paper, but do not look down at your drawing.
5. Only look at the paper when you replace the pen after filling it with ink.

Capturing life
Above, this pen drawing of tropical grass is not a study of individual leaves. The broad thick-ended marks with fine tails are made to resemble leaves by pressing the pen hard when beginning the line, and releasing it quickly when completing the line. The marks imitate the leaves.

TASK 66

Capturing life
Select a cluster of long grass or thin-leaved plants and do a similar pen drawing. Work on smooth paper with a thin solution of ink that flows smoothly.

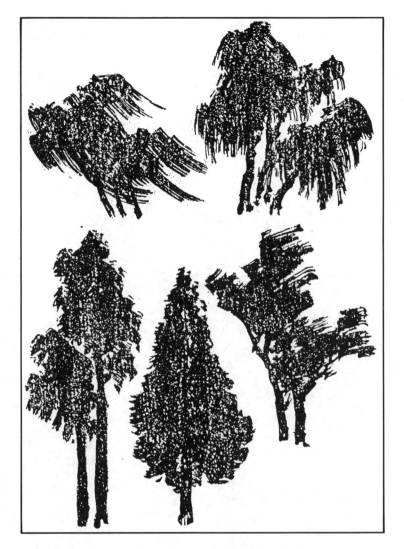

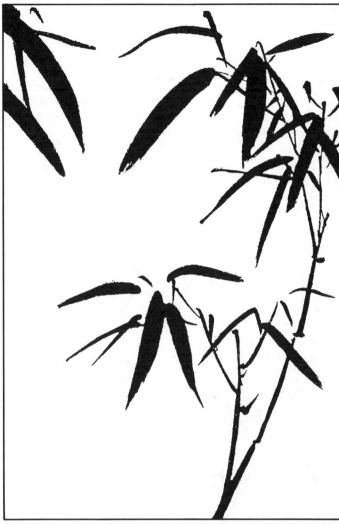

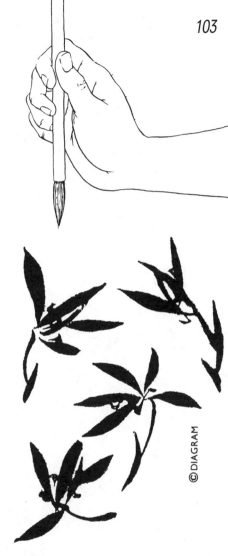

Movement
Above, these wonderful drawings of trees in a storm were drawn by the 19th-century Japanese artist Hokusai. He used a large brush, applying the ink boldly in the direction of the wind.

TASK 67
Brush strokes
Practice with a brush the technique of producing lines that have fine ends but fat center areas. Once you feel you understand how to make satisfactory brush marks, do a series of drawings of the same plant. It is better to draw grass-leaved plants than those with irregular or rounded leaves.

Vitality
Above, bamboo leaves in a 17th-century Chinese drawing instruction book. Each leaf is a single brush stroke. Each section of the stem is a single brush line. This sort of drawing does not allow for revision or correction.

TASK 68
Oriental art
Obtain a book of Chinese or Japanese art and copy the drawings. You must always try to make only the same number of marks on the paper as the original artist. If you use any tool other than a brush, you will produce a drawing with a quite different effect.

Technique
Above, one method of obtaining variety of line thickness is to hold the brush in a vertical position with only your wrist touching the paper. You obtain variations by lowering or raising your complete hand.

© DIAGRAM

Because leaves and branches usually do not form a solid surface to record, the use of tones can help sort out the visual confusion of the individual elements. Pencils, brushes and chalks can be used to create the values. Pens are not suitable as you can see from the pen drawing of the leaf on page102, where the artist had to build the tones laboriously with cross-hatching.

Creating tones
Below, this is a pencil outline with brush and wash fill-in. Opposite is a soft pencil study.

TASK 69
Variety of tones
Draw a vase containing a group of different leaves and flowers. Try to capture the range of tones on the petals, leaves and stems.

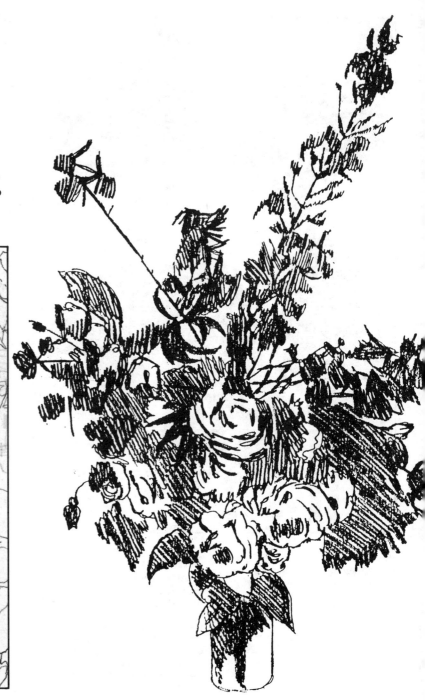

Pencil study
Below, the soft pencil study of a plant
in which the tones are carefully
recorded.

TASK 70
Light and shade
Make a pencil study of a plant with
a strong source of light. Draw the
leaves in the normal way, but fill all
the shadows in strongly.

TASK 71
Building tones
Place tracing paper over the line
drawing below and with a pencil
build up a tonal drawing of the
leaves.

TASK 72
Surface qualities
Using pencils, draw a plant with
large leaves. Try to capture the way
the light falls on the leaves,
revealing the bumps and hollows
on its surfaces.

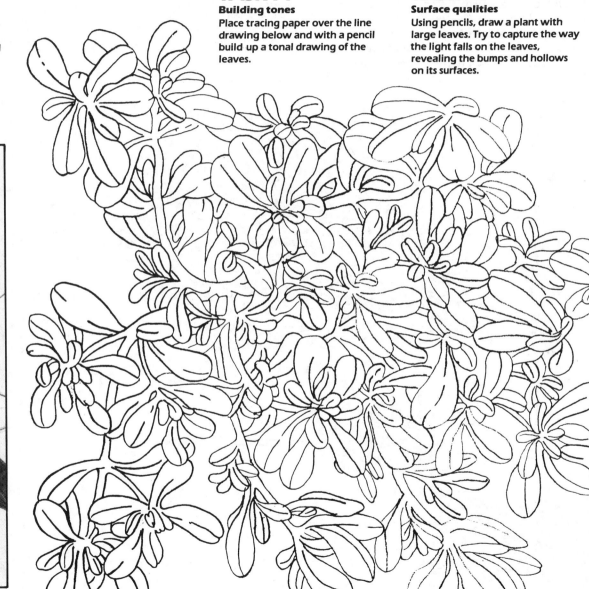

©DIAGRAM

Working out of doors

The best outdoor drawing tools are the ones you feel confident with. Pencils, ball-point pens, felt-tipped pens, are all good, convenient drawing tools. Using pens or brushes on location requires you to take ink and water, which may be difficult to hold while you are working.

Exploring texture
Below, pen drawing of foreground plants and middle-distance trees where the different textures can be explored by using scratchy pen lines.

Capturing life forces
Left, pencil study of a sunflower where the forceful lines describe the growth and not the texture, space or tones of the plant.

TASK 73
Life force
Using any drawing implement, draw a growing plant, paying the maximum attention on the force of its stems and leaves.

Seeing shapes
Below, felt-tipped pen study of a branch seen against the sky. The availability of broad and fine-tipped pens means you can use both in one drawing to record small details and large areas.

TASK 74
Felt-tipped
Do a drawing of a branch using broad and narrow felt-tipped pens. Look at the shapes against the sky to see their silhouettes; do not record texture, tone or space.

Exploring brush marks
Below, a brush drawing made with the fine point of the brush to draw pen-like lines and the brush full of ink to paint quickly and broadly the darker shadow areas.

TASK 76
Artist techniques
From books and museum exhibitions, examine closely the work of famous landscape artists so that you can study the method by which they did their drawings. Be careful with reproductions, as these are often smaller than their originals, or may even have been made with different tools than those used for the original drawings.

TASK 75
Brush drawing
Take a brush, bottle of ink, small lid for putting ink into, and screw top jar of water. Go into the garden or park and do a subject drawing on strong paper.

©DIAGRAM

Drawing on location often means recording what you can in the time available. Do not attempt complex drawings if it is likely you will only have a short time. It is often advisable to concentrate on one aspect of the subject and work with a limited number of tools.

Remembered landscapes

Above, the silhouette of trees on distant hills greatly simplifies their form. Keep a record of horizons you pass and, on later occasions, see if you can draw these from memory.

TASK 78
Remembered detail

Draw a plant in your garden, a vase of flowers in your house, a hill or row of trees you pass frequently. Do the drawing from memory, without reference to the actual location. Then visit the scene and redraw the subject, comparing your memory study with your observations.

Seeing basics

Left, most trees conform to basic patterns, some squat, some tall. When out on location, try to grasp the overall character of the subject before you record the details.

Quick sketches

Left, a pen drawing while waiting for a bus. Pocket fountain pens are very convenient for use when you have little time, but want to explore the impressions around you.

TASK 77
Sketching

Carry a small pocket notebook with you when you are out and try to spend a little time making quick sketches on location.

TASK 79
Study drawings

Do a very lengthy study of a single view, add the maximum detail, and build the drawing from its basic elements to a complete and complex study.

Capturing light and shade
Sometimes the effect of light and shade can be more dramatic than the study of the plants that cause these effects. Try to select a composition that offers you an opportunity to treat the dark areas of ground, trees and horizon in the same manner. Do not include details of textures, tones or color.

Collecting details
Right, tree trunks make excellent subjects to study. Some have vertical markings, others horizontal and others irregular.

TASK 81
Collecting details
Keep a notebook of different types of tree trunk textures. Learn how these indicate the various species.

Completing a study
Far right, old trees like these are an excellent subject that repay long and close attention. On occasion spend more than one hour on the same drawing, adding as much information as you possibly can.

TASK 80
Shadow drawing
Sit in the sunshine in a grove of trees and draw only the shadows. Half squint at the subject to reduce it to areas of strong light and dark shade.

©DIAGRAM

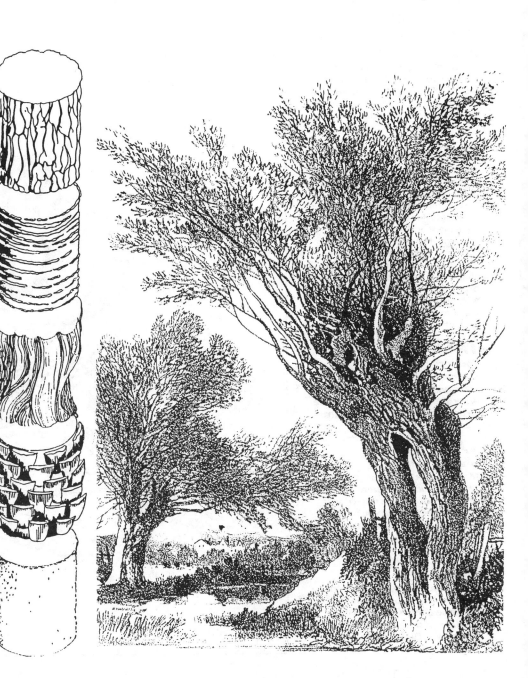

Mastering tools
This chapter directed your attention to the tools you use and your working methods. If you practice regularly, you will find that your personal preferences for tools and surfaces form a unique and individual handwriting style.

TASK 82
Travel kit
Equip yourself with some basic outdoor tools:
1. A shoulder bag, which will be very useful for carrying all the equipment and, if worn while working, leaves your hands free.
2. A small box for pencils and pens.
3. A toothbrush box for charcoal, chalks or crayons (or to store your brushes).
4. A small box for erasers, sanding block to sharpen your pencils, clips and other small items.

TASK 83
Tool kit
Sort out all your tools, making sure you have a clean and object-free work area on a desk or table. Store all drawings away to prevent them from being damaged.

TASK 84
Drawing surfaces
Make a collection, to which you regularly add, of different surfaced drawing papers. This collection is more valuable when you have the opportunity to explore the graphic qualities of a Task.

TASK 85
Self-pride
Store all your drawings, both the Task studies and other drawings you have done. Keep them in a portfolio or store horizontally in a flat drawer. Do not fold or roll them.

CONSIDERING DESIGN

Drawing from nature means observing shapes that are the result of the forces of life. Plants grow – their leaves, stems, flowers, branches, outlines and seasonal changes are all natural expressions of living organisms. These fleeting changes must be searched out and captured. Your observational drawings and your later conversions of these to patterns must contain this vital feeling of life.

Thirty-six Tasks explain how you can convert the knowledge gained by your drawing and observations into the decorative arts. Make your drawing a thing of beauty.

● The chapter begins with four pages, 112 to 115, containing advice about what you draw. Beginners feel lost with the immense choice of subject matter. How you select a subject, the area you choose, and the treatment you apply to the selection are all factors influencing the results.
● The next two pages, 116 and 117, contain compositional considerations – how you view the subject within the picture area.

● Pages 118 and 119 look at examples of the different styles of drawing, and how a drawing's qualities are the results of the artist's character, experience, origins and tools.
● The eight pages, 120 to 127, set out fifteen Tasks which enable you to transform your early studies into patterns and designs that have many applications. The decorative possibilities of your drawings are looked at.
● Finally, page 128 invites you to enjoy drawing and learn to appreciate the beauty of flowers and trees.

What do you draw indoors?

When first beginning indoor plant studies, beginners find the choice of subject is one that inhibits their selection. What do you draw? Always choose simple subjects. Always choose backgrounds that do not intrude on the plants. Concern yourself with only one aspect of the subject – its silhouette, form, life, texture, colors, tones. To be able to include all the qualities of a subject in one drawing requires experience.

A single plant
One species in one container with a simple form and texture – this is the best way to begin drawing.

Unusual subjects
These dead and dried-up plants offer interesting silhouettes. Their shapes are easier to study and capture than the elusive life forces of growing plants.

TASK 86
Photographic sources
Use indoor gardening books, seed catalogs and magazines to give you ideas about the types of plants you would like to have in your home to draw.

Containers
Including containers with polished surfaces or ornate shapes can help enhance a group of plants.

TASK 87
Flower arrangements
Select seasonal flowers and arrange them in an interesting composition. The styles of flower-arranging depend upon your sense of taste. Consult flower-arranging books and keep a lookout for interesting arrangements in the home of your friends.

TASK 88
Motivation
Decide why you want to do the drawing. Find out what you think the subject offers, and work toward capturing your intentions.

TASK 89
Containers
Collect interesting containers for your flower arrangements.

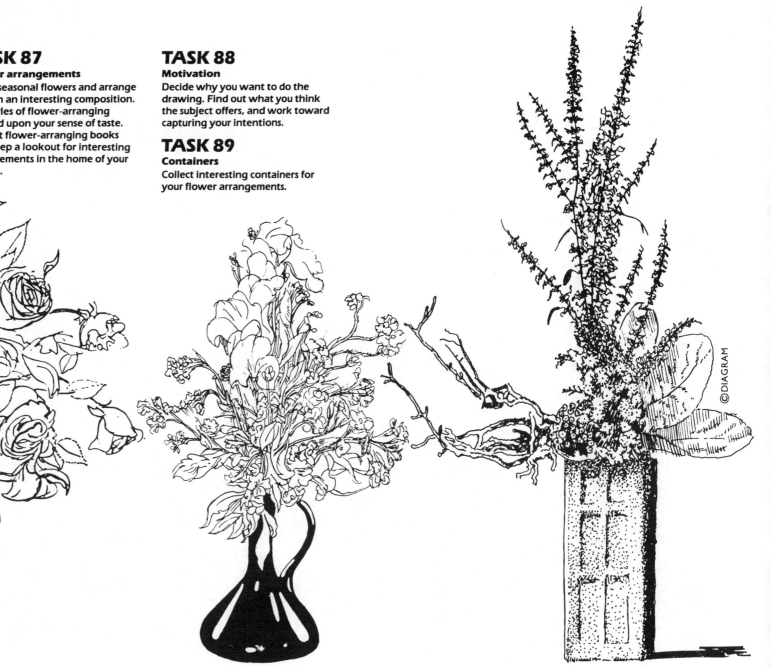

©DIAGRAM

It seems even harder to select a subject when out of doors than when viewing single objects at home. The trees and plants offer such a wide choice of picture material and you have often many positions to view them. Always be guided by what you think you can accomplish in the time available. Do not begin by selecting complicated studies. Begin with a compositional sketch, if selecting a group of trees. Then, after doing a study which may last two hours, do a five-minute sketch of the subject.

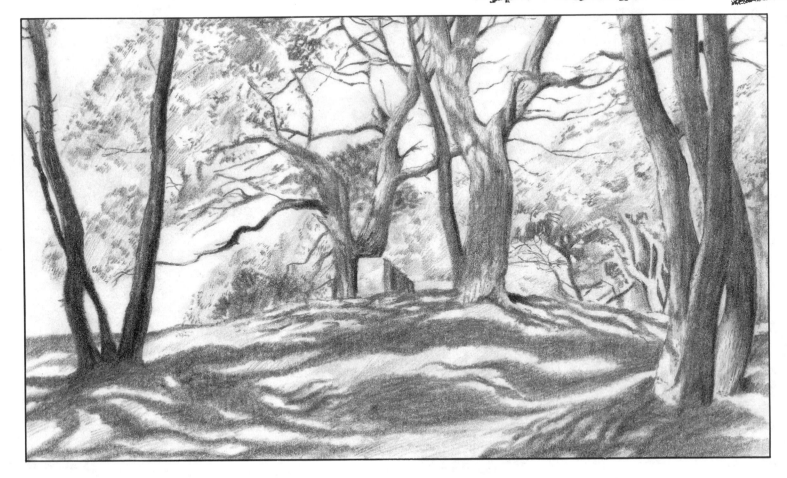

Where do you stand?
When in doubt as to the position you should take up when viewing the subject, do a series of quick sketches from several points of view. The three drawings above are the same group from different sides. Beginners should stand in front of a group and select the simplest compositions.

TASK 90
Standpoint
Draw a group of trees from a variety of positions. Try to select a group on a small hill, or separated from others, as this helps you see the shapes.

What do you see?
Left, concentrate your efforts on selecting and recording only one aspect of a subject. This drawing is an examination of sunlight and patterns of shade on a group of trees.

©DIAGRAM

What do you find?
Right, because undergrowth is usually a tangle, and individual plants often mixed with one another, individual shapes and subjects are hard to distinguish. This drawing was obtained by placing a handkerchief over the surrounding foliage and isolating the one small species.

TASK 91

Selecting features
Before beginning a study, consider looking for one aspect in the subject. You could look for plants that offer:
A good selection of textures.
A good selection of light and dark patterns.
A good selection of interesting shapes.
A good selection of forms – some old and worn, some fresh and young.

What can you invent?
Above, thinking imaginatively about what you see can offer surprising results. This sketch is of the reflections and surviving stalks of winter pond plants.

TASK 92

Species studies
On a sunny day take with you a white sheet approximately 2ft x 2ft (61cm)square and place it behind a very small and interesting plant. This shows up the tiny leaves and enables you to do a more careful study.

What can you reveal?
Right, among the tangle of natural forms, those that appear against backgrounds that isolate their shapes can be exciting. This study of hanging creepers was observed against the clearness of a sky. Studying them from the other side would have been a very difficult task as they were tangled with other plants.

TASK 93

Pattern studies
Look for the shadows of plants or their silhouettes against the sky or wall. Collect examples of interesting foliage shapes.

The design or format of your picture creates an effect on your drawing. The edges influence the elements within the picture. What you choose to select of the subject, and your position in viewing it, combine to create a composition. Before beginning a drawing, consider where you should sit and which part of the subject you should illustrate. Each drawing has three main features: its size on the page area, its position within the area; and the spatial relationships that result from your point of view.

TASK 94

Viewing frame
Make two L-shaped cards which enable you to make a variable rectangular frame. Change the frame size several times while looking at the same subject and choose some of the framed compositions to make a series of small general sketches.

TASK 95

Compositional variations
Using an early study, do a series of sketches, each time placing the drawing in a different position within the same frame shape.
1. Keep the drawing small and in the middle.
2. Make the drawing large and in the middle.
3. Make the drawing small with a lot of base ground area.
4. Make the drawing large with a lot of background area.
5. Explore a number of possible sizes and locations with the same frame area.

a

b

c

d

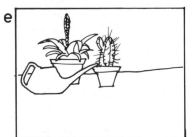

e

f

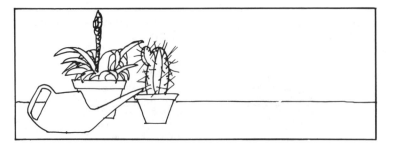

The view
Always try to select a direct view of the plants (**a**). Often drawings fail to convince because of the complexity of the view (**b**). Sitting viewing the subject straight ahead is a good way to begin a study.

The size
Normally draw the subject with enough space around it (**c**) to enable you to mount a frame, selecting the position and area at a later date. Drawings which are large and fill the total area of the page (**d**) make later framing difficult.

The position
Each subject suggests its one position within the composition. Those with extremes of space (**e**) have a higher degree of tension than those located in the middle of the page (**f**).

Frame shape
Normally the paper area you draw on is rectangular and its longest side is horizontal. When considering the composition, try a variety of frame shapes, some horizontal, others vertical.

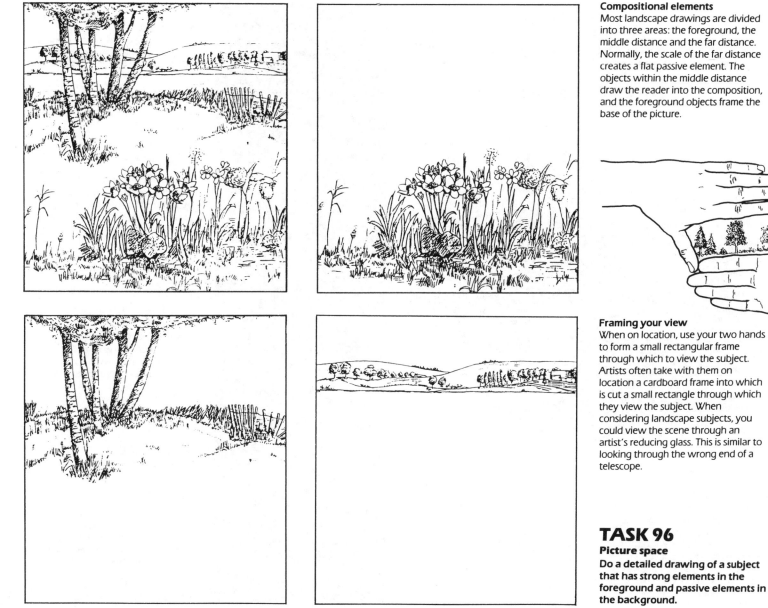

Compositional elements

Most landscape drawings are divided into three areas: the foreground, the middle distance and the far distance. Normally, the scale of the far distance creates a flat passive element. The objects within the middle distance draw the reader into the composition, and the foreground objects frame the base of the picture.

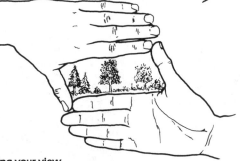

Framing your view

When on location, use your two hands to form a small rectangular frame through which to view the subject. Artists often take with them on location a cardboard frame into which is cut a small rectangle through which they view the subject. When considering landscape subjects, you could view the scene through an artist's reducing glass. This is similar to looking through the wrong end of a telescope.

TASK 96
Picture space

Do a detailed drawing of a subject that has strong elements in the foreground and passive elements in the background.

TASK 97
Artist's drawings

Make compositional sketches of drawings by famous artists of landscapes containing trees and plants.

©DIAGRAM

The style of your drawing is the result of a number of independent factors. First, your cultural and historical background. Second, your experience and skill and, finally, your intentions while doing the drawing. In addition to these factors, the method of creating the drawing (the tools you use or how the drawing may be reproduced) also affects its qualities. Remember when looking at the work of other artists that, if it is a reproduction of their drawing, then it may have been originally drawn larger or with different materials than those used in the reproduction.

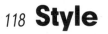

Cultural influences
Left, a drawing by a 19th-century artist in the popular Art Nouveau style. Artists modified their way of looking at natural objects so that the resulting drawings were executed in sweeping, curved, sinuous lines.

TASK 98
Professional influences
Collect examples of reproductions by botanists and examine the ways in which information drawing presents the maximum detail.

TASK 99
Subjective responses
Look at plants and trees for opportunities to do a drawing that expresses your emotional responses to the subjects.

TASK 100
Technical influences
Collect examples of plant drawings from books published before the 20th century. The illustrations will almost certainly be engravings or lithographs and, moreover, transcriptions of drawings, not reproductions of original drawings. Learn the methods of printing illustrations so that you can recognize etchings, engravings, woodcuts and wood engravings.

Material influences
Left and above, two drawings by naturalist artists. The first (left) was drawn by the artist and then copied on to the side of a piece of wood. The design was then carved to reveal a raised surface which was used as a printing block. This example is reproduced much smaller than the original drawing or the printed copy.

The drawing (above) was made by the 19th-century wood engraver Thomas Bewick, who used a sharp metal tool to cut the top end of a piece of very hard wood. This is printed here the same size it was carved and shows the remarkable skill of the artist.

Economic influences
Far left, a 20th-century architect's sketch of an intended building. His leaves and branches are inventions of the foliage – quick, cheap ways to provide visual decoration to soften the appearance of new constructions.

Traditional influences
Left, detail of a 19th-century Japanese book illustration in which the drawing of leaves and plant forms conforms to the accepted customs of the readers. Each item in the drawing is a shorthand description of formalized representations of reality.

Subjective influences
Right, a drawing by the 19th-century Dutch artist Vincent Van Gogh. Reality takes second place to Vincent's responses to the active qualities of the trees. He wants us to experience the movements of wind through foliage.

TASK 101
Cultural influences
Collect reproductions of drawings from India, China, Japan and Persia. Also, study the designs from earlier periods, such as Egyptian, Roman and Medieval.

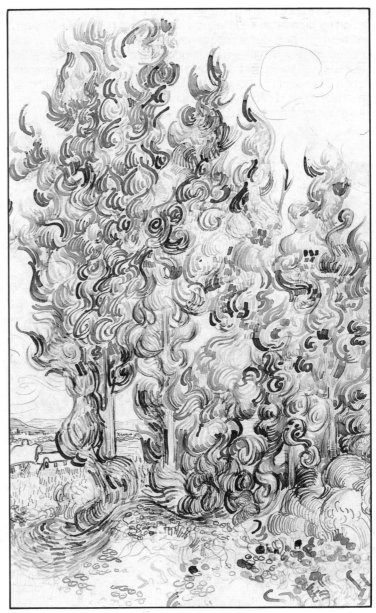

©DIAGRAM

Converting your drawings

Artists have used plants as starting points for design for more than 4000 years. The variety and aesthetic qualities of natural forms have inspired artists when they have sought to use plants as motifs for designs. Often the style of a design is the result of looking at a subject with a particular method of converting a natural form into a stylized form in mind. It is irrelevant what

subject matter is chosen as most will be capable of being converted to a formal design. There are basically three ways to achieve this: either all natural shapes are drawn as contrasting values but retain their general features; or the plant is simplified; or the drawing is formalized.

Working method
When doing the Tasks on pages 121 to 128, use only felt-tipped pens or brushes. These will automatically give you the solid areas needed in design. Pen or pencil will require laborious building up of tones.

Contrasting method
Left, a simple method of converting a drawing is to simplify shapes, objects, spaces and colors into black and white shapes.

Formalized method
Right, drawing a plant in a regular geometric manner with no regard for its living individual characteristics, the drawing becomes a representation of flowers, leaves and branches. Normally, it is constructed with lines of even thickness or on a regular grid.

Simplified method
Below, these drawings have been converted to the simplest of their elements, mainly their silhouettes with the removal of small or complex parts. There are fourteen examples at the bottom of these two pages.

TASK 102
Contrasting designs

Reduce one of your earlier studies to an arrangement of black and white shapes. Do not change the shapes.

TASK 103
Simplified designs

Copy any earlier drawings of plants, reducing them to a simplified solution and removing any smaller details. Modify the shapes and spaces so that they have an even, balanced, overall appearance.

TASK 104
Formalized designs

The sequence of drawings (below) shows you how to transform a naturalistic study to one with a rigid, formal structure. Begin with a single study drawing and do a silhouette study of the drawing, then an outline study. When you feel you understand the basic elements, repeat the shapes on a regular grid, confining areas to within parts of the grid.

TASK 105
Alternative designs

Repeat Task 104 on a different grid arrangement.

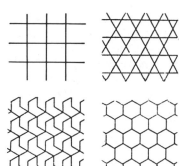

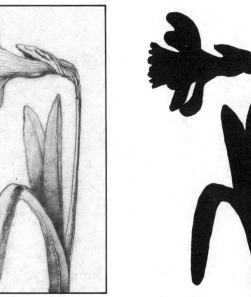

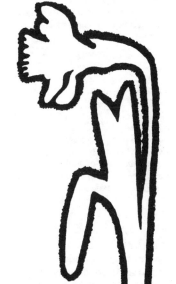

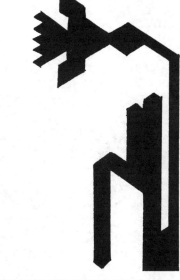

©DIAGRAM

Producing designs

Designs of formally arranged plants are easily developed into abstract designs where the natural shapes have been modified to produce an organized arrangement. This can be by a superimposed design technique, such as converting the drawing to a grid or to a stencil style, or by converting it to a symmetrical arrangement, or to a repeat arrangement.

Stencil method
These are designs where all the dark areas are separated by corridors of white space. This technique was originally intended as support for the stencil surface when the designs were cut to form holes. By using this design characteristic, you can achieve a unification of your drawings.

Grid method
The technique illustrated on page 121 where all the shapes are drawn within a regular grid.

TASK 108

Grid designs
Convert the design in Task 106 to a grid arrangement, using the method described on page 121.

TASK 106

Stencil designs
Convert one of your drawings to an arrangement of shapes each separated by white lines.

Symmetrical method
Left, these three drawings are symmetrical: all have a center line and mirror images of facing sections. Rarely do plants grow in a truly symmetrical way. If symmetry is combined with a fomalization of the natural elements, the shapes develop ornamental and irregular qualities.

TASK 107

Symmetrical designs
Take a section of one of your studies and convert it to a simplified solution as in Task 103. Copy half of the design on to tracing paper and, reversing the tracing paper, copy the same half on the back surface. You now have a symmetrical drawing. The same method can be used by inserting the design with a top to bottom repeat. The ultimate symmetry is for the top to mirror the bottom and the left side to mirror the right.

Repeat band method
Using the same design over and over in
rows or all over has hundreds of
variables. The simple motif can be
repeated, or alternated with other
subjects, or flipped left to right, or top
to bottom. Whatever the solution, the
pattern is obtained by an inner repeat
matrix which is used by the designer to
position the individual elements.

TASK 109

Repeat band designs
Using these grids, draw a selection
on to tracing paper, having
enlarged them to a depth of 3 in
(7.6cm). Then draw one of your
simplified designs in one of the
structures, and vary its position by
repeating, reversing, turning
upside down or alternating with
other designs.

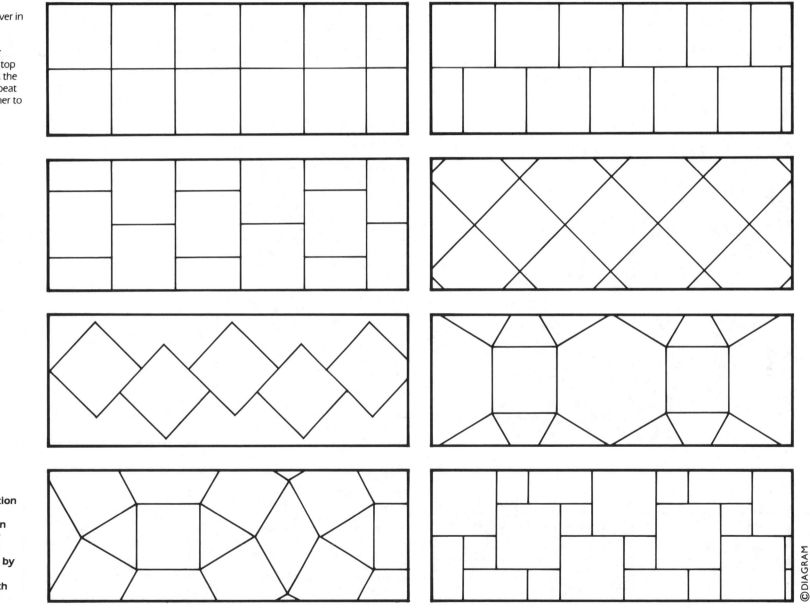

In addition to the formalization of natural motifs and their use in repeat bands, designs can be developed to produce an overall pattern. The most successful of the overall patterns are those where the individual motifs in the pattern are secondary to the whole and are not immediately apparent. Methods of achieving overall patterns are either haphazard, repeat or hidden.

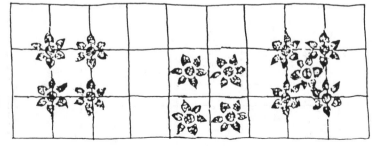

Haphazard
The scattering of a motif all over the surface may be either regular or, more often, in clustered areas of accidental groupings.

TASK 110
Haphazard

Cut a potato in half and on the exposed flat surface carve a simple plant design. Leave the areas you wish to print raised, cutting down into the potato and removing ¼ in (0.65cm) of the area you wish to have white. Press the design onto an ink pad or inked flat surface, and print a group of your designs in a haphazard arrangement (top left).

Regular patterns
Center left, these are arrangements of single motifs in a geometric structure. Usually the design is arranged with its extremities touching as this produces an overall effect of linking-up, rather than an appearance of avenues of separated white space.

Using a grid
You can plan a grouping of your designs by using a grid, which will produce a more regular arrangement (bottom left).

TASK 111
Regular patterns

Use your potato press design to print a regular arrangement of designs. Plan the grouping using any one of the grids on the right. Locate your design on the corners or in the centers or both. Experiment with other pattern arrangements.

Hidden repeats
The most satisfactory pattern solution was developed more than 2000 years ago by fabric designers. The basic technique is to cut up and re-arrange the original design, then add motifs in the spaces created. The new design is now printed in interlocking sequence producing an overall pattern in which it is hard to detect the original single unit.

1

TASK 112
Hidden construction

Make yourself a hidden repeat design using one of your simplified plant designs from earlier Tasks.
1. Draw an accurate square around the design, leaving approximately 1 in (2.5cm) around the sides.
2. Cut your design into two sections (A/B) along a vertical irregular line.

2

3

4

5

6

3. Transpose the two halves and fix together (B/A).
4. Cut the new arrangement into two halves along a horizontal irregular line (B1/A1 and B2/A2).
5. Transpose and join these (B2/A2/ B1/A1).
At this point, the four external corners of the original square should now be meeting in a central point.

6. Fill in the newly created spaces with further motifs resembling those of the first design.
7. Print the newly constructed master design in a repeat form, ensuring that the edges of each printing match up together.
The repeat design contains sections of the original design and when combined in printing, re-establishes the original design.

TASK 113
Hidden Repeats
Look carefully at wallpapers and fabrics to try to discover which part contains the basic repeat design.

7
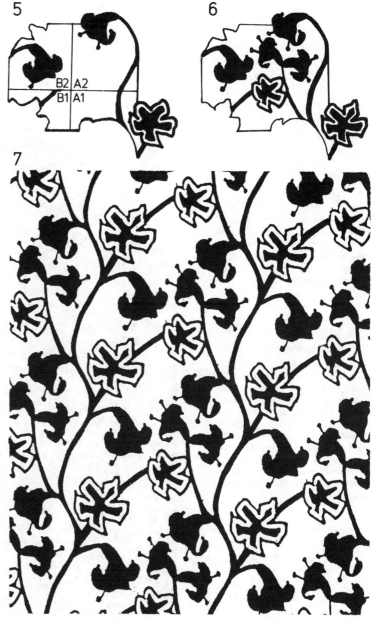

 © DIAGRAM

The study of plants and their application in the decorative arts has been an artistic preoccupation for over 2000 years. Before the 17th century, methods of reproducing factual visual studies were very limited, so the decorative interpretations were more common. Recent advances in photographic reproduction techniques have made artists' original studies more available.

TASK 114
Botanical knowledge
Right, this 19th-century decorative panel combines a wide variety of different plant species. Although you may not be able to name the species, try to do a drawing of each of them by selecting the leaf or flower shapes.

TASK 115
Botanical study
Select either a wild or domestic flower. Take care to choose a flower you can study from observations. Do a series of drawings of its real, unique characteristics. Then, from books on natural history, read about its growth and form. Having studied the botanical elements, re-examine your plant, this time observing how the scientific explanations are different from the reality.

The vine
Above and opposite, a collection of designers' interpretations of one species. The vine has three main characteristics: the leaf shape (**a**); the fruit (**b**); and the curling stems (**c**). Each of these artists has organized the elements in a variety of ways. These adaptations are the consequence of their culture, the materials used, the tools employed and the intention of the decoration. Although reproduced here in different sizes to the originals, try to identify approximately which civilization the artist lived in, for what purpose was the motif created, and how the design was produced?

TASK 116
Applications
Visit a museum of decorative arts or folk arts, or a grand house open to the public and make notes when you see floral designs on domestic objects.

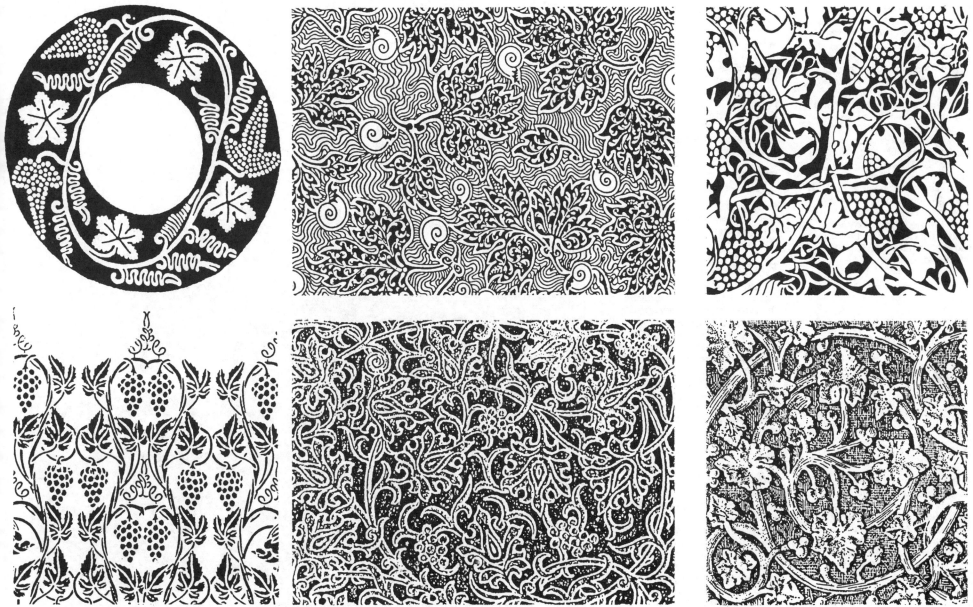

Your achievements

After more than 100 Tasks directing you to the study of plants and trees, your portfolio should now reveal evidence of the knowledge you have gained in looking carefully at natural forms. You should also have learned how difficult it is to capture the sense of life in nature. Remember that each of your drawings commits an observation to your memory, FOREVER. Each drawing is a development of earlier attempts. Remember, too, that however difficult you may find the subject, the results of effort always show in the sense of achievement you feel when successful. Always work hard and always have pride in your work. Drawing plants is very, very difficult, but can be great fun when you present a successful drawing to your friends.

TASK 117

Artistic variety

Collect examples from every possible visual source of one species. You may perhaps choose an oak, a tulip, a palm tree. Build a scrap book of cuttings from magazines, your own sketches of decorations, or depictions on buildings, fabrics, ornaments, emblems, flags or any other applications of the variety of plant you choose.

TASK 118

Application

Make your own greetings or gift card, either by a home printing technique or professionally printed. Before converting your original drawing for commercial printing techniques, discuss with the printer the costs and methods of preparing the drawing. Print enough copies for all your needs, but retain one example forever in your files.

TASK 119

Pride

Select your very best study. Spend money on having it professionally mounted and framed. Display it in your home.

TASK 120

Original drawings

Right, a beautiful pencil study by the 16th-century German artist, Albrecht Dürer. Before photography, reproductions of drawings of this type of study were very difficult and so rarely seen by a majority of people. Try to examine original drawings in museums and galleries, and when you see reproductions, consider the ways in which they differ from the original drawings. This is a reproduction in black and white of Dürer's colored study.

TASK 121

Pleasure

Regularly buy cut flowers and make arrangements at home. Cultivate indoor and outdoor, plants as these can be a great comfort during times of stress. Remember, although all plants appear to die, nature is eternal and will always offer you pleasure without asking for a reward or thanks.

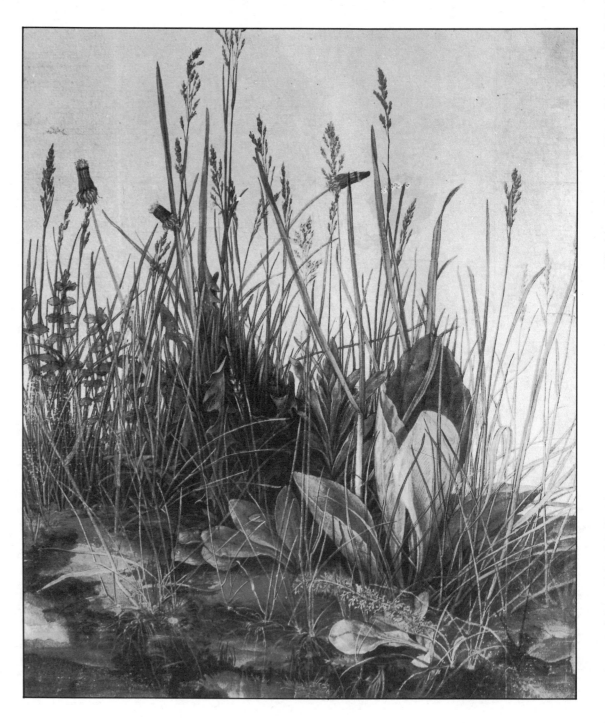

PLACES
LOOKING AND SEEING

Places, or landscapes, have long been the most popular subject for artists to draw. Going out sketching is like setting off on a voyage of discovery, the rewards of which last your whole life. Your drawings will not only be committed to your memory, they will also transmit to others an experience you had and which they can share.

Be selective when you draw landscapes. The world is too full of detail, and the time too short to record every tiny feature. Your drawing reviews what you find interesting in the world. Study it carefully.

Work slowly. One fully detailed study is worth lots of half-attempted studies.

You begin drawing places by going there or by copying photographs taken on location. The first chapter is your path to exploring your observations of the world outside your room.

You will find thirty-two Tasks to sharpen your judgement of what you see. Good drawing is 90 percent good observation. Look carefully, record accurately, and interpret what you see intelligently.

- The first two pages, 130 and 131, contain the most important idea in this section – places recede from you and contain solid objects – but you have only a two-dimensional surface on which to record them.
- Pages 132 and 133 suggest where, when and how you draw your pictures out of doors.
- Pages 134 and 135 encourage you to seek ideas for your drawings in photographs and other artists' works.
- The next four pages, 136 to 139, direct your attention to the surface of your subject. Observe its light and dark features (tones), and its textures and colors.

- Pages 140 to 143 advise you on ways of looking at the scene: first as flat shapes interlocking to form areas of patterns on the surface of your paper and then as points set at varying distances in space but recorded in only two dimensions on the surface of your drawing.
- Finally, page 144 recommends you to re-examine your work and expose it to the criticism of others by placing your drawings on view on a notice board.

All objects take up space and are set in space. Reality is solid, it has bumps and hollows. The world is a display of colors, shapes, textures and tones, which combine to offer hints as to the volume and space of the subject you draw. Drawing places is the art of interpreting these features on a flat, usually white surface.

Edges of fields
Top right, this drawing by Jane, aged 11, carefully records the textures of the trees, but does not convey correctly an impression of depth in the field.

Hills
Right, drawing valleys is an excellent introduction to capturing space. Each subsequent hillside pushes the obscured hills further and further into the background. Roads and streams help to reveal the folds and bumps by forming a spatial net over the surface.

TASK 1
Tracing space
Right, place tracing paper over this drawing or those on pages 151 or 177. Using a soft pencil or felt-tipped pen, draw lines that travel across the surface of the hills. This exercise helps you think spatially, and helps you understand the variations in landscape forms.

TASK 2
Seeing into the distance
Draw a scene with a far distant view in which you can see for more than a mile. Try it from the top of a building or hill. This helps you study the recessional features of a composition.

Canal houses

Above, in many respects the houses in this view are correctly drawn. They have vertical sides, are comparable in size and all have bases along the canal bank. Most importantly, they face across to their correct opposite building. But as a drawing, it is not a record of one vital feature of landscape drawing – it has no single point of view. Where is the observer supposed to be standing? In reality those buildings furthest from us would be drawn smaller than those nearest to us.

TASK 3

Reducing scale

Draw a row of houses from one standpoint and notice the recessional features of your drawing. Things appear to get smaller.

False perspective

Right, a drawing by the English 18th-century artist William Hogarth produced to illustrate by errors the major features of landscape drawing.
1. Figures in the distance should be smaller than those in the foreground (note the lady leaning out of a window is the same size as the man on the hill).
2. Distant objects cannot overlap foreground objects (note sign of Inn).
3. Only one view of an object is possible at one time (note both ends of church).
4. Base points are horizontal (note foreground floor appears to fall away).

TASK 4

Consistent scale

Draw the same row of houses but this time stand in front of each house in turn so that the windows and roof lines are always horizontal. Compare the proportional relationships on both drawings. This helps you check whether you draw what you think you see or what you actually see.

Sketching out of doors

Working out of doors offers the most challenging and enjoyable experience of drawing. The world is an infinitely variable place with fascinating opportunities to record your impressions. Always allow enough time for the amount of detail you wish to include.

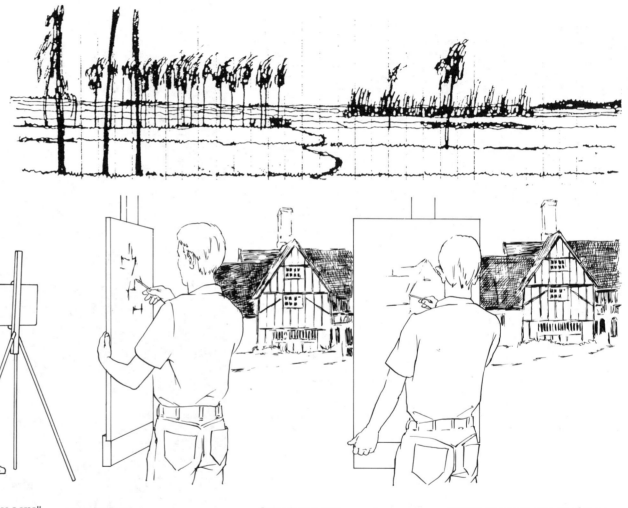

TASK 5

Keeping records
Buy a small pocket sketch pad, no bigger than 6 in × 4 in (15 × 10cm), and carry it with you regularly, making small drawings of views you like.

1 2 3

Sitting comfortably
Above, left to right, the position you occupy when you are drawing outside influences your ability to concentrate on the subject.
1. Always find a simple fixed position from which to observe the subject. Sit on a wall, bench, tree or comfortable perch.
2. When purposefully sketching outdoors, take a small folding seat.

3. For more lengthy studies use a small easel as this enables you to hold the drawing surface vertical and parallel to your picture view.

TASK 6

Timing yourself
Do a drawing of a landscape taking only six minutes. Sketch the main features as accurately as possible.

TASK 7

Examining reality
Do a drawing of the same subject as Task 6 from the same point, taking sixty minutes and adding as much detail as possible.

Capturing reality
Above left, transferring your impressions to the drawing board is a key element of maintaining an accurate record. Try not to move your attention through a wide arc from subject to board.

Wherever possible, place the board as directly parallel as you can to the direction of the subject you are drawing.
Hold the board as if it were a lower half of a window through which you are looking.

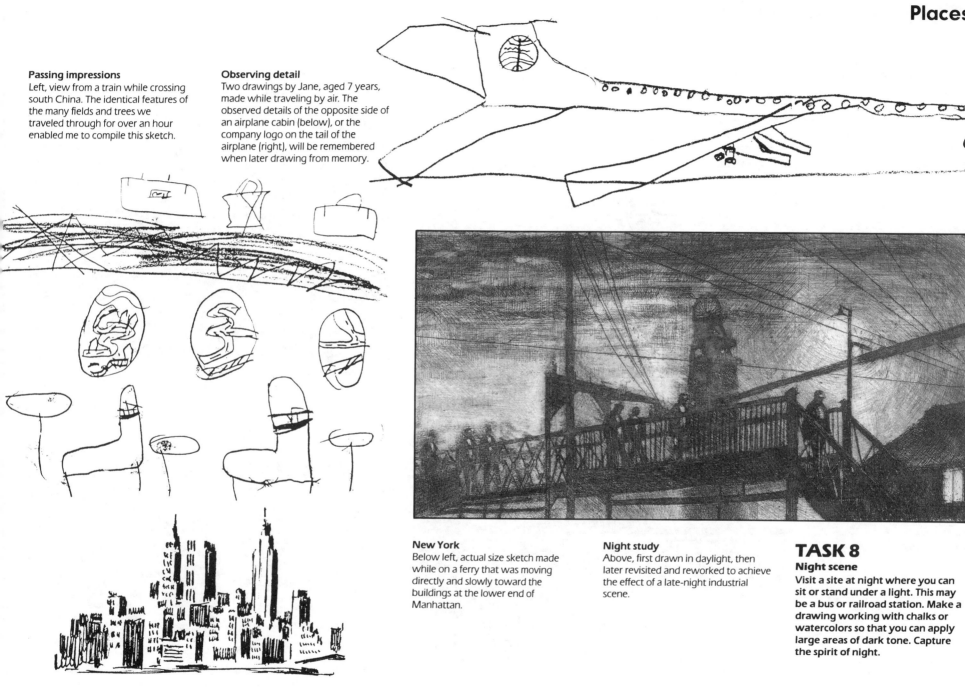

Passing impressions
Left, view from a train while crossing south China. The identical features of the many fields and trees we traveled through for over an hour enabled me to compile this sketch.

Observing detail
Two drawings by Jane, aged 7 years, made while traveling by air. The observed details of the opposite side of an airplane cabin (below), or the company logo on the tail of the airplane (right), will be remembered when later drawing from memory.

© DIAGRAM

New York
Below left, actual size sketch made while on a ferry that was moving directly and slowly toward the buildings at the lower end of Manhattan.

Night study
Above, first drawn in daylight, then later revisited and reworked to achieve the effect of a late-night industrial scene.

TASK 8

Night scene
Visit a site at night where you can sit or stand under a light. This may be a bus or railroad station. Make a drawing working with chalks or watercolors so that you can apply large areas of dark tone. Capture the spirit of night.

Drawing from photographs is not a matter of copying the different degrees of shading. Photographs can be used to build your confidence. They offer views of places you may never have the opportunity to visit. As they are a record of light upon a flat sensitive surface, they capture shapes and tones that may not at first be noticed when observing reality.

Beginning an idea
Photographs can be used to stimulate ideas for pictures. The availablity of the photograph means you can re-examine it for further details, or see it in terms of a collection of gray shapes.
Far right, a photograph of the rooftops of Kyoto, Japan. Right, a landscape experiment from the Kyoto photograph that brings out contrasts of white and gray, not possible working on-the-spot in the cold of the winter.

Exploring composition
Photographs offer the opportunity to redraw the scene. Changing parts of the composition by moving them, or enlarging them, or even omitting them. Right, sketch of shoppers in Rotterdam appears spontaneous, but it is made from a photograph (far right) taken in a busy street.

TASK 9
Visual archives
Collect postcards and magazine photographs of subjects that interest you. Travel brochures are a good source of exotic locations. Old books often have illustrations of cities and the countryside which can be used for study.

TASK 10
Cross checking
Take a camera on a walk, using the viewfinder to help you select a composition. Photograph a subject you have already drawn and then compare the prints with your study.

TASK 11
Tonal awareness
Stand this book upright, open at this page. Support it at the back and then copy the central areas of this photograph as if you were viewing the scene from a window. Try to record as accurately as you can the tonal values (grades of shading) of the roofs and shadows.

TASK 12
Spatial awareness
Try a small sketch of the central areas of this picture as if you were viewing the buildings from directly above. This is an excellent test of your understanding of the spatial qualities of the subject. Only after completion, compare your results with the illustration on page 144.

©DIAGRAM

Almost all landscape studies have at the time they are drawn only one single light source, the sun. Surprisingly, beginners often fail to use this feature when drawing what they see. Color, textures and how they think things look, obscure their use of light and dark. Pictures drawn with strong lighting rely on the eye looking carefully at how surfaces jut out or recede from a form, which can be shown simply by how the shadow is cast.

Building facades
Very easy to sketch under a strong Mediterranean light. Balconies protrude, windows recede.

Shadow sketching
Left, the pencil drawing records only the shadow and ignores the textures and colors and forms of the buildings.

Raised or lowered
Above, shapes which are drawn with line only (**A**) could represent any spatial arrangement. The drawing (**B**) clearly indicates a receding facade and drawing (**C**) a protruding one.

TASK 13
Recession and protrusion
Above, place tracing paper over this line grid and using a soft pencil, create shadows from a constant direction to indicate which of the surfaces is raised or lowered on the grid.

Shadow studies
These studies of a home, showing only shadows, create their form by controlling the direction of light and ignoring the other surface qualities.

TASK 14

Observing shadows
Place tracing paper over any of your previous drawings and draw only the shadows.

TASK 15

Creating light and dark
Right, place tracing paper over this drawing of a suburban scene, and without retracing any of the lines of the drawing, shade in shadows as if the sun were falling from behind you and in the direction of the dotted lines.

TASK 16

Changing light sources
Repeat the previous Task, but imagine the sun is falling from behind the car at a low level.

©DIAGRAM

Color, tone and texture

The surface of objects very often creates a profusion of detail which confuses the beginner. Drawing *every* tile on the roof, *every* leaf on the tree, *every* brick in the wall, presents the beginner with a daunting obstacle. Nevertheless, attempting to draw a picture in which part is produced with great care, and which records every possible observable detail, is a rewarding activity.

TASK 17
Studying detail
Draw a section of a brick wall, garden, park, or any objects outside, taking great care to observe and record all the small details in lines only. If this is not possible, place tracing paper over the drawing (below) and lightly outline the main structures. Then, placing the tracing paper on a white background and with a fine pen, detail some areas of the drawing as in the example (right).

Country cottage
This pen and ink drawing is by the American architect Richard M. Powers. It is reproduced here smaller than the original drawing. A window section (below) is reproduced actual size so that you can judge the scale of the detail.

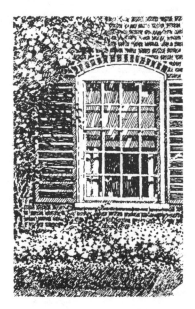

TASK 18
Studying color

Redraw with colored pencils the subject of Task 17. Take great care to keep the points of the pencils constantly sharp and draw only the colored areas of the detail. Again, if you have no access to a subject, place tracing paper over the outline drawing (below right) and, very carefully, add detail in the colors you think most likely. Always add very small areas of color and do not generalize.

TASK 19
Studying tones

The very subtle tonal values of a subject must be recorded accurately if you wish to capture some of the character of the objects. Use the subject of Task 17 to produce a drawing recording only the tonal aspects. As a guide, you can half close your eyes and squint at the subject to reduce their complexity to a more simple tonal pattern. If an outdoor subject is not available, use the outline drawing (right) and tracing paper to convert the detailed drawing (opposite) into a tonal exercise.

TASK 20
Matching tones

It helps your drawing ability to be able to judge tonal values with accuracy. Practice carefully, building up gray areas so that they do not reveal the individual pencil lines. Using soft pencils and cartridge paper, copy some of the areas on these pencil-shaded examples (above). Fold over your study so that the tone is on the folded edge, then place it against these examples to test your judgement.

©DIAGRAM

Checking shapes

The next four pages direct your attention to methods of checking your accuracy. The first two pages consider the flat interlocking of shapes; the second two pages, the recessional positioning of points in space.

Silhouettes
The most conspicuous feature of objects is their outline shape. Buildings, trees, hills, lakes, all have observable edges between them and the space they occupy. Above, the boat and shore were drawn in Cuba against a blue sky and sea. Their solid qualities, color and tones were ignored in the search for their shapes.

TASK 21
Flat shapes

Draw a scene recording only the skyline and, where possible, outlines of objects in the middle and foreground. Choose a city scape, group of hills, or trees in full leaf, seen against the sky.

The shape of space
A good method of constructing a drawing is to check the outline shapes of each part, one against the other. Check both vertical and horizontal alignments, as if the scene were a flat photograph. The lake view was used because of the clear distribution between flat and irregular surfaces.

TASK 22
Flat space

Draw a lake, a twisting path, or coastline. Take great care to record the edges of the smooth flat areas against the textured surrounding areas.

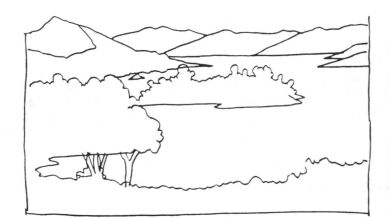

Grids

Seeing shapes that are often irregular and infinitely variable as you change your viewpoint is best accomplished by either working on gridded paper (graph paper) or viewing the scene through a grid.

TASK 23
Grids

Revisit the scene of Task 7 and redraw it on graph paper, taking care to record the shapes accurately.

TASK 24
Viewing Grids

Draw a grid of squares the same size as these (right) on to a window or a sheet of clear plastic placed upright in front of your view. Carefully record the irregular shapes as they cut across the horizontal and vertical lines on to tracing paper over this grid. Artists very often square up their drawings for enlargement and use this grid method to check the shapes.

© DIAGRAM

Relating objects

Landscapes are not an assembly of flat shapes, although seeing them as such helps record them accurately. All objects stand in recessed space. From a normal viewpoint, you must take care to show how and where they stand if you wish to capture the inner space of a picture.

The stars
The stars in the sky all appear to be on a flat dark background. Above, three stars seem to form a triangle but may not have this relationship in space. Below, in space, the stars are often millions of miles beyond each other, yet are always viewed on the same plane in a photograph or drawing.

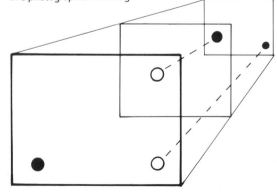

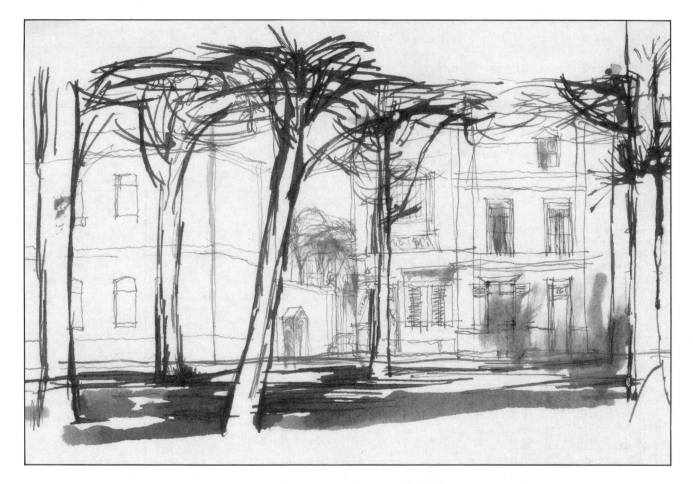

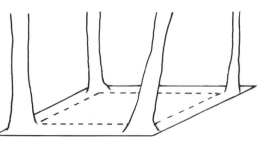

Base points
Above, from overhead these trees form a square. Seen from the side they appear to be almost in a line with one another. Always try to retain the concept of spatial relationships when recording the base of objects.

TASK 25
Base points
Draw a group of trees or separate standing objects such as cars in a carpark. After drawing the group, redraw them from another position where the bases take up a new relationship. Sketch a plan of the group and see if your drawing reveals this.

Figures on beach
Right, the clear area of sand makes an
ideal background to judge the depth of
position into the picture of the figures
and trees.

TASK 26
Checkered space
Right, thinking of the base of space
areas as a checkerboard helps you
plot the positions. Draw a tiled
floor with objects laid on it, taking
care to look 'across' and 'into' the
space.

TASK 27
Base point checks
Plot base points on to photographs,
city squares, beach scenes, carparks,
harbors. All have strong horizontal
situations on to which are laid, as if
small toys, the individual objects.

TASK 28
Thinking spatially
Make a sketch plan of the
foreground of the buildings on
page 135. Draw a plan of the
buildings, trees, car and fence in
the picture on page 137.

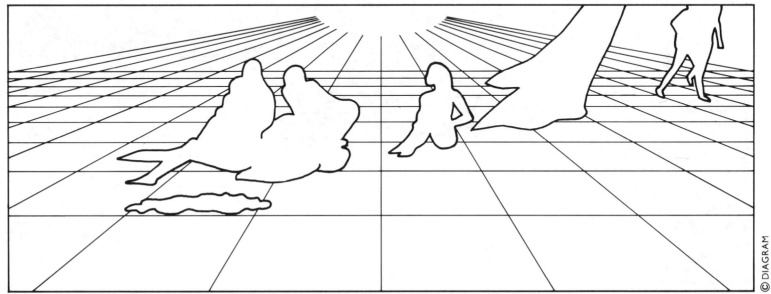

© DIAGRAM

Accurate observation

The previous group of Tasks were to teach you to look carefully at the subject you are studying. Constantly re-examine your observations and the scene in front of you. The correct way of looking helps you record accurately your impressions and by a slow process of care, you will produce excellent landscapes.

TASK 29

Re-checking

Revisit the location of Task 7 and check your drawing against the subject for tonal values, textural values, shapes, spatial plotting and an accurate description of the inner space.

TASK 30

Observable accuracy

Compare this drawing by Lee, aged 17, with the photograph on page 135 and see if his study and yours both record the tones correctly.

TASK 31

Presentation

Check that you have signed and dated all your drawings in pencil in the corner. Then make a notice board of hardboard or cardboard and display your best drawings on it for criticism by your friends and, most importantly, by you.

TASK 32

Artistic vision

Copy in pencil a reproduction of a famous painting. Take care to match the tones and shapes of the original.

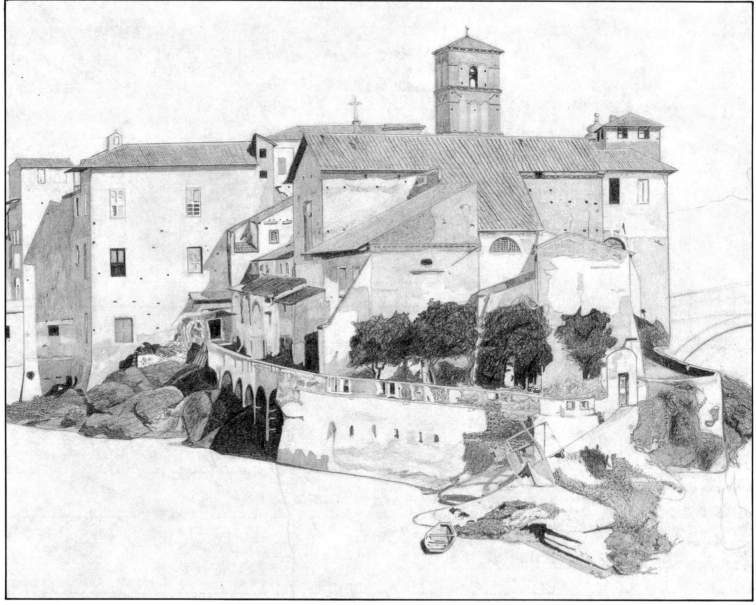

©DIAGRAM

UNDERSTANDING WHAT YOU SEE

This chapter describes how to achieve a spatial quality in your drawing – how to make your picture seem to recede into the page. The simple laws of perspective can help you to achieve a sense of reality and, although thought of as a complex 'mathematical' system, the basic principles are very simple and can be easily mastered.

- The first two pages, 146 and 147, invite you to step into space. Consider the drawing techniques used by artists to project objects into a recessional area.
- Pages 148 and 149 highlight a very simple principle: objects appear smaller as they recede into the distance.
- Pages 150 to 153 describe a very common technique used by artists to achieve this spatial effect. Objects in the foreground are drawn overlapping those behind them, and objects in the distance have a grayer and less detailed quality than those closer to the viewer.

- Pages 154 to 161 explain in basic terms the most frightening of topics for beginners of landscape drawing – perspective. This is the law of constructing a picture to comply with the Western 'civilized' view of drawing space. As a method of drawing it is not natural to either a child or an uninitiated draftsman. Perspective is really only of value as a means of checking what you see, and not a system to be imposed over your observations as a rigid set of laws.
- Finally, page 162 helps you to review your work after thirty-six Tasks.

Stepping into space

Every object occupies space but a drawing of it can only be flat. The main task of a draftsman is to describe the three-dimensional world using a two-dimensional medium. A drawing is not a model of the subject, it is a flat description.

Spatial transference
Right, you view objects as if through a glass surface called a PICTURE PLANE. This imaginary flat surface is at right angles to your view. Points in space are transferred on to the plane along lines from the objects to your eyes. Objects seen flat have a proportional reduction of width (**A**) and height (**B**), but have a distorted reduction of depth (**C**).

Properties of space
Right, as you will see in the drawings, there are five main properties of objects you see in space.
1. Scale. The doors appear smaller as they recede.
2. Location. Where they are in relation to your view of them.
3. Diminishing surface details. The bricks on the wall appear to be smaller on walls further away.
4. Overlap. The near wall will appear to be in front of the other walls because it obscures some of their surfaces from your view.
5. Haze. A very distant wall would not have distinguishable features.

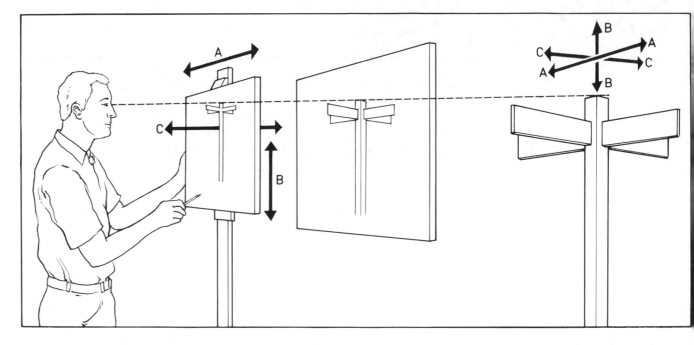

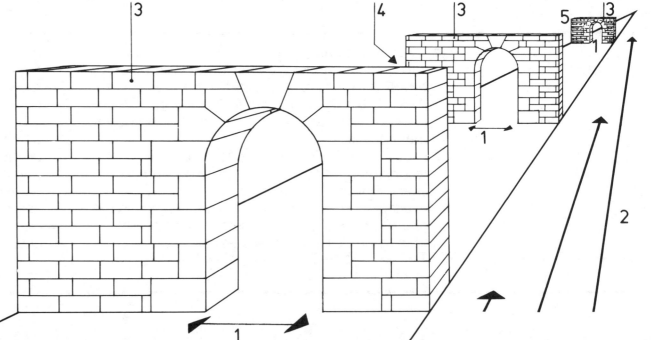

Drawing space
Right, the sketch of Rotterdam shopping area uses all five techniques to describe space.
1. The scale of objects.
2. The location of objects.
3. The diminishing surface details.
4. The overlap of objects.
5. The haze of distant objects.

TASK 33

Placing objects in space
Draw a landscape with a group of similar-sized objects in space. Try rows of telegraph poles or trees of similar height.

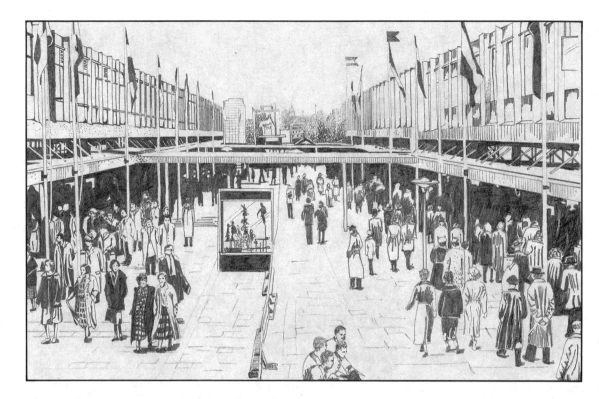

TASK 34

Plotting bases
Draw a landscape with objects the bases of which can be clearly related – boats in the harbor, or cows in a field.

TASK 35

Observing texture
Draw a landscape with objects that have a common texture, such as a row of buildings or similar types of trees.

TASK 36

Studying overlap
Draw a landscape with overlapping objects, perhaps branches of trees, or a rooftop view of houses.

© DIAGRAM

1 Scale
Figures in the drawing represent people of average height, but those in the distance are drawn smaller than those in the foreground.

2 Location
The placing of a figure in the picture helps locate its position in space. Figure **A** represents a figure of the same size as figure **B**, but if they were placed side by side in the picture, **A** would appear larger.

3 Surface
As objects recede, our ability to observe individual small features decreases. We see more textures on foreground surfaces than on distant ones.

4 Overlap
A figure or object in front of another hides part of the one behind. It is this depletion of the surface of the second one that places it behind the first.

5 Haze
Drawings are usually on white paper, so drawing the distant objects in lighter tones than those in the foreground helps them to recede into the picture. This graying also occurs in nature as the air between us and distant objects makes them appear fainter than those in the foreground.

Getting smaller

Objects appear to be smaller the further they are
from your view. An object near you offers more
of its top surface than one further away.
Working with lines enables you to draw the
foreground objects with more specific lines than
those in the distance, which can only be drawn
in general terms.

Shrinking shapes
All objects appear to diminish in size in
proportion to the distance they are
away from you. Their reduction will
occur at a regular rate if they are
evenly spaced apart.

City rooftops
The windows in the buildings are
mostly the same size, yet those in the
distance can only be represented by
tiny dots. Those in the foreground can
have the individual glass panes drawn
in as these would be visible at this
distance.

TASK 37
Diminishing detail
Draw a facade of buildings flat on
to your view, so that the windows
can be drawn all the same size.
Move your position to near one
corner of the building and redraw
so that the distant windows are
smaller.

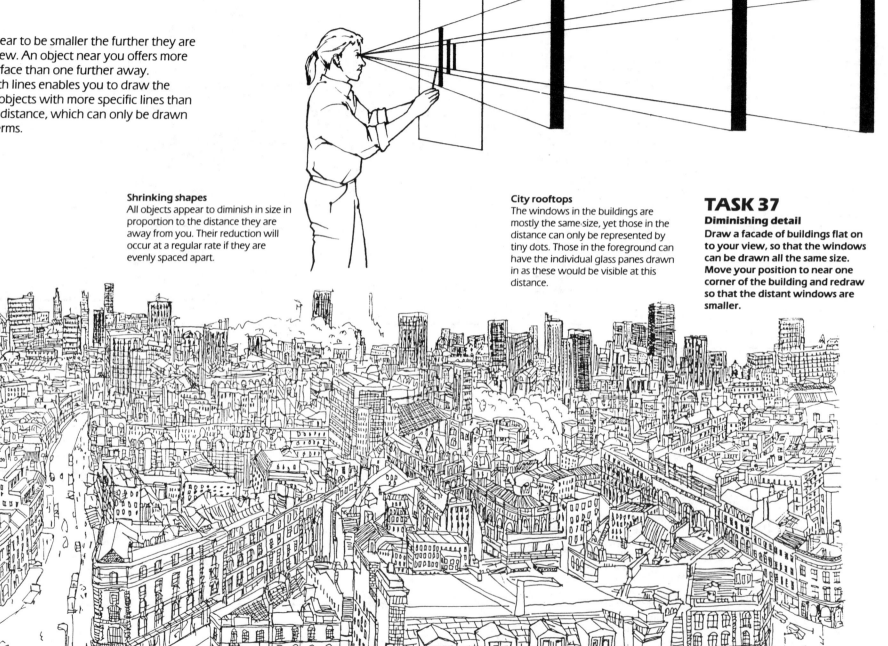

Seeing tops
An object closest to the horizon — your eye-level view will appear almost side view. You will be unable to see much of the top surface. Objects close to you will reveal more of their top surface as they approach your picture surface.

TASK 38

Seeing on top
Place two books of similar size on a long table, one at either end. Sit at a distance from one end of the table and draw both books in one view. Notice how the further one presents less of its top surface to you than the nearer one.

Diminishing scale
The grass in these fields is all the same length. Nevertheless, the individual blades are drawn more specifically in the foreground. This is a very successful technique when you are drawing in line, as your lines can very easily represent scale.

TASK 39

Diminishing line marks
Draw a countryside landscape in which the crops in the fields appear gradually to offer fewer scale details. Use your pen or pencil to emphasis this feature.

TASK 40

Seeing objects side on
Sit on a bridge overlooking passing traffic, either rail, road or river. Notice that the distant vehicles offer only their fronts or backs to your view, but those passing under the bridge offer their tops.

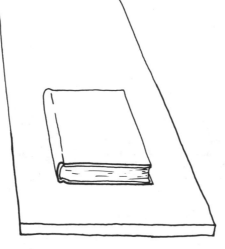

© DIAGRAM

Overlapping the shapes in a drawing is one of the clearest ways to make them appear to be set into the space of the composition. The normal convention of drawn lines means that objects can be very economically described by this technique.

Traditional overlapping
Right, the drawing by an 18th-century Japanese artist uses overlapping to place figures in front of and behind the bamboo screen.

Overlap
Mountain **B** is clearly four mountains behind mountain **A**, and although **A** and **B** are drawn the same height on the picture plane, **B** must be larger if so far into the composition.

Line quality
This group of overlapping lines has little space value. It is hard to estimate whether area **A** is much in front of area **B**. But when reviewed upside down (turn the book around), then **A** is clearly a foreground area. This effect is produced both by overlapping and by increasing the line thickness.

Receding surfaces
The three areas **A**, **B** and **C**, each overlap one another. Because they are inter-related they cannot be parallel to the picture plane and must bend beneath each other.

TASK 41

Overlap practice
Draw a subject that has fences, roofs, or walls that overlap. Draw a tree in winter and examine the overlap of the main branches.

Landscape
Below, this drawing has none of the normal features of reality. There are no tones, colors, textures, scale or hazy distance. The drawing relies on describing the rocks by the technique of line overlap.

TASK 42
Conversion to line
Redraw one of your earlier Tasks using only outlines to describe the positions of the objects in the space of your composition.

TASK 43
Line solution
Draw the scene in the photograph on page 144 (a view of Rome) in lines only, making the foreground group of buildings appear ahead of the distant ones by drawing them in stronger lines.

TASK 44
Facets and planes
Below, this drawing uses tones to describe the irregular surface of a newspaper. The bottom drawing copies the subject study but restricts the description to the use of lines. Crumple up an old newspaper or draw the ruffled sheets and blankets of a bed. Either study can be of help if you do not have access to sketching a mountain range. You can also copy location photographs of hills and mountains.

©DIAGRAM

Objects seen at a distance appear to lose their sharp qualities. The shadows are weaker, there is less definition of detail and the colors all have a blueness. This is because the intervening air acts to subdue the colors and shades of distant objects. To discover how much light dims distant objects, view your subject through half-closed eyes, squint at the distant objects.

The effects of distance
The examples on pages 136 and 137 show how shadows illustrate the subjects' surfaces. The shadows make areas come forward or go back. Right, the drawings describe the box-like elements of the buildings which, when seen close up, (bottom) have protruding side and center buildings. As you recede from the subject (center and top), so it becomes less distinctive, more unified as a single surface.

TASK 45
Judging tones
Very often beginners fail to spot the diminishing tonal values, so draw distant objects as dark as near ones. To test your abilities at assessing tones, estimate where on the graded scale (left) the three patches of tone appear.

TASK 46
Diminishing details

Draw a building or group of trees from three points, each further away than the other. Notice that the details of the contrasts of shadows will be reduced as you move further and further away from the subject.

TASK 47
Receding space

Below, place tracing paper over this design and shade the areas to make it appear as if the shapes are receding into the page. Keep the patterns of tone of near equal value in the center, either light or dark. Give the shapes around the frame very strong contrasting tonal values, dark and light. The design will appear like a view down a tunnel.

Winter afternoon
Below, drawing of a view from a window. The winter sunlight of an afternoon made the distant trees and fences appear dull and misty.

TASK 48
Atmospheric changes

Draw a row of gardens or houses, or a subject where regular objects recede from your view. Do the drawing on a dull day when there is little sunshine. Use a soft pencil or brush and watercolor. Try to capture the tonal values accurately.

© DIAGRAM

Point of view

To a beginner, the subject of perspective is a frightening challenge. The 'laws of perspective' seem to be a mixture of geometry and mathematics — a complex group of laws producing nets of lines. But the world around is clearly indicating these laws. Perspective is only the science of understanding what you see. Its only value and interest is in that it enables you to record more accurately your responses to what you see.

Eye level
The line at the level of your vision. Always horizontal, but very often not the horizon line, as the ground may be higher or lower than your standpoint.

Ski lift
An object passing across your vision reveals different aspects of its surfaces as it moves up or down. Objects beneath your eye level show their top surfaces. Objects above show their underside.
A. Objects well below you reveal a large area of their horizontal surfaces.
B. As the objects come closer to your eye level, you see less of the top surfaces.
C. When level with your eyes, top and bottom surfaces disappear and you have a complete side view.
D. As objects rise, you see more of the underside.
E. When the object is well above your position, you see a great deal of the underside.

A staircase
Right, drawing copied by a student from the graphic work of the Swedish artist, Sven Olov Ehrén. This view is an excellent way of understanding that horizontals offer a constant check of your position. You see the tops of objects which are well below your eye level. Those above your eye level are seen only as an edge.

TASK 49
Point of view
Draw a staircase from the bottom step and then from the top. Do not be too concerned about the difficulties of recessional space. Simply record as accurately as you can the top surface of each step.

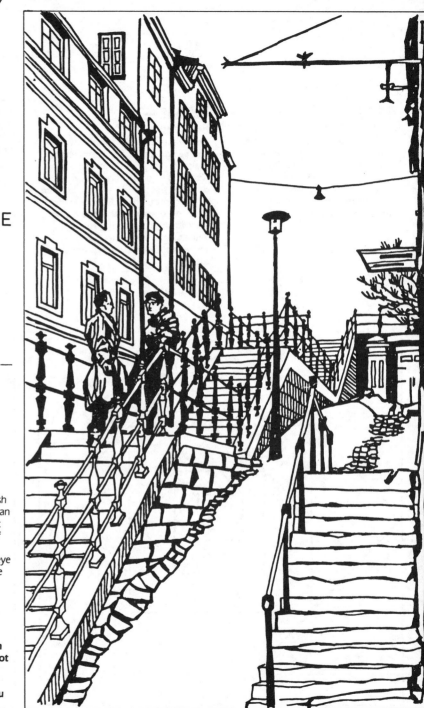

Rules to remember
1. Objects seen flat on and from afar have vertical sides and horizontal features. Both the vertical and horizontal elements are parallel to similar parts on the object.
2. Objects seen at an oblique angle: you see more than one side, and if viewed from afar they have vertical sides but converging horizontals.
3. As you approach the subject the vertical parts appear to converge. This rule is true when looking up at a subject (**3**), or down (**4**).

Vanishing points
Parallel lines, when extended, appear to converge on the horizon — a railroad track, for instance, seems to meet in the distance. Right, this drawing aboard a cargo boat clearly shows the parallel lines of the rails getting closer together.

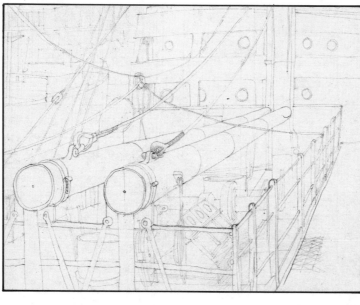

©DIAGRAM

TASK 50
Converging lines
Stand on a bridge overlooking a river, road or rail track. Very carefully record the converging sides and the reduction of objects on either side of the horizontal banks.

TASK 51
Judging horizontals
Hold a pencil out at arm's length and try to keep it horizontal. Then judge the angle of the edges of objects seen beyond the pencil. This technique is used by artists to judge the depth of surface angle.

TASK 52
Eye level
Draw on photographs and drawings in magazines the eye level of the artist. The simplest way is either to draw the converging horizontals or to judge how much you see of the top or underside of objects.

Objects viewed end on have regular vertical and horizontal features. Subjects seen set at an angle to the picture plane have a common vanishing point. Looking into a receding space is easily understood if you first establish your eye level, then your vanishing point, to which all horizontals will point.

TASK 53

Understanding eye level
Place tracing paper over this page and draw a corridor, either imagined or observed. Place a chair or table in the composition. In this picture, the vanishing point is approximately 2ft (60cm) from the ground as if you were sitting in a low chair.

Street scene
Below, the building on the right is seen flat on, the windows are rectangular. The two sides of the street recede from you and have converging horizontals.

TASK 54

Changing eye level
Turn the book around and redraw the corridor with the vanishing point now 6 ft (1.82m) above the ground level. Compare your two drawings, in the first you should see the underside of the tops of door frames, in the second, you should see down on to window ledges, tables or drawers.

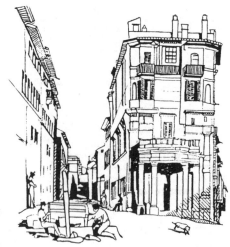

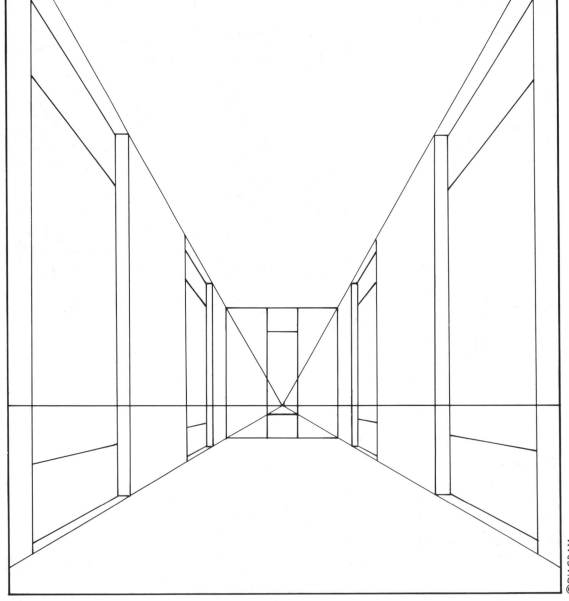

©DIAGRAM

Sloping surfaces
All horizontal surfaces converge on a central vanishing point, but as can be seen from this drawing of the State Capital building in St. Paul, USA, the far distant section of the avenue has a higher vanishing point than those edges nearer to you. This is because the distant section of the road slopes up. It is a tilted surface, so its vanishing point is higher than the foreground lines.

TASK 55
Sloping surfaces
Stand at the edge of a road which dips then slopes up. Notice how the sides of the road appear to meet at different vanishing points. Do a drawing which clearly shows this feature.

TASK 56
Testing raised and lowered surfaces
1. Place this book with its spine pointing towards you and sitting about 3ft (1m) away. Draw the book's top surface, to establish a vanishing point and eye level. Project the top side edges so they meet at a common point at your eye level.
2. Place other books or objects under the near edge and redraw, noticing the new lower vanishing point. Although your eye level has not changed, the vanishing point will be below this level.
3. Repeat the exercises with the supporting objects under the far edge. This time the vanishing point will appear higher than your eye level.

1

2

3

©DIAGRAM

Two-point perspective

Objects seen at an angle to the picture plane have two independent vanishing points for the two sides of the object. Both points are set along your eye-level line and may be of differing distances from the object, depending on how much of the surface you see.

Moving vanishing points
Right, as you move around an object the two vanishing points move closer to or further from it.
1. Seeing the building end on creates an elevation with no vanishing points.
2a and **2b**. As you move around the building, angles come into view, and their two vanishing points change positions.
3. Faces of the subject seen almost parallel to the drawing's surface have a vanishing point well away from the subject.
4. Faces seen very obliquely to the picture surface have a vanishing point closer to the subject.

Establishing vanishing points
1. First draw your eye-level horizontal. In this case it is the base line of the building.
2. Then hold out a pencil so that it is pointing in the direction of the horizontal sides of one part of the building.

3. Now draw a line extending from the horizontal side till it meets with the eye level.
4. Repeat this on a number of horizontals in the drawing and you will find they all meet at a common vanishing point.

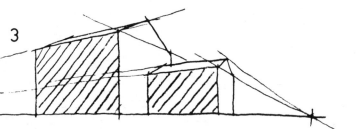

TASK 57
Moving vanishing points
Draw a single building having first extended the horizontals to common meeting points at either side. Then move your position to a more flat-on view and compare the new vanishing points' positions.

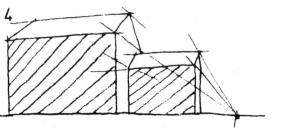

Two-point subjects
There are many similar examples among buildings and industrial landscapes.

TASK 58

Two-point subjects
Draw a subject with very pronounced line work, such as rail tracks with sleepers or a single building seen from a corner point of view.

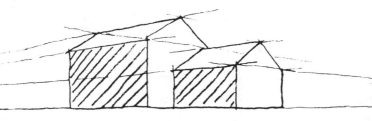

Viewing position
The convergence of the lines depends very much on your level of viewing the subject. Normally from a standing or sitting position, the ground level is almost horizontal and the roof is sloping downward. But if you adopt a position well above or below your subject, the lines of horizontal recession will change drastically.

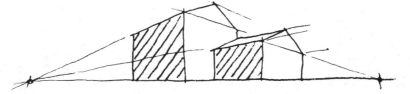

Clues
Above, the small detail of window frames, sills, brickwork, all offer an indication of the direction of the lines pointing toward your vanishing point.

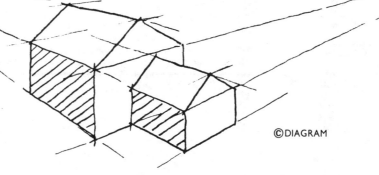

TASK 59

Distance
The closer you stand to the subject, the closer are the vanishing points. This can be easily demonstrated by doing two drawings of a subject. The first from over 50 yd (46m), the second from nearby.

©DIAGRAM

TASK 60

Judging eye level
Sit high up on a hill and look down on a group of buildings, or sit at the bottom of a steep hill and look up at a group of buildings. Draw both groups.

Three-point perspective

One of the major difficulties in constructing an accurate group of converging lines is that the vanishing points are very often outside the limits of your sheet of paper. One simple principle to remember is that the two points for converging horizontals must always be along your eye level and be horizontal to one another.

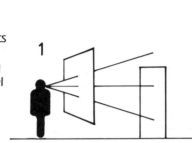
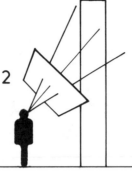
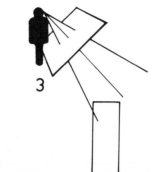

Tilted picture plane
1. Looking at subjects through a vertical picture plane.
2. Looking up at subjects tilts the picture plane upward.
3. Looking down at subjects tilts the picture plane downward.

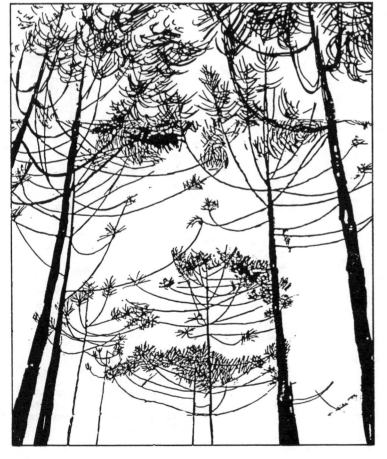

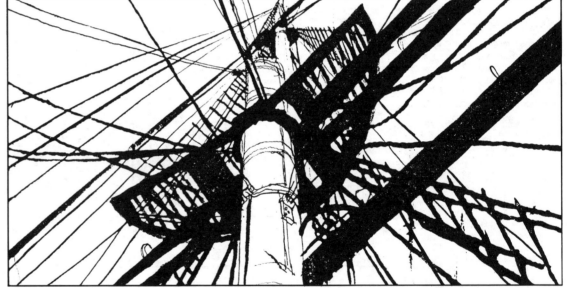

Trees
Left, a group of tall fir trees seen from a position on the ground. This sort of view is one in which you encompass an all-round 'fish-eye' view with all the verticals appearing to converge in the sky. The interiors of tall buildings can achieve the same effect.

Sailing boat mast
An exceptionally complex arrangement of lines as the verticals (the masts), and the horizontals (the yard arms), are further confused by supporting ropes which are at various angles.

TASK 61
Ascending three point
Practice the converging verticals by looking upward inside a tall narrow, building. The interiors of churches, public buildings, or industrial locations offers the opportunity to draw criss-crossing straight lines.

TASK 62

Beneath the trees

Less easy to draw than buildings, but dramatic in results, is the view from below a group of trees. Draw these in winter when the leaves and shadows do not confuse the ascending shapes.

TASK 63

Illustrative examples

Place tracing paper over the most dramatic view in a comic magazine and project out the perspective lines until they meet with a common vanishing point. Comic illustrators seldom construct the illustration with all the lines of recession, but rely on judging the dramatic effect by eye and experience.

TASK 64

Descending three point

Do a drawing looking down from the top of a tall building, or from the edge of a bridge, on to vehicles and objects.

Three-point view

Using three-point perspective occurs less frequently than two or one point. It is the result of drawing a subject from a position close to a foreground surface. You may be looking up at the subject or down onto the subject, but in both cases the normal picture plane (the window through which you view the subject) is tilted away from the normal vertical position of the picture plane.

Skyscrapers

A view drawn from a photograph. This is a very dramatic view and creates a sense of depth. The drawing was created by placing tracing paper over a photograph and drawing quickly the verticals, horizontals and shadows. This further increases the sense of energy that this type of view typifies. The three-point construction alongside was achieved by projecting lines out beyond the picture area to three vanishing points.

©DIAGRAM

Check your work
To help check whether you have understood the simple principles of perspective and their effect on the shapes of subjects you draw, try the following simple Tasks.

Distortion
Distortion of subjects is the result of the position you take up when drawing. Three simple principles to remember are:
1. Objects viewed flat on have correct height and width but distorted depth.
2. Objects viewed at an angle have correct height but distorted width and depth.
3. Objects viewed close up have distorted width, height and depth.

Poor understanding
Below, this drawing is spoilt by the artist not checking the descending horizontals on the two sides of the tower. His drawing 'flattens' the two sides.

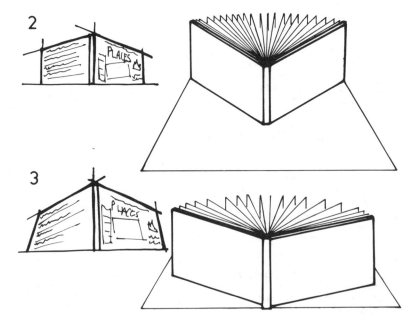

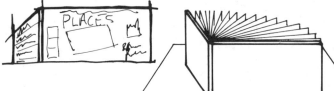

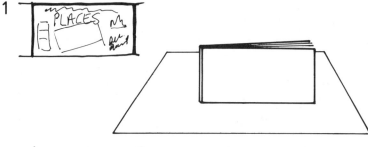

1

2

3

TASK 65
Basic proportional test
Place this book upright on a table with the front cover facing you. Sit on a chair with your eye level parallel to the edge of the table. Draw the front cover of the book. Check that the proportions of your drawing are correct by placing the lower left-hand corner of the book on the lower left-hand corner of your drawing and check that both your drawing and book have similar diagonals.

TASK 66
One-point perspective
Open the book wider than in Task 65 so that you can see some of the back cover. Do a drawing that reveals some of the back and note that the horizontal top edge is now sloping downward.

TASK 67
Two-point perspective
Push back the front cover until you have a central view of the spine, with both front and back sloping away from you. Notice in your drawing that both top edges of the book now slope downward.

TASK 68
Three-point perspective
With the book open to the same amount as in Task 67, move the book forward so that the spine is close to the edge of the table. Move your position forward, as close as possible but retain the same eye level. Your drawing will have a design with sloping sides.

MASTERING TOOLS CHAPTER 3

Drawing tools make a variety of marks, some are more suitable than others for producing the results you have in mind. While out on location, pencils, ball-point pens and felt-tipped pens are best for the task of quick, confident drawing. In the quiet of a studio, pens and technical pens are more appropriate if you wish to build up the detail in your drawing.

Some implements, such as pens, and brushes do not allow you to make corrections, so the results of the marks and their individual effects are more serious than when working with pencils or chalks.

Brushes are not often used on location as they require you to carry water, inks, and a mixing bowl.

There are twenty-three Tasks inviting you to concentrate on the quality of the lines and textures of a drawing – the graphic qualities of the art.

● The first four pages, 164 to 167, invite you to work out of doors, taking a small collection of familiar tools and enjoying the weather and the environment.
● Next, pages 168 and 169 are a plan to set up your home studio, a guide to equipping a small work area.

● Pages 170 and 171 introduce you to the methods available for changing the size of an original drawing or reference.
● The six samples of the same subject on pages 172 and 173 are drawings with different tools so you can understand the graphic qualities of a drawing.
● Finally, the review on page 174 contains a challenge. Do a drawing using your less-familiar drawing hand.

When working on location you will need tools that are reliable and easy to use. Do not take tools that cause you difficulties and with which you are unfamiliar. Carry a small shoulder bag, large enough to contain your tools and your sketch pads. When on location the bag can be pushed round to your back leaving your hands free to hold the drawing pad and pencil.

Paper
When you first begin sketching out of doors, you will find a sketch pad is preferable to working on paper fixed to a board. The pad enables you to turn quickly to another subject, and it is a more convenient way to store the drawings.

Drawing on location
Below, a pencil drawing of an old agricultural machine. During the drawing, the weather turned to a heavy shower so the second drawing, opposite left, was made from the shelter of a barn using pen, brush and ink.

Tools create style
Opposite page, sectional details from two drawings, the first (center) a pencil study on rough paper using a soft pencil. The second (far right) a pen and ink study on smooth thin paper.

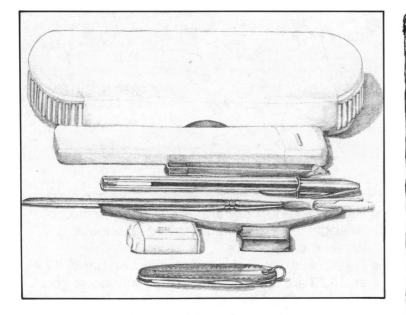

Outdoor tools
You will need a small box to hold the tiny objects, such as erasers, board-clips and those that damage with travel, such as chalks or pen nibs. I have found that plastic date boxes are good as they have a tight-fitting lid. Individual tools, or a quantity of charcoal wrapped in paper, can be stored in a plastic toothbrush box.

Take pencils and do remember to take a pencil sharpener or penknife. Place brushes in protective covers. You can make your own brush cover by rolling a tube of stiff paper the size of your brush and sticking it together with tape or glue. Remember to lick the end of the brush each time you place it in the cover to prevent the outside hairs from being bent backwards in the tube.

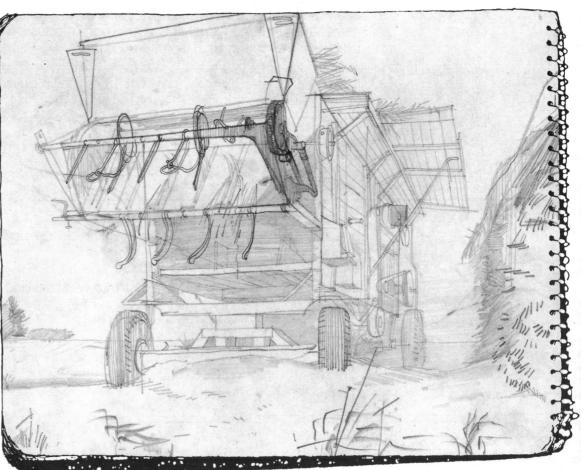

Four Tasks

Four Tasks to introduce you to the marks tools make. Each should be of the same location and from the same position, so select a view where you can study without disturbance and can spend long periods of time in some comfort, such as sitting on a wall.

TASK 69
Pencil

Do a series of studies first with a soft pencil on rough paper, then with a hard pencil on smooth paper.

TASK 70
Charcoal or crayon

Do a series of studies each on different colored papers. The tonal effects of working on dark paper, and adding highlights with white chalks is often very effective.

TASK 71
Pen and ink

Repeat the subject study and work one drawing very quickly in pen. Make a second study taking more time and adding lots of detail. Draw on smooth strong paper.

TASK 72
Brush and ink

Your final drawings of this subject should be on thick paper, strong enough not to buckle when you add areas of diluted ink with a brush wash. If the paper is smooth enough, you can work the final drawing using both pen and brush.

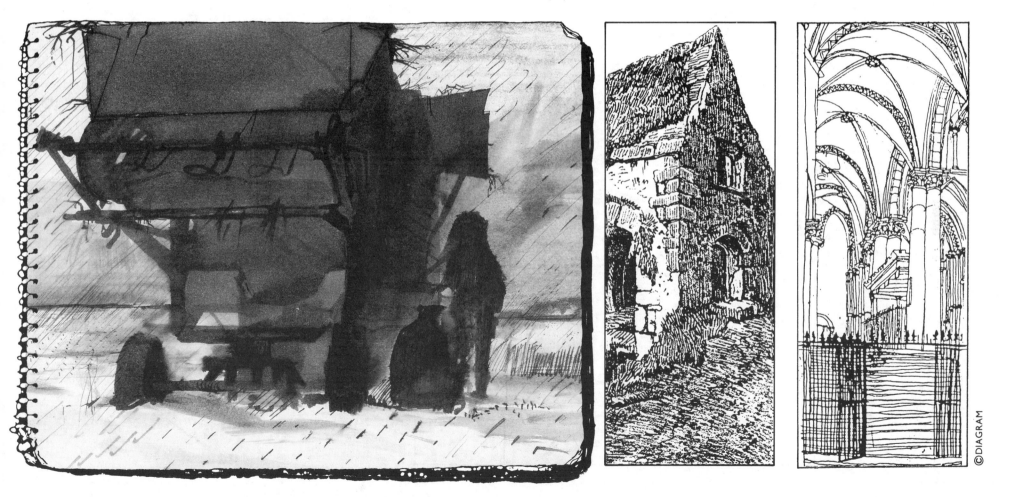

©DIAGRAM

There are two objectives when drawing out of doors. The first is to record a subject as accurately as possible, and the second is to try to capture some of the atmosphere of the view. Either may be your prime interest, and certain tools are more suited than others to achieve your aims.

Street scene
Below left, a pencil study of a winter street scene. The moving figures and the misty shapes of roofs are best recorded on rough paper with a soft pencil.

Buildings and trees
Below right, the strong hard light of the Cuban jungle is more easily captured with a dark felt-tipped pen line on smooth paper.

Exploring atmosphere
Four Tasks to explore the atmosphere of the same location. Choose a spot where you can shelter from bad weather, and on which there are, on occasions, a gathering of people. Choose perhaps a street market, a bus or rail station, a park, or a popular beach.

TASK 73
Detail study
Draw a scene on a quiet sunny day with maximum detail in your study. Record as much of the subject as you have time for, spending about two hours on the drawing.

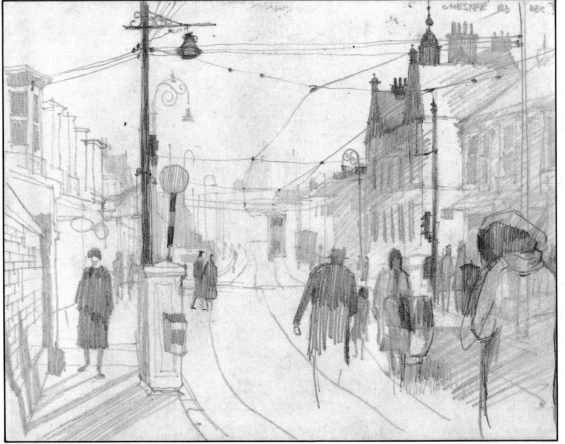

TASK 74
Atmosphere study
Draw the same scene on a dull, cold, damp day, or early in the morning, or at dusk on a winter's day with poor sunlight.

TASK 75
Crowd study
Return to the scene at a time when it is most busy, and do a series of crowd studies, working fast, and keep a number of small drawings going at the same time.

TASK 76
Combined study
Using all three studies, do a drawing at home in which you include a great deal of detail, a sense of atmosphere, usually achieved with tones and adding people to give the drawing life.

Bar scene
Below left, the smoke-filled Irish tavern is best captured with smudgy soft pencil marks on rough paper. Do not worry about errors when trying to capture atmosphere: It is the mood of the drawing, not its detailed accuracy, that is important.

Winter gardens
Below, brush and diluted inks working on a cold morning from a high window. Normal pen inks must be diluted with distilled water, as normal water causes them to produce blotchy tones. You can carry a bottle of ink and a bottle of distilled water, mixing small quantities on the lid of a cosmetics compact or a food jar lid.

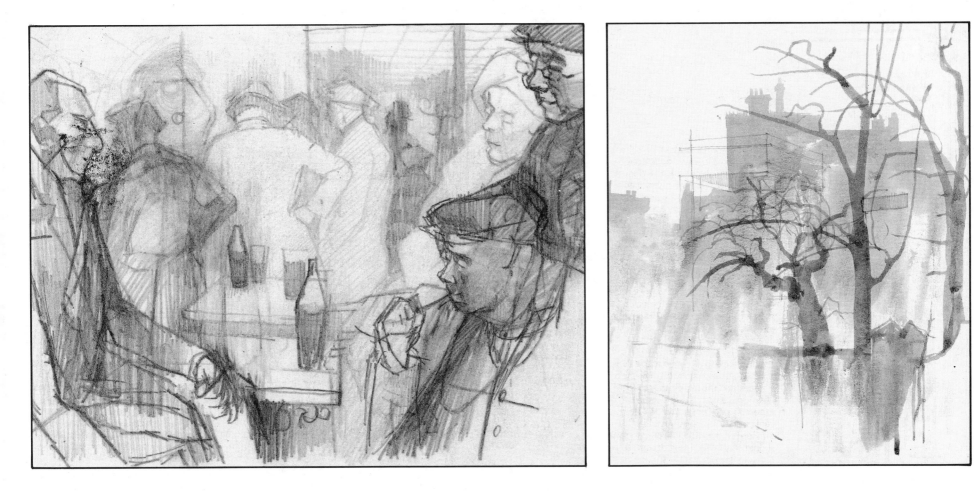

©DIAGRAM

Drawing indoors

Many successful landscape drawings have been produced indoors, without any direct reference to the real world. Using either photographs or studies made on location, you can build attractive compositions by combining details and information from more than one source.

Studio tools
Left, all the normal location tools are useful at home, but two additional ones to have when working indoors are a blow spray for fixing pencil and charcoal drawings and a scalpel and a supply of blades. As technical pens cannot produce a varied line, so you must buy a selection of pens to obtain different line thicknesses.

Technical pens
Most art supply stores now stock a variety of technical pens. These produce an even thickness of line – usually in black ink. They are used mostly by artists whose work is intended for reproduction. They require care and attention as the pen only works successfully on smooth surfaces, and the pen clogs and does not produce even lines if the nib is exposed to the air for a while. Great care must be taken *NOT* to apply pressure on the nib as the drawing line should only be the result of contact between the nib and the surface.

Your work area
Most people can spare a small permanent space for working. A hobby corner. More important than the size of the space available is the efficiency with which you use the space. The basic requirements are;
1. An inclined drawing surface so that you are not leaning over the work.
2. A place to store drawings, whether a plan-chest or a portfolio.
3. Small drawers to store tools and notepaper.
4. Jars to hold the tools which you most frequently use.
5. A natural light source, usually from the front and left side if you are right-handed.

Working practice
Remember some simple rules when you are working.
a. Everything should be within easy reach of your drawing surface and you should be able to sit comfortably for long periods.
b. Allow no distractions, so sit facing a wall or a quiet view.
c. Always keep your work area clean and free from clutter.
d. Store away tools not in use.
e. Buy serviceable, not glamor, tools. Never buy cheap tools as these very quickly deteriorate.

TASK 77
Work area
Make a permanent work area with a surface of approximately 2 ft 6 in × 5 ft 0 in (76.2 × 152.4 cm). One very successful work surface can be made from a door laid over two small filing cabinets, then covered with hardboard and linoleum.

TASK 78
Work efficiency
Sort out all your pens, pencils, brushes. Discard old worn-out tools. Sort the very small objects such as paperclips, penknives, erasers, into a small drawer or box. Regularly, maybe once a month, wipe down all the surfaces of your work area to keep them free of dust. Regularly wash out the water jar and mixing dishes.

Studio techniques

Working indoors enables you to add a great deal of detail to your study, which would require lengthy attention on location.

Left, a drawing of buildings in New York made in the 1920s by Jonathan Ring.

Drawing surfaces

Papers, cards, boards, all offer a wide variety of surfaces. Most stockists have paper samples and it is advisable to buy very small quantities of materials until you are confident that you can get the right quality of line from your tools on various surfaces.

A simple guide is;

1. Pencil works well on most papers but slides and is weak on smooth surfaces.

2. Ball-point pens, felt-tipped pens and office pens of all types work on most papers.

3. Pens work best on smooth surfaces; they do not work on rough textured surfaces.

4. Technical pens should only be used on smooth surface papers.

5. Brushes must only be used on strong thick papers. Thin weak papers will only buckle and cause blotches when water is applied.

Fixing

Above, pencils, chalks, crayons and charcoal drawings should always be fixed to prevent them from smudging. It is better to use a solution of fixative which is sprayed on to the drawing with a blow spray. The pressurized canisters of spray fix damage the atmosphere and are dangerous when you inhale the fine spray.

TASK 79

Storage

Check that all your pencil, charcoal and crayon drawings have been fixed and are stored. Where necessary interleave some with tissue paper to prevent them rubbing together.

TASK 80

Supplies

Collect as many different types of paper as you can – samples of rough, smooth, dark, light, cheap, expensive, and whatever other paper surfaces you can find. They often add a unique quality to your drawings.

© DIAGRAM

Changing the size

This book does not contain drawings. It uses reproduction of drawings – often the difference in quality can be quite striking. Four factors affect the appearance of the reproductions. Their size in relation to how large they were originally drawn. The color of the original drawings. This ranges from the color of the paper originally used to the tones originally produced by the pencils, brushes and crayons. Then there is the texture of drawings, some of which may have been done on a rough surface, but are now reproduced on a smooth surface. And, most importantly, how well their original quality is captured in the quality of the printing of this book.

Size
When I was 12 years old, I frequently copied from illustrations in books and magazines. While a student, I was shocked when examining original artwork to see it was often drawn much larger than its reproduction. Somehow I felt this was cheating. In later life, my experience taught me that successful illustrators may have deliberately drawn their originals larger but while retaining the idea of how it would appear at the smaller size.

TASK 81
Judging scale
Estimate the original size of drawings in this book or in other books. One clue is the size and nature of individual lines.

Changing sizes
You can change the size of your drawing or reference by a variety of methods, some very laborious, others much simpler.
1. Estimating the new proportions by use of diagonals (**A**) or protractor (**B**).
2. Enlarging by the square-up method.
3. Enlarging by pantograph (**C**).
4. Enlarging by a lens.
5. Photographic enlargement.

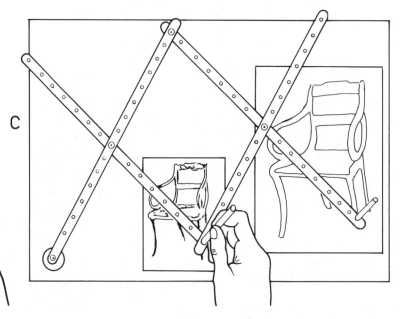

Proportional enlargement
When enlarged or reduced, a drawing has a common diagonal with its original size. This principle helps when thinking about the size change. However, the technique only gives you a new width or height change. It does not help with details. A small wheel-like scale is available called an enlarging protractor, which enables you to calculate the new dimensions of a drawing. For example, if you change the width from 10 to 15 units, then by turning the discs to matching these two numbers all other alignments on both scales are proportionally changed, e.g. 8 to 12, or 6 to 9.

Enlarging protractor
Above, the plastic disks are used to find the relationship of measurements when enlarging or reducing.

The Pantograph
A series of parallel rules which proportionately change plotted points on a drawing.

Actual size

Examples of details from drawings within this book are printed here actual size. Can you locate the drawings in the book? All the examples selected in this book were, of course, drawn prior to publication, with no intention of being included and were produced in a wide variety of sizes and styles.

Basic squaring up

This method is more than 3000 years old!

Either draw a series of squares on to your drawing or, preferably, on to a covering of tracing paper. On your intended new surface draw a second series of squares, this time to the new size. Slowly and carefully copy by hand the intersections of the major elements of the design, transferring the shapes to the new grid. To avoid confusion, greater accuracy is achieved if the drawing is turned away from you so that you do not read the information other than as shapes.

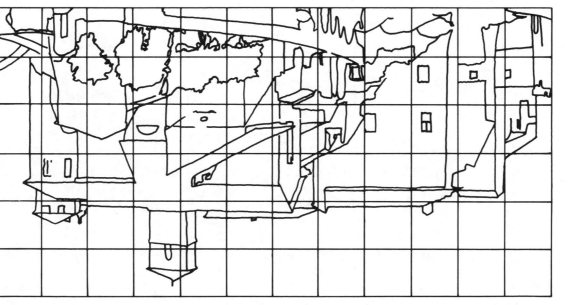

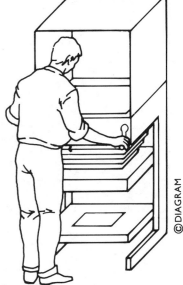

© DIAGRAM

TASK 82
Artists' originals
Make an effort to visit art galleries and museums and examine artists' original drawings. Very often these are not on display, but are stored in archives of the collection and can be examined upon request.

TASK 83
Re-scaling
Re-scale one of your less complex drawings using the squared-up method, producing two versions, one smaller than the original and one larger.

TASK 84
Photocopy
Take one of your most detailed drawings, preferably one you did with a pen, to a photocopier service, and buy a series of enlarged and reduced versions of the original. Pin them up on your notice board and compare the tonal qualities.

Studio enlargement
A lens-like machine, which can enlarge or reduce your original by projecting the new size on to a glass screen from which you can make copies.

Photograph enlargement
Your drawing can be photocopied at a new size

Graphic qualities

It is important that you learn to understand the graphic qualities of drawing. These are marks made by various drawing instruments and the manner in which the marks are made. Pencils, pens and brushes all produce different effects and each is more suitable for certain tasks than others. Many beginners copy published drawings using tools different from the original artists, so the resulting copy has a different drawn quality.

Six examples
A detail, actual size, of the drawing on page 144 and using different tools or techniques.

1. Smooth pencil work drawn very carefully, slowly building up the tones.
2. Pencil on rough cartridge.
3. Ball-point pen.
4. Technical pen, cross-hatched.
5. Technical pen, built up of dots.
The first and last two solutions are not suitable styles when working out of doors as they require time and care.

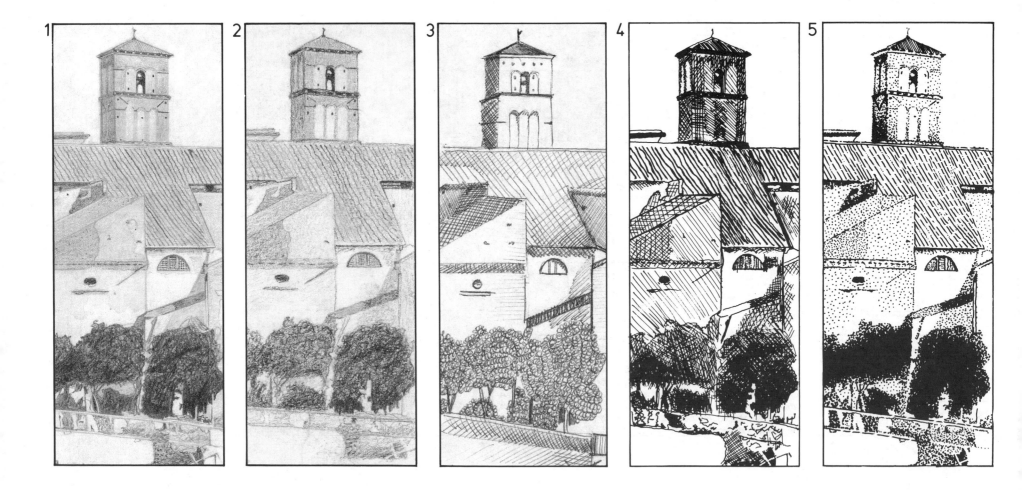

Time influences style
6. A fast sketch using felt-tipped pens: the flat areas are produced by a broad soft marker and the detailed areas by a felt-tipped pen with a small point.

TASK 85
Exploring tools
Copy the photograph below using a pencil, then repeat the task using a pen or brush. Compare the different effects. The same experiments should be made on location, choosing a view that offers you lots of detail.

TASK 86
Artists' techniques
Copy the drawings of famous artists using the same tools as they did to achieve similar effects.

TASK 87
Varying techniques
Copy the drawings of famous artists, using different tools from those used by the artist. It is great fun to reproduce with a brush a drawing originally produced in pencil. You will find that tools very strongly influence your style of drawing.

TASK 88
Time
The speed with which you produce the drawing also influences the style. Do another drawing of the photograph below taking only five minutes to record as much detail as possible. Use any tool you wish.

6

©DIAGRAM

Understanding technique
This chapter was about how drawings are produced – the technique of drawing. Never be over-influenced by the technique: what matters with a good drawing is how you see the subject and that you understand how to capture what you see. It should be your vision of the world.

TASK 89
Recording the technique
Mark in a soft pencil in one corner of each of the previous 88 Tasks the method by which you did the drawing. If most are in pencil, consider using other tools for later Tasks and even redoing some of the earlier Tasks, using pens or brushes.

TASK 90
Conversions
Turn any previous Task into a brush drawing.

TASK 91
Uncomfortable tools
Try redrawing a Task in chalks on colored paper, or with a fine pen, building up the tones by cross-hatching.

TASK 92
Handwriting
Do a drawing either from location or photograph using a pencil but holding it in the hand other than the one normally used for drawing. You will immediately feel unsure of the lines and need to concentrate much harder on the effects.

The importance of tools is that they can very easily undermine your confidence. You feel uncomfortable with some implements. Try always to be able to use as many tools as possible, as this widens your graphic abilities.

Handwriting
Top, a very fast ball-point pen study using my right hand, which is my normal drawing hand. Below, another drawing using my left, unfamiliar hand. The second drawing took much longer as I had little confidence in the ability to make the correct marks.

©DIAGRAM

CONSIDERING DESIGN

<div style="text-align:right">

CHAPTER 4

</div>

This chapter is devoted to considering your drawings as rectangles containing a network of shapes, tones, and lines. Also, how to think of your drawing as a graphic (flat) object. The thirty-one Tasks will help you enjoy the pattern of your pictures, that is, your view of the subject through the picture frame.

We also look at those factors that influence your drawing: selecting subjects; selecting areas of the subject; selecting the position of the subject within your picture frame; and selecting the qualities of the subject.

- We start with what to draw. The first four pages, 176 to 179, help you decide where to stand when on location.
- What should I choose for a composition? Pages 180 and 181 offer you the chance to consider the overall effects of the position of the elements in your picture frame.
- Pages 182 and 183 are concerned with bringing your pictures to life. So often beginners are afraid to include figures in their studies. As figures often move, and as they seem harder to draw, they are left out. But, the presence of human activities helps set the scale and tone of the composition. Figures are often a focal point in the composition.

- Pages 184 to 187 explore the design of your drawings. How to think of the image as a 'picture' and consider its texture, tone, pattern and style.
- The final page of this chapter invites you to review all Tasks devoted to drawing landscapes.

What do you draw?

Selecting what to draw is often the hardest part of the task; for example, where to look, which section to choose and which feature to examine. Beginners often feel inhibited by the complexity of the real world. One simple method of selection is to direct your attention to one aspect of the subject. Draw the skyline to the exclusion of the middle distance and foreground.

Draw a particular building or object on the landscape. Draw only the textural differences and light and shade effects. Draw passing events. This last activity — sketching — requires experience as the events pass and memory of them must be retained in your mind's eye. What is important is to make your choice of approach before you start, and begin your drawing with a particular viewpoint.

Framing
Left, when out sketching make a frame with your two hands and view the landscape through the center area.

Five examples of styles
A. Horizon study
B. Building study
C. Texture and tone study
D. Sketching
E. The larger illustration is an example of in-depth study, which involves drawing the space which is moving into the picture and away from the viewer.

TASK 93
Skyline

Do a tonal study of the edges of the subject against the sky. You can copy this photograph or draw the skyline using a view from your window.

TASK 94
Buildings

Do a study of a particular building in this photograph, or a building you can see from your window.

TASK 95
Texture

Do a texture study of a part of this photograph. Compare water, trees and buildings to each other.

TASK 96
Framing

Cut two L-shaped pieces of card of similar size and place these over the photograph and select an area to draw. By changing their proportions and moving them around you can reveal other interesting compositions.

Where do I stand?

The position you take up when out drawing will very much influence the resulting drawing. Sitting is preferable to standing, to occupy an unobtrusive position is better than a conspicuous one. Try not to draw attention to your activities, unless you like sketching in front of an audience of passersby.

Mosel Valley, Germany
Below left, a view from a bridge looking up at the hill-top castle.
Below, the same subject viewed from the top of a hill with the same bridge in the distance.
Each drawing creates a different impression of the location.

TASK 97
Point of view
Do two drawings of the same subject, each from a different point of view.

Boats, Hong Kong
When undecided about a particular view of the location, try drawing some of the individual elements in the scene. This can be helpful as these studies may be used in later compositions.

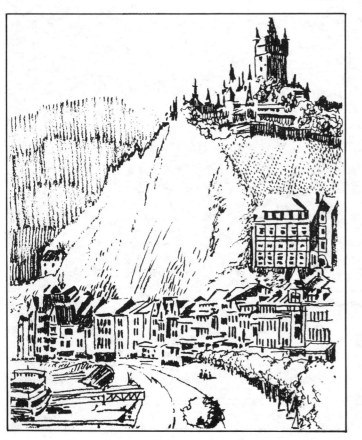

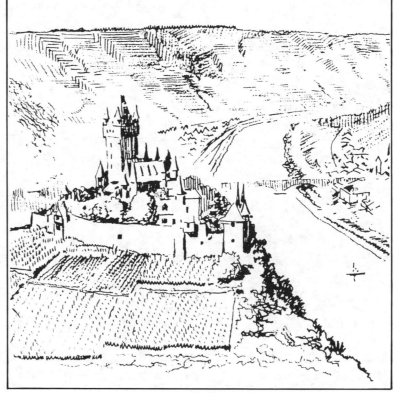

TASK 98
Collecting details
Keep a small note pad with you constantly and jot down individual subjects, such as boats, cars, trees, people. These can be of use in later studies.

TASK 99
Uninteresting subjects
Visit locations which at first would seem to offer very little interest, such as Industrial Trading Estates, residential areas in the suburbs, motorways.

TASK 100
Recessional subjects
Visit a location that offers a view deep into the composition. Examples are looking along a street, or a river, or rail tracks. Use the diminishing details as a device to draw the observer into the subject.

Sitting comfortably
This sketch by the Dutch artist Vincent Van Gogh, must have been made from a seat outside the cafe. Try to sit where you can enjoy the experience of observing people and places.

Recessional subjects
The best subjects of deep space to record are those containing small elements of diminishing patterns, such as cobblestones, tiles, paving stones or planks.

Stockholm street
Right, this sketch, based on a Swedish artist's painting, shows that he must have stood on the edge of the sidewalk to avoid being interrupted by the passersby.

Industrial scene
Below, an old, abandoned dock scene offers ideal quiet to study the shapes, as this sort of location is usually undisturbed.

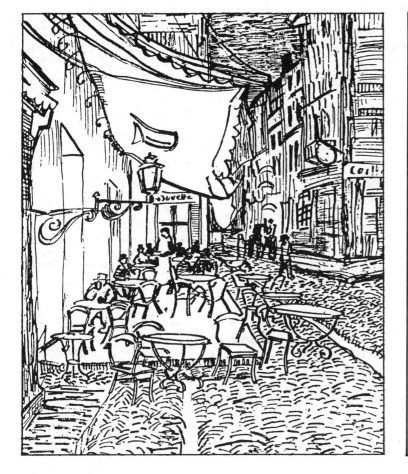

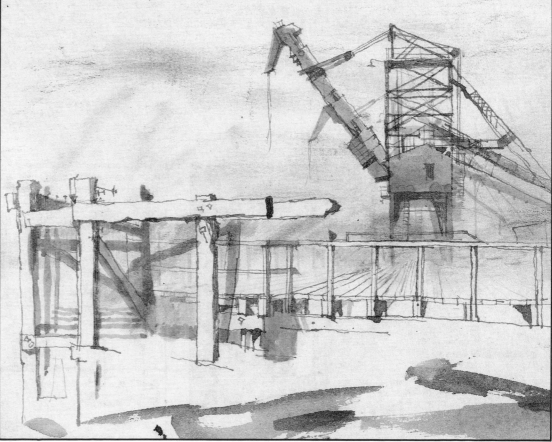

The format and form of the picture create special effects. The shape of the frame and the positions of the elements within the frame, both interact to influence the composition. When on location, or planning a picture at home, use a rectangular frame to judge the picture area.

The shape of the frame
Left, three views of the same landscape, each within a different rectangle. Each creates a different impression of the composition.

TASK 102
Panoramic views

Make drawings of open fields, sea scapes, or from high up in an urban area. Make your study at least four times as wide as it is high.

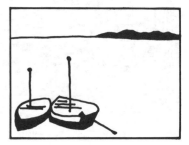

Outward or inward responses
Above, this drawing of distant fields is wide and even. The eye roams over the landscape to settle on different parts of far distant fields.
Left, this scene from under a bridge draws the viewer into the picture. Attention is directed towards the vehicle just over the crest of the road.

TASK 101
Recessional compositions

On location draw a view through an arch, under a bridge, or into some confined space.

Spatial tensions
Below, three similar frames in which the composition varies by the way the elements within the frame are positioned. There are three factors which interrelate. The position of the boats, landscape and edge of frame to create different styles of composition.

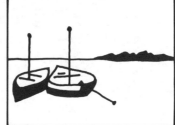
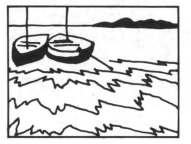

Four compositions through a viewing frame.

When out on location, you can frame the scene either with your hands or through a small hole cut in a card.

1. Scene close up to form an intimate view.

2. Scene at long distance to form a deep composition.

3. Scene selected to create spatial tensions.

4. Scene selected to give impression of movement.

TASK 103

Viewing

Make a viewing frame and take it with you on your next location trip. Try doing a series of ten-minute sketches of different compositions of the same view.

Recessional space

Far right, most compositions contain foreground (**A**), middle ground (**B**), and distance (**C**). Greater interest can be achieved by balancing these elements. Right, this 19th-century drawing sets the scene as if it were a stage set, with each part flat and overlapping the others.

TASK 104

Extended compositions

Place tracing paper over landscape photographs in magazines and draw the basic compositional elements. Mark foreground, middle distance and far distance as three distinct areas. One way to accomplish this is to imagine you have to paint three flat screens for a stage play, each as part of the composition.

© DIAGRAM

One of the most important aspects of a composition is the presence of people in the picture. Figures help to create an illusion of space by their reducing size, and they add a sense of scale to the surrounding objects. Artists have always used the presence of figures and even when reduced to the simplest of details on a drawing, they help to create life in the composition.

TASK 105

Sketch books

Keep a small note pad in which you regularly sketch single figures or groups. Try to capture the basic shapes without recording too much detail. These notes will be invaluable when you come to add figures to your more developed compositions.

Scale

Figures in a landscape give scale to a scene. You can judge the size of objects against figures, because we all know the normal height of a standing figure.

TASK 106

Estimating scale

Which of the two figures (below) would be appropriate in the foreground of the beach scene? The answer is on the review page of this chapter.

Focal points
Human beings as focal point in a composition. This pencil study of a famous painting of a winter scene by the 16th-century Flemish artist, Pieter Bruegel, takes all the dynamics out of the picture. There are no figures here. The original had a strong human interest. Can you guess where the artist placed the figures?

TASK 107
Locating figures
Place tracing paper over this picture and copy the basic elements. Then add figures. Compare your results with a small study of the painting on the review page of this chapter.

TASK 108
Landscape artists' work
Trace the major elements of the compositions of famous paintings of landscapes that are reproduced in books. Then add in solid outline the position of the figures in the composition. This reveals the inner dynamics of the painter's subject as the figures stand out from the context of the space of the picture.

Dynamics

A sense of energy, the dynamics, in a drawing can be achieved by a variety of methods, or a combination of methods. The most common techniques are: the subject itself; the view chosen by the artists; the tonal effects of the drawing; and the technique by which the drawing is produced.

TASK 109

Technique

Do a drawing using a very unlikely drawing instrument. For example, sharpen the wooden end of a pen or brush and use this crude implement dipped in ink or paint to do the drawing. Or simply do a pencil drawing without resting your wrist on the paper. At all times only allow the tip of the pencil to touch the paper. This produces a very shaky nervous line.

The technique

Right, this is not a drawing of a landscape, it is a collection of marks made by dabbing cloth first dipped in ink onto the surface of the paper. The method of drawing has created a dynamic of style which would be hard to create with a pencil or pen.

Idea

Right, this is a study of the Ponte Vecchio in Florence. Such a well-known subject is made interesting by exploiting the effect of the reflection of the bridge which creates a structure unfamiliar to us.

TASK 110

Idea

Draw a landscape while sitting in the car looking into the convex reflector mirror. Try to capture the distortion of shapes. Think of some subject which offers this unique and arresting approach. Try standing on a bridge and drawing the view directly below of people or vehicles. Or find a scene where the lighting effects are unique.

Tonal effects

Left, black trees against a white sky. White sheep against a dark ground. Each is contrasted against the other to create a very interesting effect.

TASK 111

Tonal effects

Do a drawing using only one value and white, no grays. Make a pattern of the landscape matching darks against lights. Choose a simple composition with very few elements to avoid producing a very complex image.

The view

Right, a 19th-century Japanese book illustration. The view of the path interrupted by the foreground tree excites the interest and makes the eye zig-zag into the composition.

TASK 112

The view

Find a location where you can select a very startling view of the subject. This is often achieved from a high or low vantage point, but can also be the result of how you cut the sides of the subject.

The first pages of the study of landscape began with the problem that all drawings are flat. They are marks on the surface of the paper. The artist uses various techniques to create the illusion of space. These two pages offer ideas for exploiting the paper's flatness. Your drawing becomes a pattern of shapes, and not a description of reality.

Patterns of light
Below left, old buildings drawn on location. By emphasizing the shadows the sense of space suffers. The interest is maintained, however, by the patterned quality of the drawing.

TASK 113
Light and shade
Convert one of your earlier drawings in to a design of shapes. Follow the edges of the shadows and fill in large areas of the composition by selecting a low light source. Tasks 14, 15 and 16 will help you start on this method of creating a design solution to a drawing.

Patterns of texture
Below, rocks on a coastline. Our interest is held by the textures of the rocks, recorded with a soft pencil and use of smudging with my fingers.

TASK 114

Textures

Working with crayons, chalks or soft pencils, select a subject which has a strong textural surface such as rocks, trees, fields or hills. Try to select a subject you can study from a frontal position so that you are not distracted by recessional space problems in your drawing.

Patterns of detail
Below, the Swedish artist Sven Olov Ehrén used a method of drawing whereby all the edges are thick lines and all the surfaces flat tones.

TASK 115

Linear net

Convert any drawing in this book or any of your earlier Tasks into a flat network of lines. If you use a thick pen or pencil line, you will produce a strong design. If you use thin lines, the pattern-making quality will not be too clear.

Patterns of shape
Below, a forest scene. Branches, foliage and shadows are all fused into a pattern of shapes. The most extreme form of drawing is to reduce all tones, colors, textures, forms and shades to shapes.

TASK 116

Shapes

Convert any drawing in this book or any of your earlier Tasks into a pattern of shapes. Use black and white in large areas and avoid details. To copy a drawing successfully turn it upside down, then you can consider only the shapes and not their intended descriptions of reality.

©DIAGRAM

If you continue the subject of landscape drawing you are following in the footsteps of many great artists. Remember, there is no such thing as a bad drawing. There are only drawings you are not pleased with. If you work hard, examine the subject carefully and record accurately, you will produce good drawings. Strangely the fun you get from your work is captured in the quality of the lines on the paper. Whatever you discover, you reveal.

TASK 117
Observation

Do a series of drawings sitting in the same position. Each drawing should be at a different time of the day, but of exactly the same scene. It may be from your window, or from a bench in the park. Be sure you do each study without reference to the previous studies. You will find that you notice some slight difference of aspect each time you scan the subject. The overall effect of perhaps five drawings, each in detail, can produce an overwhelming impression of a place.

TASK 118
Time

Reality is never constant. Lighting, weather, events, your reactions, all interact to produce unique impressions of a scene. Do four drawings from the same spot, each drawing at least three months apart. Choose perhaps public holidays scattered through the year. The comparison of the studies is made more striking if they contain plants or trees.

Scale
In Task 106 you had to locate one or other of two figures. The drawings were made from a photograph and the figure in the foreground marked **A**.

Focal point
The painting by Bruegel relies very strongly on the foreground group of figures. They are walking into the picture space. The middle distance has lots of tiny figures who not only hold our interest, but somehow invite us to move closer to the picture to see what each is doing.

TASK 119
Research

Visit art galleries, collect books on art, cut illustrations from newspapers and magazines. Study the work of artists you admire, copy everything of interest.

TASK 120
Tradition

Buy a print or drawing by a living artist you admire or whose work you like. This maintains the tradition of art. You become a sponsor. Never buy as an investment. You can only make money, or lose it. Buy a picture because you like it.

TASK 121
Records

Check that all your drawings are marked with the location, date and your signature. You must constantly re-examine your work, but you must have an inner pride of your achievements to spur you on to more studies.

TASK 122
Pride

Select your very best study. Spend money on a professional service and have your drawing mounted and framed. Display it in your home.

TASK 123
Continuity

Begin a life-long enquiry into one feature of your locality and whenever possible do a study of it. It may be a park, a river, beach or just your neighborhood.

Portraits are universal. We know what faces are like, so we can judge how much of a person's character is seen in their face. This is easily proved when an inexperienced artist copies a photograph of a famous person. The drawing doesn't look like that person. Somehow, what is in the person is not in the drawing.

Try to identify what makes a particular person unique. Your drawing should reveal their inner quality. The individuality of a person can be captured by observing an expression or mark.

This first chapter starts you on the path of examining your subject and your view of it. Looking is not seeing, nor is seeing necessarily understanding. There are twenty-eight Tasks designed to draw your attention closer to the process of looking at the subject and helping you to be aware of how your drawing is the result of your observations.

- The first two pages, 190 and 191, contain the most important idea in this section – transcribing a solid, three-dimensional world onto a flat two-dimensional surface.
- Pages 192 and 193 offer methods of checking what you see.
- Pages 194 to 197 explain how we 'read,' or interpret, the light and dark areas of a subject.
- These are followed by pages 198 and 199 which offer a method of constructing your drawing by finding points on the subject, and then transferring these to your drawing.

- Next, pages 200 and 201 offer twenty examples of how the subject's personality, the artist's view and skills, and the medium of the drawing interrelate to produce the drawing.
- Finally page 202 recommends you to make a notice board in your room onto which you regularly display your work so that you and other people may re-examine the drawings and review your achievements. Time and practice are two certain ways to improve your abilities.

What we think we see may not be what is there. All drawing converts solid objects to a flat shape. The physical world consists of changes in color, shape, volume, texture and shading. You must describe all you see with lines and built up tones, using only a flat surface and with the normal drawing instruments of pencil, pen, chalk or brush. Drawing is interpreting what you see.

TASK 1
Seeing solids
Wrap elastic bands or ribbons around a glass jar, bottle or tumbler. Do a careful pencil drawing, observing how the bands turn around the sides of the solid form. Try to draw the parts nearest to you in a heavier line than those furthest away. This exercise helps you to see the solid quality of objects.

TASK 2
How do you interpret?
Copy a photograph of yourself or copy a portrait in a newspaper or magazine. Try to do the drawing approximately the same size as Task 1. Do not simply copy the shadows and lighting, use the photograph to understand the volume of the head.

Steve's self-portrait
Left, drawing by Steve, aged 16, is clearly recognizable from his photograph (above) taken later, but he has failed to see the volume his head occupies. Steve has drawn a map of his head.

Lee's glass
Right, drawing by Lee, aged 17, is very well depicted. You can see the empty space inside the glass.

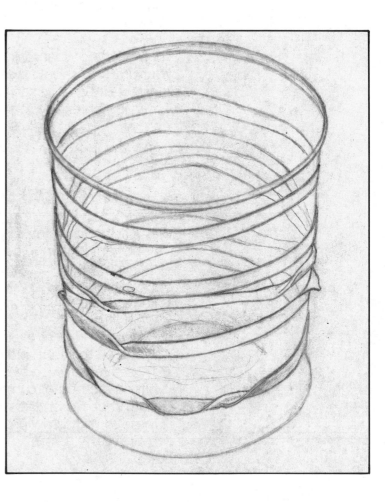

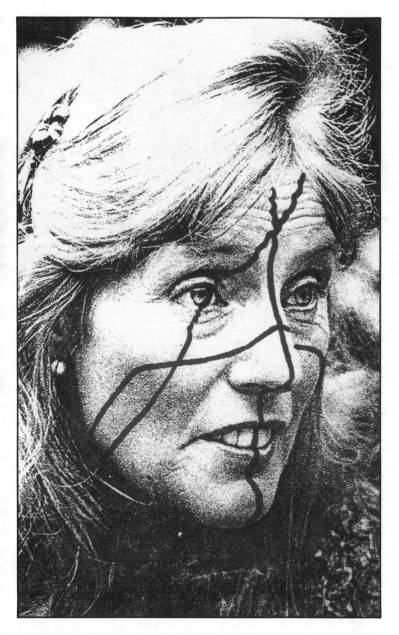

Tracking

Left, felt-tipped pen lines have been drawn over a photograph to explore the rise and fall of surfaces. This is made simpler by choosing a clear, well—lit subject.

TASK 3

Understanding volume

Collect large photographs of faces from magazines and newspapers and, using either a soft pencil, ballpoint or felt-tipped pen, draw lines across the faces as if there were tracks on the surface. This will reveal the 'bumps and hollows' of solid forms.

TASK 4

What do you see?

Sit in front of a large mirror with a constant light in front of you either to the left or right side. Draw your portrait approximately 8 in (20.3cm) high on whatever paper you feel comfortable with. Pencils make the easiest tool as they have a wide range of different marks – other drawing implements require more practice.

Breaking out

Right, Rembrandt's portrait of a fellow Dutchman was drawn more than 300 years ago. Not only does it successfully capture the form of the head – but the hand reaches out beyond the surface and into the space on the page.

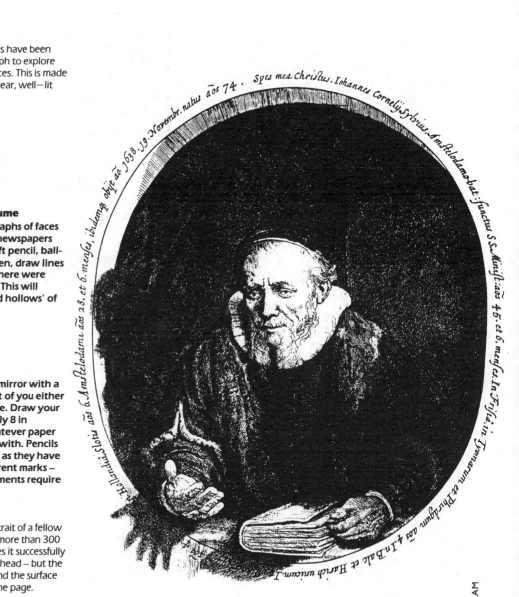

When beginning to master drawing, it is useful to rely upon some simple checking devices. All are based upon the idea that it is easier to record irregular shapes if they are related to regular ones. When viewing the subject against a vertical or horizontal edge, you must only use one eye. To reveal the difference in viewing with two eyes, hold out a pencil vertically. Retaining the pencil in the same position for both tests, view an object with the left eye only, then the right. Notice the 'shift' in vision.

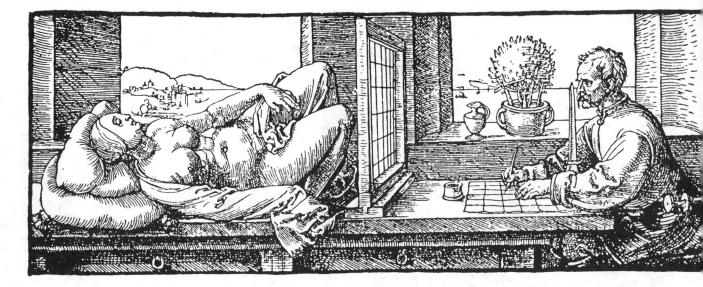

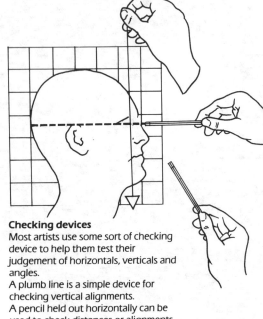

Checking devices

Most artists use some sort of checking device to help them test their judgement of horizontals, verticals and angles.

A plumb line is a simple device for checking vertical alignments.

A pencil held out horizontally can be used to check distances or alignments across the subject.

A frame or grid behind the head helps you to judge relationships of shapes.

A pencil held at a parallel direction to the shape to be drawn assists the definition of angles.

All these devices are intended as aids and, if used constantly, will greatly increase your accuracy and confidence.

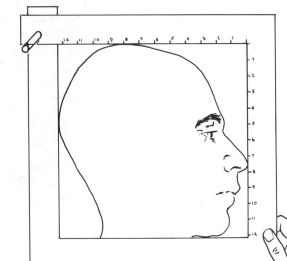

TASK 5

Checking shapes

Cut two identical right-angle frames from card, each with sides of approximately 10 in (25cm). Mark the sides of the card at regular intervals. Using paperclips, join the two cards together to form a square or rectangle similar in proportion to the area of your drawing. Draw the same shape with marks at the same regular intervals on your paper. Hold out the frame in front of you and view the subject through it, then carefully plot the points where the figure touches the frame's edge and mark the same points on your drawing.

Framing your view

Above, many artists have used a grid onto which they have plotted their drawing. Many construct a frame through which to view their subject. Here, the artist keeps his eye in a fixed position to the marker, then, viewing the shapes through a net of squares, records the patterns onto the grid. The drawing becomes a grid of squares, each containing a group of irregular shapes.

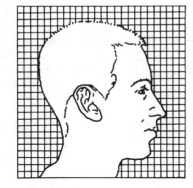

TASK 6
Make a plumb line

The simplest way to check points in a vertical line is to test their positions against a hanging cord. Make your own 'plumb line' by attaching a key to approximately 18 in (45.7cm) of thin cord. Hold out the hanging line at arm's length against the subject and view the subject through one eye. Locate two points on the subject, one above the other, and plot them on your drawing.

TASK 7
Checking your work

To check the accuracy of your work, place tracing paper over the photograph you selected in Task 2 and draw a pattern of squares over the picture. Repeat the pattern on another piece of tracing paper over your drawing. Check that the vertical and horizontal relationships in both are similar.

TASK 8
Portrait shapes

Sit your subject comfortably in front of a window frame, paneled door, or any surface with regular horizontal and vertical lines. Fix in your mind's eye the relationship of some of the points on the head to points on the surface behind. For example, the chin's furthest extent, the top of the head, the angle of the nose. Using tracing paper over the grid (right), carefully plot the shapes against verticals and horizontals on the background. During drawing, use the grid to examine the relationship of different features within the head to each other, checking vertical alignments with a plumb line and horizontal ones with a pencil held out.

Light and shade

Light and shade have always been used by artists to describe the form of objects. Our eyes 'read' the dark and light areas of a drawing to explain its features. Light normally falls from above and from the left or right sides, producing shadows and highlights. By observing carefully the direction of light, you will be able to judge the extent to which surfaces protrude or recede.

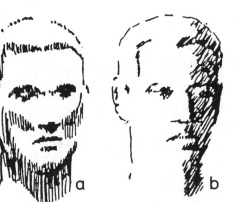

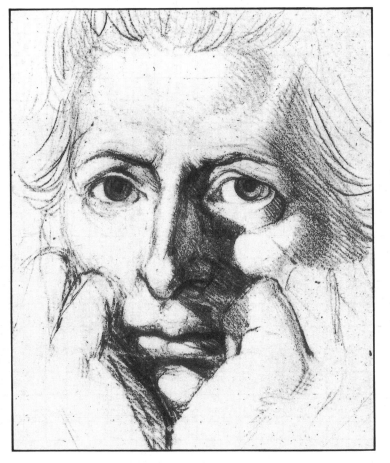

Shadow shapes
Left, this drawing by the 18th-century artist Henry Fuseli uses the strong effects of shadows to describe the protuberance of his nose and lips. The single light source, possibly a candle, helps to create a strong and clear description of the forms of his face.

Directional light
Above, three drawings of a head describe the source of light as coming from (**a**) above, (**b**) the left, and (**c**) below. Each drawing is of the same head and the different results are produced from our interpretation of the lighting effects.

Negative and positive
Negative descriptions seldom explain forms satisfactorily as we are accustomed to seeing shapes as the result of light areas created by a light source. Right, a drawing describing the forms as we normally see them. Far right, a reverse, negative version of the same drawing, in which the viewer has difficulty in understanding the forms.

TASK 9
Negative is not the opposite to positive
Using a soft felt-tipped black pen, fill in the areas of shadows on a portrait in a newspaper or magazine. On a tracing overlay, fill in the remaining white areas to produce a negative of the photograph. Compare the two.

TASK 10
Understanding light and shade
From newspapers and magazines collect photographs with dramatic lighting effects. These are often on the entertainment pages.

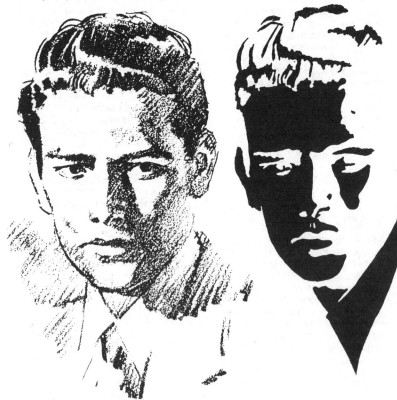

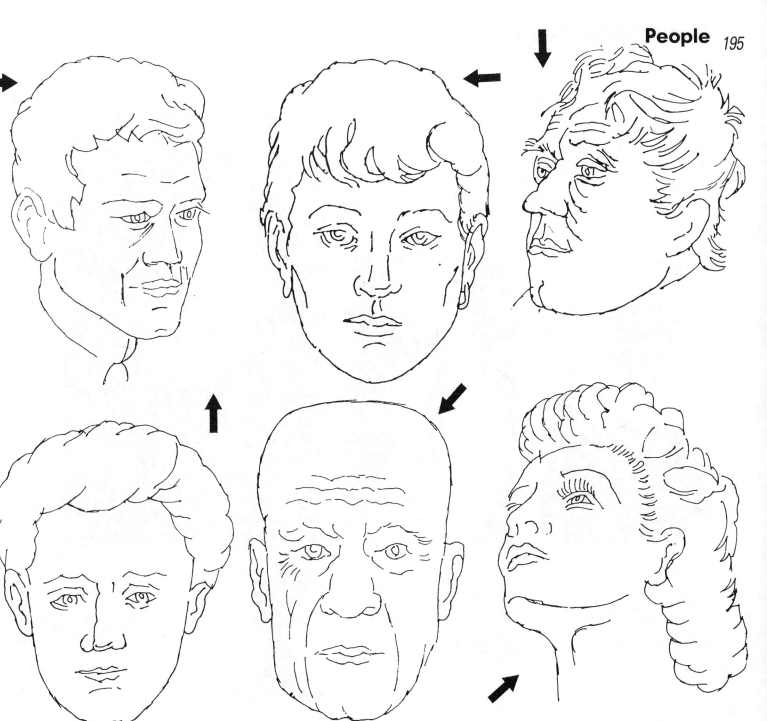

TASK 11

Exploring lighting effects

Sit a model in a comfortable position and light the figure from one source. Use an office desk anglepoise lamp as its beam can be directed easily and its position moved with ease. First draw the head by only shading in the shadowed areas. Retain the position of the model but move the light to a new position, and redraw the same details. Compare your two drawings.

TASK 12

Shadows make forms

Place a piece of tracing paper over each outline drawing on this page and shade in the faces, imagining the source of light to be coming from the direction of the arrows.

©DIAGRAM

The inside shapes

We seldom see shapes as separate parts of a drawing. The shapes are 'read' by us as a subject. We superimpose our preconceptions. This is an uniquely human characteristic. Animals do not normally respond to a photograph of another animal. They see only the flat patterns of tone. When drawing a subject you must see it in terms of both independent patterns and, at the same time, as a form.

Double meaning
Above, seeing two meanings in one drawing. A young lady with a low neckline, or an old woman with hunched shoulders. Both are correct 'readings.' By adding spectacles or a cigarette (opposite), only one meaning is possible.

Clues to understanding
Above, at first glance these shapes do not convey any impression of a face. They are just shapes. When you turn the page upside down the drawing is clear. Images need to be explicit. Vase (right) could be two people talking.

TASK 13
Simplifying shapes
Artists very often narrow both eyes and squint at subjects to reduce the patterns to simple forms. Try this when studying a real subject.

TASK 14
Simplifying patterns
Mike, aged 16, drew outlines around the stronger tonal areas on his photograph (above left). He then filled these in to produce a tone drop out of his portrait (opposite left). Try this exercise on one of your tone drawings or on a photograph.

TASK 15

Testing your shapes

Cut out the silhouettes of heads from newspapers and turn them over. With a black felt-tipped pen, fill in hair and other features on the back of the cutting.

TASK 16

Locating the insides

Place tracing paper over this outline. Draw the eye, nose, ear and hair details where you consider they should be. Now place your tracing over the picture on page 237 to check your knowledge of inside shapes.

When drawing a subject, do not rely on your natural ability to draw the relationships of the parts correctly. Artists very often cross-check their work relating one point on the drawing to another by lines or dots. They build up a network of marks into the patterns of the subject. Always remember that it never spoils a drawing to double-check its accuracy.

Coordinates make patterns
Left, the stars appear to be in random display in the sky. Very early in man's history, groups were linked up into a pattern to form memorable relationships and add recognition. This is the Plow, with and without the links.

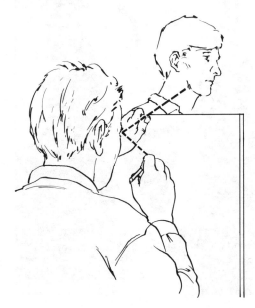

TASK 17
Through a mirror
What we see, and what we think we see, and what is really there, are not always the same. For example, what size is your reflection in a mirror? To test the accuracy of plotting, use a wax crayon or felt-tipped pen and draw your reflection directly on to the mirror. Compare the positioning of the parts with those in your self-portrait drawn as Task 2.

TASK 18
Direct transfer
All drawing is transferring what you see on to a flat surface, and many inaccuracies are the result of the difficulties of this transference. The subject and your paper should be as close to parallel as possible, so you just flick your eyes from one to the other.

Try doing a drawing with the paper at right angles to the view of the subject (above left). Then do a drawing with the paper surface at right angles to your view (above right). In the former, each mark requires you to move your head, in the latter (the correct method), each mark only requires you to transfer your glance from the subject to the surface.

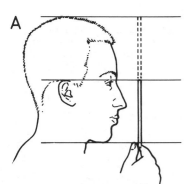

A

B

C

TASK 19
From drawing to reality
You can use the relative proportions of the features to help you place the ear correctly when you are drawing a head from the side. First check the proportions on your own head. Your eyes occur halfway up your head, and the top of your ear is on the same level as the center of your eye (**A**). Measure the distance from your eye to your chin (**B**) and compare it with the distance from your eye to your ear (**C**). You will find that the distances are the same. You can then use this principle – that the distance from the chin to the eye equals the distance from the eye to the ear – to draw your subject's ear in the correct place.

TASK 20
Point to point
Having carefully drawn the outline of a face, measure the distance on your drawing from chin to eye (a). Transfer this distance horizontally to a point within the head (b). This then establishes the position of the ear (c). Imagining these three lines will help when drawing other details such as hairline, cheekbone, and nostrils.

Building links
The drawing (far right) is an assembly of built-up points. Like the plotting of stars, these patterns are the result of linking each small item to the other local parts.

a

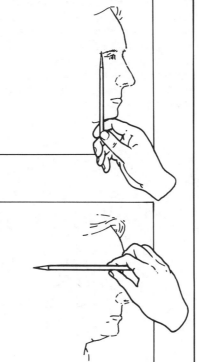

b

c

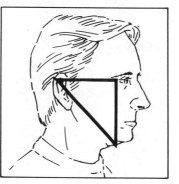

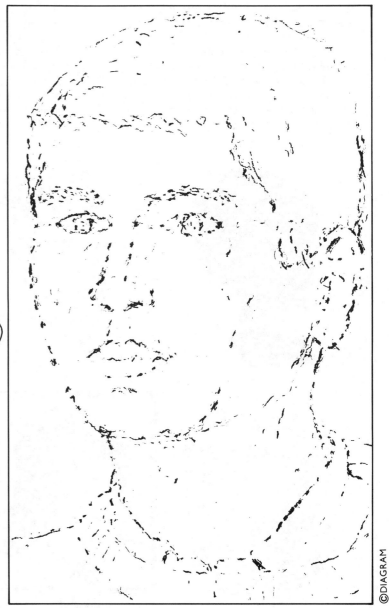

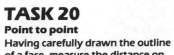

©DIAGRAM

Diversity

There are four factors which interrelate in a drawing. The subject's personality, the artist's view, the artist's skills and the medium. Although the basic elements of a head are common to all humans, the various combinations of minor differences of features are infinite. People come in all sizes and shapes, colors and textures. Studying people offers you an enormous variety of subjects.

The artist's view of the subject is the consequence of education, social norms and personal reactions. The artist's skills are a result of self-training and instruction.
The medium very strongly influences the end result. A drawing of a person on a notepad, bank note, memorial plaque, medical chart, satirical cartoon...each describes a person in a different way.

Variety
These two pages contain twenty examples of the wide variety of ways of describing the human head.

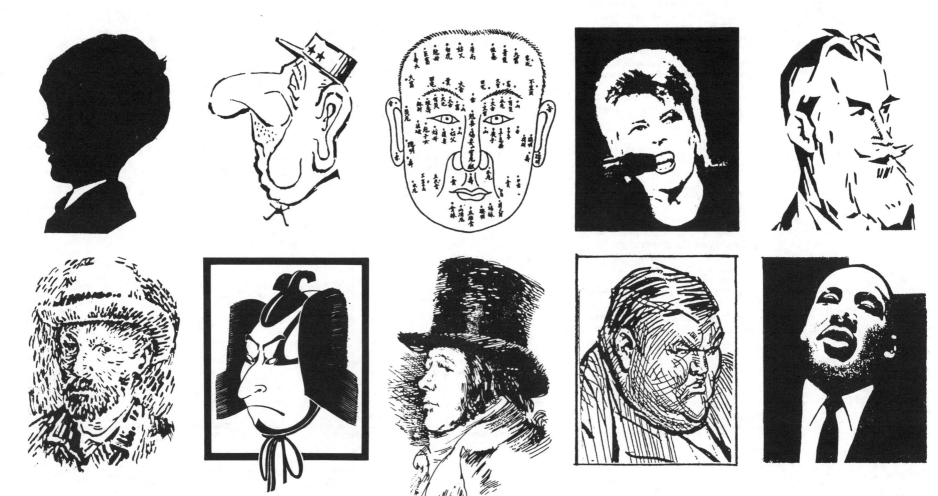

TASK 21
Human variety
Collect examples from magazines and books of faces with character.

TASK 22
Artistic diversity
Collect examples from magazines and books of drawings by artists of faces where their view of the subject has been a strong element in the drawing.

TASK 23
Drawing variety
Using a public library's resources, look at drawings by a famous artist when he was young, and compare it with examples of his artwork from later life.

TASK 24
Reality
Keep a collection of objects with drawings of heads – coins, bank notes, stamps, posters, advertisements in newspapers. Collect as many as possible.

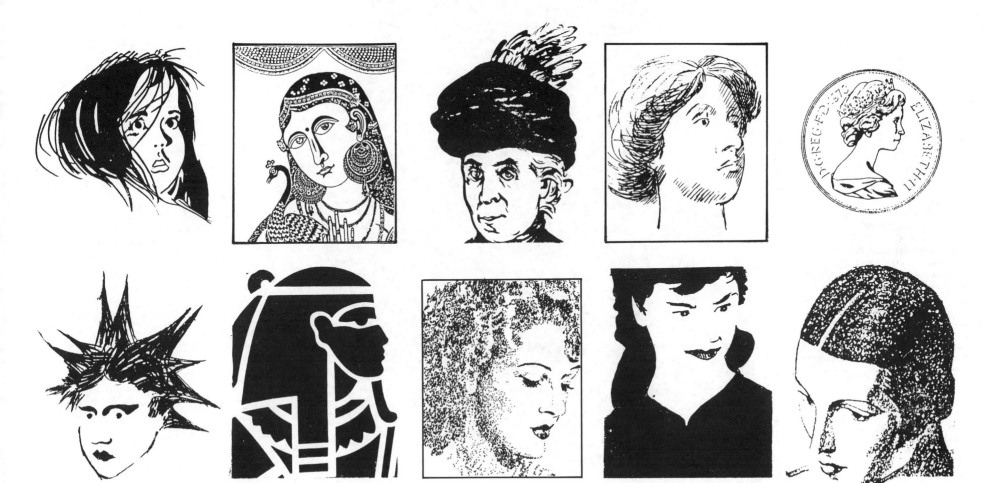

©DIAGRAM

Review

All in the mind
It is hard to hold thoughts of form, shapes, light and shade, patterns and unique variety in mind all at once. It is harder still to apply all these and in addition overcome your initial inability to record all these aspects in your drawing. The sooner you make your mistakes and discover your weaknesses, the sooner you will be able to correct them.

TASK 25

Make a notice board
Your work is evaluated by reviewing it in public. Never be afraid to expose yourself to ridicule. Every drawing is worth considering on its merits, irrespective of the circumstances of its production and artistic merit. The most important task in this book is for you to make a notice board on which to display your drawings. You will be amazed how interesting your work is after a while.

TASK 26

Check for common mistakes
Re-read the text on each page and see how it relates to Tasks on other pages.

TASK 27

Test for accuracy
Copy the tones and forms of the photograph of the sculpture (left). Then turn your drawing and book upside down and compare them.

TASK 28

Cross-consideration
Using Task 5, check its accuracy against Task 8 and then its tonal patterns against Task 11.

UNDERSTANDING WHAT YOU SEE

This chapter contains thirty-two Tasks to help you understand what you see. The knowledge you bring to your drawing helps you examine the subject. More understanding of the basic features of the head enables you to search out clues as to the overall form of the head. Drawing is not copying what you see – it is understanding what you see and recording your views of your understanding.

- On pages 204 and 205 you will be helped to think of the head as if it were encased in a net of lines that travel over the surface and reveal the convolutions.
- Pages 206 and 207 present the head as though it were carved from a block of solid material. The features are presented as hollows and facets.
- Pages 208 and 209 take you into the head, the bones and muscles that from the inside produce the basic structures.
- Pages 210 and 211 show that to understand the head's unique characteristics you must learn the relationship of the parts to each other and to the whole.

- The next two pages, 212 and 213, describe the bumps and hollows of the individual parts – the eyes, nose, and lips.
- Pages 214 and 215 take you on a trip around the head to the sides and back.
- Pages 216 and 217 draw you closer to the surface to examine the qualities of texture on youthful or aging skin and hair.
- Finally, the Review on page 218 helps you to go over common mistakes made from lack of understanding of the basic proportions and features of the head.

An artist can indicate form by using lines, drawn like the texture of fine hairs, to follow the contours of bumps and hollows. Lines drawn closely together form darker tones than those drawn further apart, and this optical effect creates light and dark areas. When using this technique, it is vital you always think of the solid forms you are overlaying with lines. The result will miraculously reveal the volumes and masses you are describing.

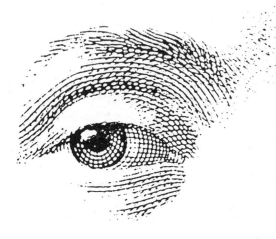

Mapping a head
Right, the drawing describes a head by the technique of contours. Each line is of connected points of equal height on the face. This method, which is usually used in cartography to describe hills and valleys, has been produced here by a computer scanning a person's face. To produce a drawing by this method, you would have to examine very carefully 'altitudes' on the face, and you would have to ignore colors, textures, tones and light and shade effects.

TASK 29
Encasing volumes
Place tracing paper over the self-portrait (Task 2) and carefully plot center lines, making an altitude map of your face.

A linear net
Below, the three drawings show how a series of parallel lines following the contours of a face, when overlayed, can create a sense of form. Drawing (**A**) is of vertical lines running down a face, drawing (**B**) is of horizontal lines. As both were drawn on tracing paper, it was possible to overlay them and the resulting combination (**C**) reveals the hollows and bumps of a face.

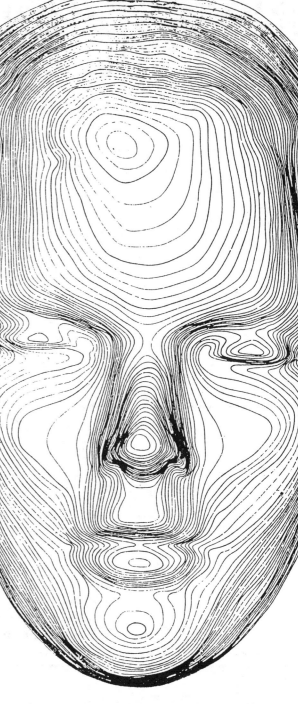

Directional lines
Above, this drawing of an eye is created by a series of parallel lines, running along the direction of the forms. Like plow furrows on a hill, the lines flow along the ridges and hollows. This technique is very often used in etchings and engravings where the tones have to be created by building up multiple layers of lines. In the drawing of Churchill's head (far right on opposite page), the artist used a brush and the ink strokes flow across the forms like the texture of bark on a tree trunk.

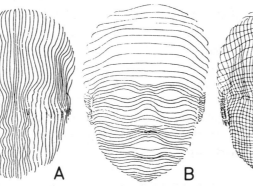

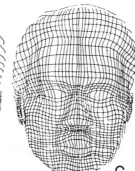

A B C

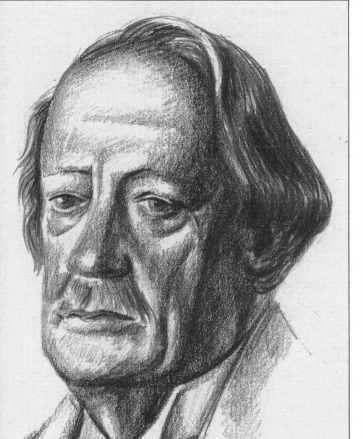

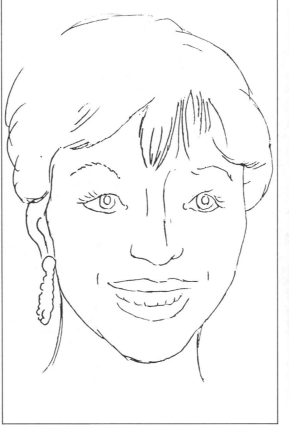

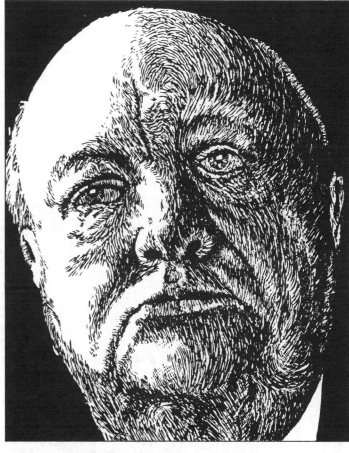

TASK 30
A linear net
Place tracing paper over the drawing (above) and draw a series of parallel horizontal lines following the forms on the face. Repeat the exercise with vertical lines. The resulting grid should, when lifted off the drawing, retain some of the features of undulation.

TASK 31
Mapping forms
Place tracing paper over the drawing (above) and draw a series of vertical and horizontal lines over the face. With a drawing like this, very little indication of form is suggested, so you must think your way round the features.

Directional ticks
Above right, the head was drawn by building up rows of ticks as if the face had been plowed with parallel lines. These lines, like the bark on a tree, help describe the form.

TASK 32
Plowing surfaces
Place tracing paper over your self-portrait (Task 2) or over any large photograph, and re-draw using the directional tick solution to describe forms.

©DIAGRAM

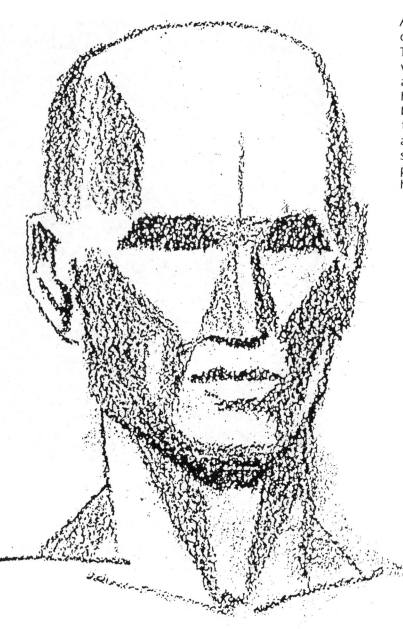

Artists very often try to see the head as a block of solid matter, a sculptured, carved-out form. This technique, although it has its limitations, is very often useful to keep in mind when drawing a real head. Some kind of an assembled block is helpful when planning to draw a head not based upon observations. A ball jammed into the top of a bucket is a simple construction, and an egg with the features marked out on its surface is another. Both these solutions help you plan out your first thoughts when sketching a head.

Abstract man
Left, this drawing is an idea of a head. No person has these ridge places on their face. Each has the unique, particular details of themselves. Nevertheless, the description of the structure is useful to bear in mind when recording a real person.

TASK 33
Boxing in
Work on newspaper or magazine photographs with a soft pencil or crayon in order to change the surface of a photographic face to flat planes.

TASK 34
Carving out
Using Task 2, your self-portrait, or a photograph or drawing in a newspaper or magazine, produce a drawing in any medium which portrays the surfaces as if carved out of wood.

Carved out
Below, this drawing was produced over 400 years ago by Albrecht Dürer. Artists producing paintings and drawings on a flat surface have always been aware of the carved, sculptured qualities of the human head. This drawing is much easier to 'read' because of the simple planes of the form, than if it were sketched without concern for volume.

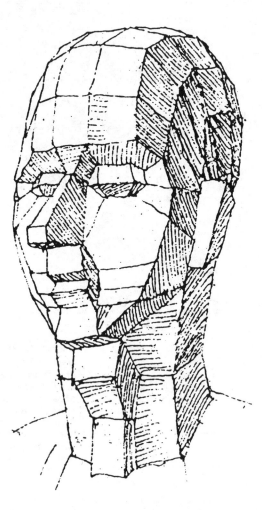

TASK 35

Egg head
Sketch the positions of the face and ears on an egg shape, and imagine their relationships changing as you view the egg from different viewpoints.

TASK 36

Bucket and ball head
Draw a ball. Draw three lines around the ball (**A**). Add a bucket to the bottom of the ball and extend two of the lines from the ball onto the sides of the bucket (**B**). Draw a circle on the side of the ball at the point where these lines cross (**C**). Remove a circular side segment (**D**). You now have a basic construction for an imaginary head, onto which you can plot the positions of the features (**E**). This construction is constant at whatever angle you view the imaginary head (**F**).

A B C D E

F

©DIAGRAM

Caged head
Above, this drawing encases the head in a wire frame of lines. This technique is very good when you are checking your construction while you are drawing. Seeing the head as a volume, with an opposite side, helps you relate very accurately the turning away of the forms at the edges of the head.

It is always helpful to have some knowledge of the inner structure of the forms you are studying. This knowledge of what is happening on the inside helps explain what you see on the outside. The surface qualities of youthful or aged faces sometimes distracts from the inner structure. Always remember that these surfaces have beneath them different substances which produce different kinds of shapes. Soft fatty tissue, tight muscular features, or hard bone parts all combine to add variety to the surface.

The skull
Right, front, side, top and three-quarter view of the skull. Pencil drawings by Michael, aged 16. If possible, try to do still-life studies of a skull. Failing access to a real skull, do some studies from an anatomy atlas.

Dürer's mother
Left, this study by Albrecht Dürer beautifully describes the soft wrinkled forehead, the drawn hard cheekbones, and the muscular sinews of the neck. Try to study heads with strong structural features such as these to help your understanding of human anatomy.

TASK 37
Aging
Draw an old person, if possible directly from a study of someone sitting comfortably in front of you. If this is not possible, then try to do studies from photographs.

TASK 38
Surface clues
Wherever possible on newspaper or magazine photographs fill in on the head those areas where the inner bone is close to the surface. Choose those parts of the skull where cheekbones, chins and foreheads produce hard parts of the surface.

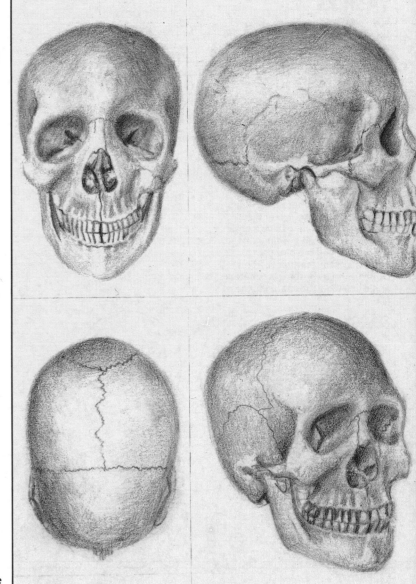

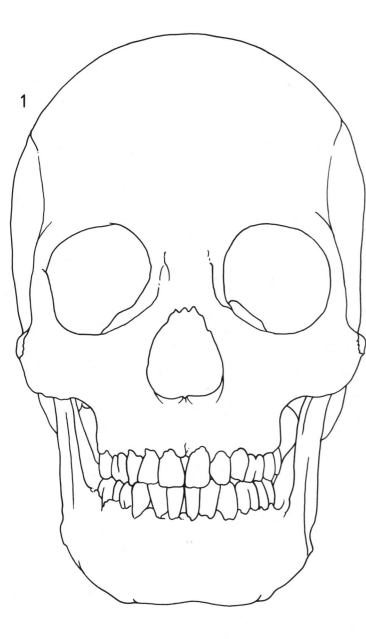

1

TASK 39
Bald beauties
Very often beginners fail to realize that the hair covers a dome-like hard bone. To test your knowledge of the top of the head, draw on to newspaper and magazine photographs the skull's top edge.

TASK 40
X-ray vision
The drawing (below right) by Mark, aged 15, was produced by:
1. First tracing off the skull outline (left).

2. Sitting in front of a mirror and drawing his self-portrait (below left) on a tracing overlay placed over the skull.
3. Then superimposing the two drawings to produce this X-ray version (below).

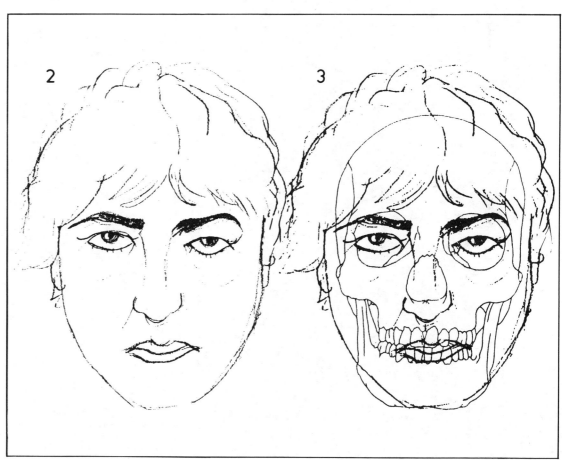

2

3

©DIAGRAM

Whatever we look like, our features – eyes, ears, nose and so on – are in the same proportional relationship. A thin face and a fat face both have underlying skulls that determine these proportions. In order to draw heads well, you need to understand this underlying structure and the relationship between the features. You need to draw what is really there, not what you think is there: careful observation and checking is what counts when you are drawing a head. However, it is important that you do not let your understanding of the framework interfere with the feeling and quality of your drawing.

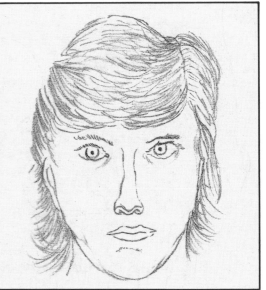

Understanding proportions
Above, Michael first drew his portrait without due attention to the proportions of his face. After reading the instructions (opposite page) he redrew his face with much more concern for the size, positions, and relationships of the parts (above right). Left, Marlene's drawing was achieved by very close attention to the proportions and forms of her face.

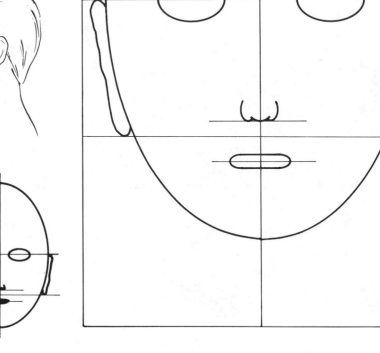

TASK 41

Measuring yourself

This exercise will help you to discover the proportions of your face. First draw an oval to represent your face, and divide it in half with a vertical line (**a**). Use a pencil to measure the distance from the base of your chin to your eye (**b**). Place a hand on the top of your head to establish the top of your skull, and measure the distance from your hand to your eye (**c**). If you plot these distances to scale on your oval, you will find that you have drawn your eye halfway up the center line (**d**). If you continue to work out the relationship between your features, you will find the following: measuring up from your chin, your nose is a quarter of the way up the center line (**e**); measuring down from your nose, your mouth is at about one-third of the distance between your nose and chin (**f**); the width of your eye is equal to the distance that your eyes are apart (**g**); the tops of your eyes and ears align and the bottom of your ears align with the space between your nose and top lip (**h**).

TASK 42

Construct the ideal face

Applying the method of construction for the proportions, place tracing paper over your Task 2 (your self-portrait) and measure the relationships on your drawing with the actual facts you have just discovered about your face.

TASK 43

Your own self-portrait

Sit in front of a mirror, place tracing paper over the structure grid, (right), and carefully draw your features, locating them along the guidelines. Try to record the small details of your face, using the grid only as a guide to position.

TASK 44

Another person's portrait

Placing the tracing paper over the the grid (right) draw a portrait of a friend or copy a photograph to these proportions.

b

c

d e f g h

Bumps and hollows

Studying the bumps and hollows of the face helps you to see the elements of the eyes, nose and lips. These fleshy parts have rounded shapes which are useful to keep in mind when drawing their position on the head. Eyes are spheres set like an egg, in a cup, into two encasing eyelids.

Noses are tube-like forms set on a sphere – a sort of upside down ice-cream cone. Lips are folded, overlapping forms which, when the mouth is closed, interlock.

TASK 45
Draw one eye
Sit close to a mirror with the light fully from the front and above your head. Do a series of studies of your eye in which you watch carefully the edges of the lids. On some drawings you can apply the surface tracking lines to check your understanding of the forms.

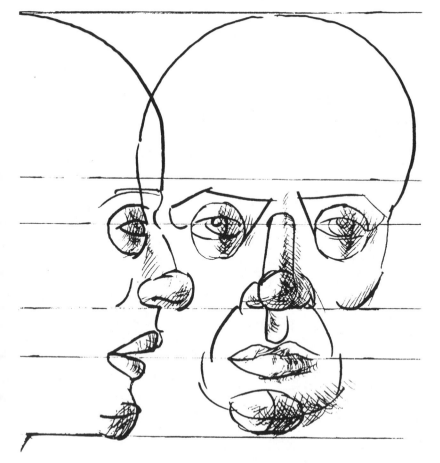

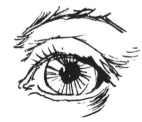

The eye
Whatever it may appear to look like when studying a face, an eyeball is a sphere. The lower and upper eyelids have an edge that catches the light or causes thin shadows on the eye. These edges help to give shape to the eye.

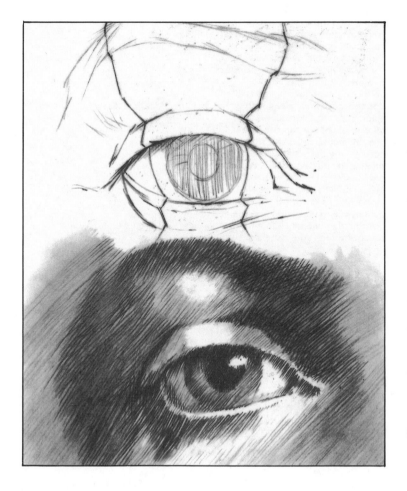

TASK 46

Draw your nose

Using gray paper, black and white chalks, and strong lighting on your face, do a series of drawings of your nose, building up the plan with dark areas and highlights. Notice how when you view the nose straight on you must work up to the light area of the ridge to produce a protruding plane which ends at the tip of the nose

The nose

Below, the top section of a nose usually shows a hard, sharp edge – the section which supports spectacles. The lower section spreads out in three spheres to form an overhanging horizontal triangular plane above the upper lip.

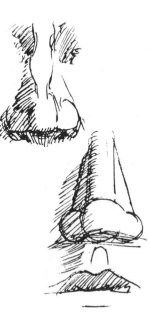

TASK 47

Draw a nose

Below, by studying a friend, or using the double-mirror technique on page 237, build up tonal drawings of the nose from a variety of views.

TASK 48

Draw lips

Do pencil studies of your lips, or a friend's, or copy from photographs. Carefully record the vertical and horizontal relationships as these give the position of the lips on the face.

The lips

Right, the basic curve of the lips horizontally across the front of the face is very useful as an indicator of the directional tilt of the head. Pay careful attention to an imaginary center line from the base of the nose to the center of the chin.

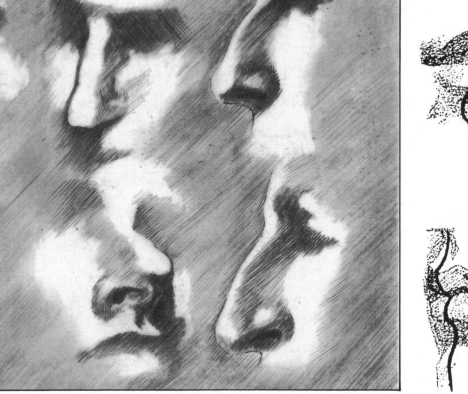

© DIAGRAM

Architects are trained to see buildings as three-dimensional spaces — boxes fixed to boxes. The volumes of the inside of the building are reflected in the patterns of the outside. Drawing portraits has a similar need of grasping the 'space-filling' properties of a head. Another useful reminder of this aspect is to think of the head as a vase. As the vase revolves or tilts the patterns (the human features) and the handles

(the ears) change relationships one to another. By cross-checking these relationships carefully as you do your studies you will establish the correct angle from which you should view the model, and the correct tilt of the head on the shoulders.

Elevations
Below, the four drawings are considered as if we were studying a vase. The front, three-quarter view, side and back (opposite left) are all drawn to the same scale and on the same eye level. Note that the elements are all parallel to one another across the four drawings.

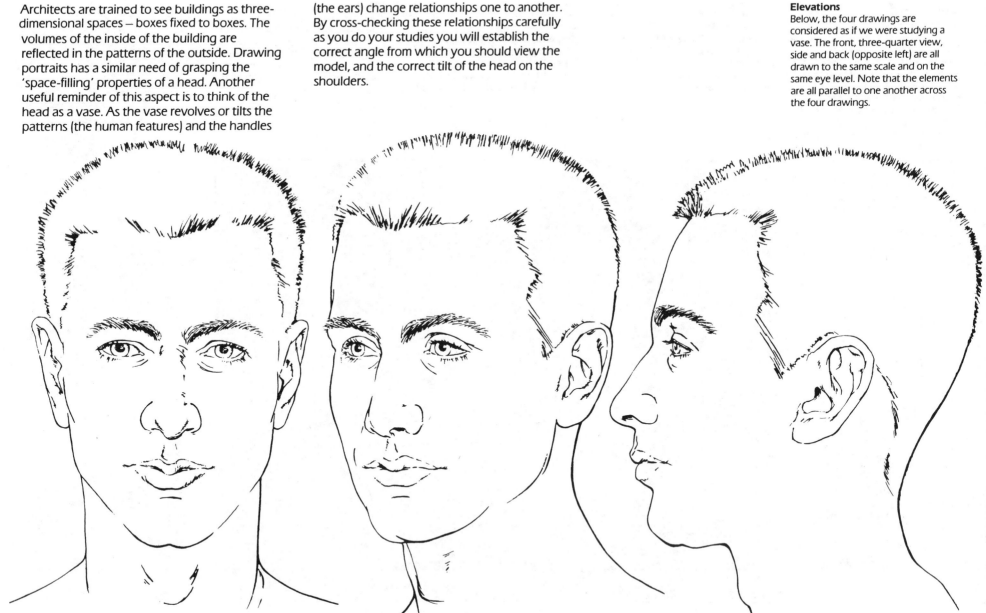

TASK 49

Front/side

Copy these drawings by eye. Do not trace them. Then, using photographic references of other heads, or observations of your own or a friend's head, add the same hairstyle to all four views. Watch the edges of the hair growth on the brow and sides of the first three views.

TASK 50

Side/back

Draw the three-quarter front view, the second drawing, by eye, and do not trace it from the book. Find a good photograph of a pair of spectacles, or obtain a real pair. Draw these on to the head. Do not invent a pair of spectacles.

TASK 51

Back

This Task requires the help of a friend. If you have already drawn the front view of a friend, now draw the back view exactly the same size as the first drawing on these pages.

TASK 52

Tilt

Again ask your friend to pose for you. This time with the head tilted slightly away and to one side. This pose can make the neck ache, so do quick studies from this view.

Tilt

Drawings from life are very rarely seen directly front or side on. The artist usually has a view which includes some small part of adjacent sides. When constructing the drawing always try to see 'across and around' the head to similar elements at the other side.

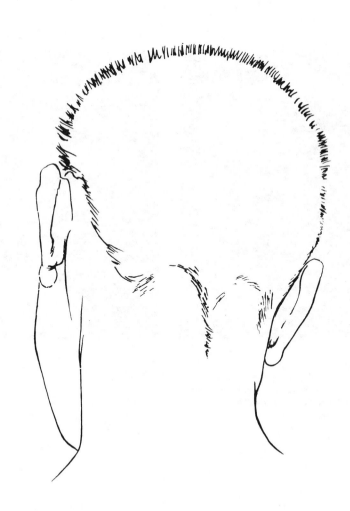

The surfaces of a human head have a variety of qualities. Smooth, as with a new baby, or worn and wrinkled, as on an aging person. Sometimes they are dull absorbent surfaces, or reflective glossy surfaces. Hairstyles are usually the most characteristic feature of a person.

When studying surface detail always retain the memory that it is set on the solid spherical form of the head.

Hair
Right, wild, fuzzy, bush-like growth to smooth, glossy head-clinging forms. The variety of styles and textures is infinite.

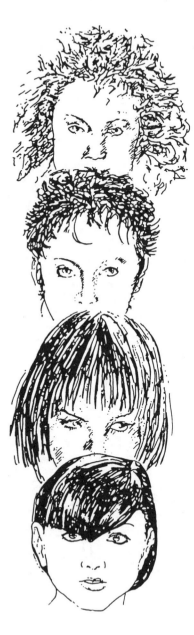

Aging
Above left to right, the author aged one year, ten years, twenty years and fifty years. Notice how hair and skin change with age.

TASK 53
Skin textures
Your skin texture varies with age and from one part of the body to another. To examine the subtle variety of texture do two small drawings of your skin, both actual size. Draw an area of the back of your left hand, then an area of the palm of the same hand.

TASK 54
Aging
Copy a photograph taken of yourself at an earlier age, and one taken recently. Compare the two, noticing changes in shape and texture.

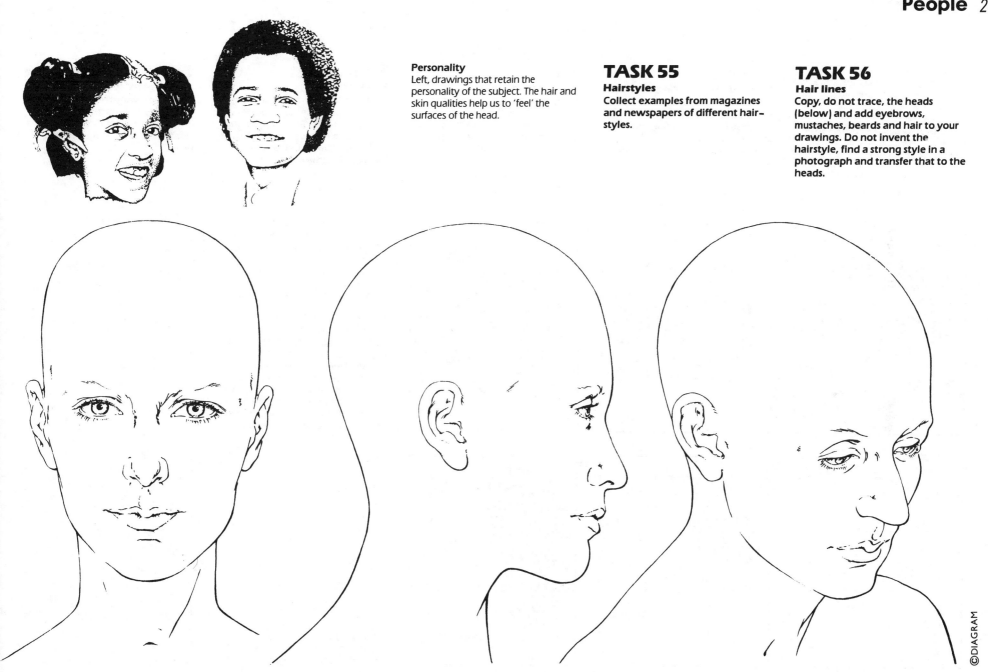

Personality
Left, drawings that retain the personality of the subject. The hair and skin qualities help us to 'feel' the surfaces of the head.

TASK 55
Hairstyles
Collect examples from magazines and newspapers of different hair-styles.

TASK 56
Hair lines
Copy, do not trace, the heads (below) and add eyebrows, mustaches, beards and hair to your drawings. Do not invent the hairstyle, find a strong style in a photograph and transfer that to the heads.

©DIAGRAM

Review

Successful portraits
Most successful portraits are produced when you take care to record accurately what you see. Three important points are to check proportions; to describe the bumps and hollows; to keep the volume of the head in your mind's eye.

TASK 57
Proportional checking
Check each drawing for basic faults of proportion. Are the eyes midway between the top and the bottom of the face? Do the sizes of the features relate to one another at the correct scale?

TASK 58
Shadows and tones
Check each drawing for its inner structure. Could the skull fit into your outline of the head? Does the drawing show hard and soft parts of the inner structure?

TASK 59
Surface texture
Check each drawing for its ability to describe surface textures. Have you in your early Task 2 drawn the eyes so that it is possible to guess at their color? Do your drawings of hair look like the hair you studied?

TASK 60
Mapping surfaces
Do your drawings reveal the bumps and hollows of a face? Do the eyes look round and set into the head? Does the nose stick out from the face?

Common faults of beginners:
1 Features too large for size of head
2 Face appears flat with no description of form.
3 Nose seen side-on when the head is from three-quarter front.
4 Eye seen front-on when drawing side view of the head.
5 Top of head too small for face.
6 Ear in wrong position.
At this point you will have done over fifty Tasks and it will be useful to review all the work from the point of view of understanding what you see when you draw. When checking your faults, do not correct your drawings. retain them in their original form, and if you feel inclined, re-draw them correcting the errors.

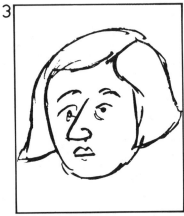

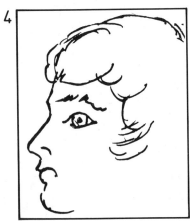

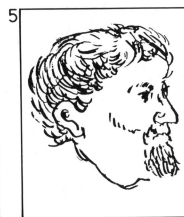

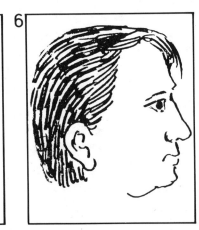

Observing detail
Right, portrait of Uma by her school friend Helen, aged 12 years.

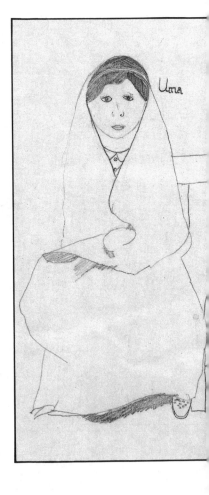

MASTERING TOOLS CHAPTER 3

In this chapter we look at how the choice of tool affects the type of mark you make. Some tools are more suitable than others for producing the results you have in mind. Pencils are the best and easiest to achieve a wide variey of line qualities. Brushes, pens and technical drawing instruments all require some degree of confidence and experience. Commercial writing tools like ball-point pens and felt-tipped pens do not allow you to make corrections, so your confidence in the marks you make must be such that you can build on erroneous marks without damaging your ultimate effects.

Never be afraid of the drawing implement. You are the master of the tool. Work slowly and carefully when beginning with an unfamiliar tool. Remember it is not what you draw with, or how you draw, that matters, but what you say in your drawing. The surface of your drawing must also be considered – rough papers are not good for achieving fine details, and smooth papers are hard to work with for tonal drawings.

- The flrst two pages, 220 and 221, offer an opportunity to look at drawings simply as marks on a page. You explore their graphic quality.
- Pages 222 and 223 set you working only in tones, while pages 224 and 225 deal with restricting your work to expressing form and color in lines.
- Pages 226 and 227 show examples of artists enjoying the textured surface of their drawings.
- Finally, page 228 brings you back to drawings where your main concern is to explore the graphic qualities of your work.

The twenty Tasks in the chapter teach you to master the tools. Experience is the best teacher.

Marks tools make

Each different drawing implement makes different types of marks on the paper. Some provide opportunities for grays and gradual tones (pencils and chalks), others are very difficult to correct (brushes and pens). There is no correct tool to use. The best tool is the one you feel confident with. Some tools require you to consider the surface you are using. Pencils are not good on smooth glossy paper. Chalks require a soft surface for the fine particles to hold. Brushes are very bad on thin paper or tracing paper as the water causes the surface to buckle. Pens and technical drawing instruments should be used only on very smooth-coated, glossy paper, or on thin plastic. Pens on rough paper cause frustration and error.

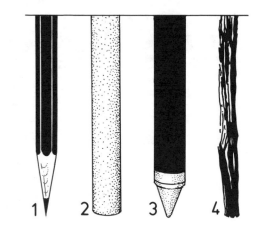

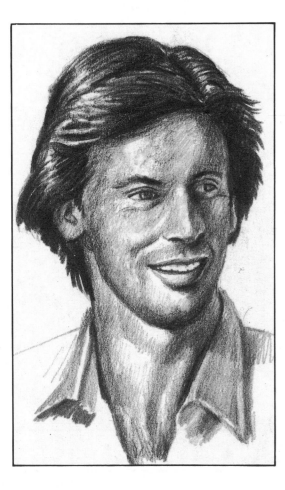

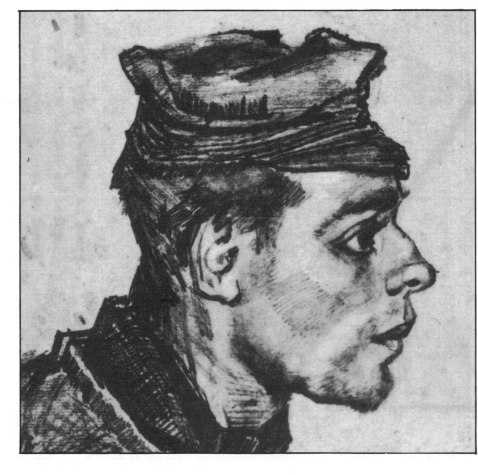

Dry-medium tools
1. Pencils are the most popular and most accessible.
2. Chalks require fixing with a spray after completion of the drawing to prevent later smudging.
3. Crayons, the waxed variety, are hard to use as errors cannot be corrected easily and the points of crayons seldom stay sharp.
4. Charcoal offers a wide range of tones, but must be 'fixed' when completed to avoid smudging.

Pencil drawing
Far left, the drawing, reproduced actual size, is a copy by Lee from a photograph. He was able to achieve a close copy of the tones by varying the weight of the line.

Charcoal drawing
Left, Vincent Van Gogh's study of a peasant. It was most probably drawn on rough-surface paper.

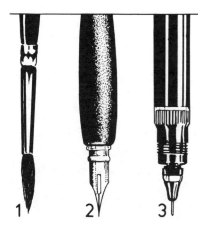

1 2 3

TASK 61
Collect drawing examples
Artists throughout history have explored the effects of different tools. Collect examples reproduced in books or magazines.

TASK 62
Make a tool kit
Caring for your tools is an essential part of working efficiently. Store pencils upright in a jar with their points uppermost. Keep a tidy tool kit box of chalks, crayons, pastels. Store brushes upright in a jar.

TASK 63
Collect papers
Store in your portfolio examples of different types of paper. Use these to experiment on when trying new drawing techniques.

TASK 64
Explore tools
Repeat Task 2 (your self portrait), using only a pen, brush or other unfamiliar drawing instrument.

Wet-medium tools
1. Brushes are a difficult tool to master, yet wonderful soft energetic results are possible with a great deal of practice.
2. Pens, excellent for quick sketches, reproduce in publications very well if the ink is constant and strong.
3. Technical drawing tools, for example the rapidograph – a tool suitable only for very careful drawings – usually used for reproduction from earlier studies of photographs.

Brush drawing
Right, Rembrandt's drawing of his wife, Saski. Only masters can achieve confidence with a brush. By varying the pressure and amount of ink on the brush a wide range of marks are possible.

Technical drawing instrument
Far right, a drawing, actual size, on thin plastic. The drawing was first planned from reference material, then the tones built up by adding areas of tiny dots.

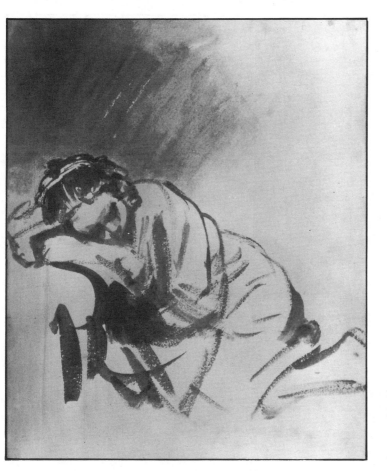

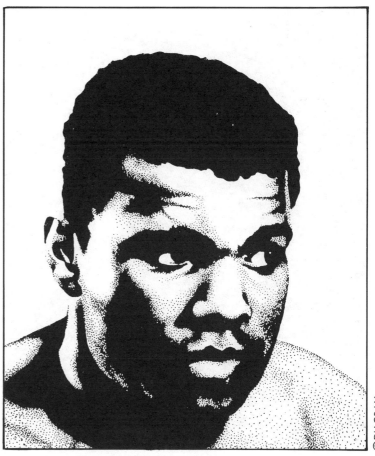

©DIAGRAM

Tones

Seeing reality in its tones, or different grades of shading, is the easiest part of drawing. Natural light creates whites, grays and darks. Seeing drawing in terms of lights and darks requires you to hold two images in your mind at the same time. The first is the description of reality, the second the patterns of tones on the page. Artists enjoy playing visual games with the shapes, colors and tones of their drawings. They bring out in a particular view two-dimensional patterns that are not present in the world they observe.

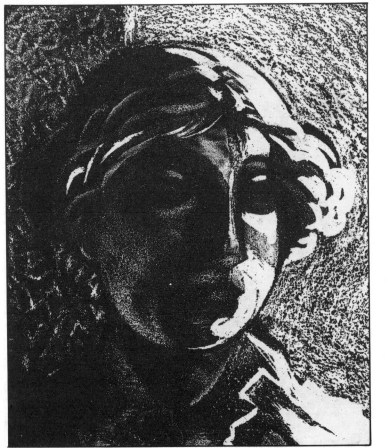

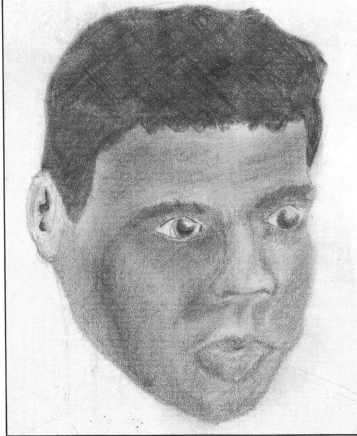

TASK 65
Flat tones
Do a copy of the pencil rendered tones above, and check your copy by folding over the edge and placing it on the page, alongside a similar tone.

Color
Left, a drawing by a 16-year-old boy. He took care to record the color of the eyes and skin.

Light and shade
Far left, exaggerated lighting effects can produce a drawing with high dramatic qualities. This head is lit from one source.

TASK 66

Tonal match

Copy a head from a photograph in a magazine, and try to record the tonal values as carefully as you can. Then fold the photograph vertically in half and hold it close to similar areas of your drawing. See how your tonal values match those on the photograph.

TASK 67

Out of darkness

Using a gray paper, work with white and black chalks to build up the effects of lighting on a face. Use either a photograph with strong lighting, or do a self-portrait posing with a direct single lighting source as in Task 11.

TASK 68

Color

Select a color photograph or a reproduction of a painting and redraw it in black and white. Keep the related color values in balance with the tonal values of your black and white drawing.

Pattern

Far left, this is not a drawing. It is a print of a linocut. The artist drew with a sharp gouge, cutting away the white areas. This method requires you to think of your drawing in terms of strong patterns.

Graphic texture

Right, an example of the texture of the drawing tool marks. This study utilizes the hand-repeated shading lines to build up areas of tone.

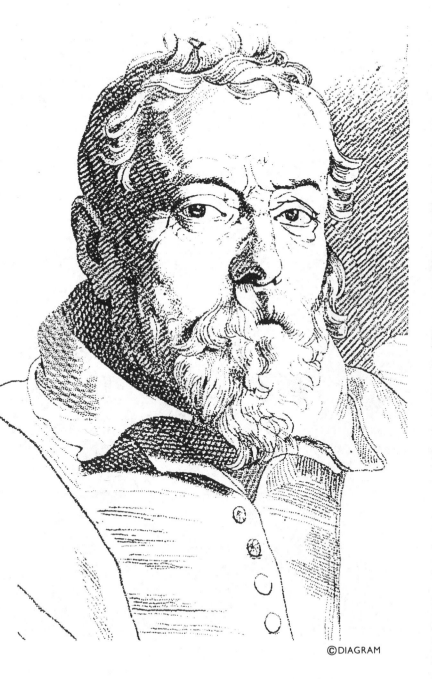

©DIAGRAM

Lines enclose areas called shapes, but they do not exist in nature. They are the edges of forms or changes in texture, or tones of colors. When you draw in line, you reinvent reality. You use a language of conventions. It is by the standard of their line drawing that you can test the quality of an accomplished artist.

When you work in line you are using a sort of shorthand for reality. Beginners should feel confident that they can weed out of the subject all the details not needed when presenting their view of the subject.

TASK 69
Collect line drawings
Wherever heads are drawn, in cartoons, comics, newspapers, magazines, books, posters and emblems, collect and copy them into a scrapbook of ideas.

TASK 70
Convert tone to line
Select any one of your earlier drawings and produce a new version of it, converting the tones in the drawing to a series of outlines.

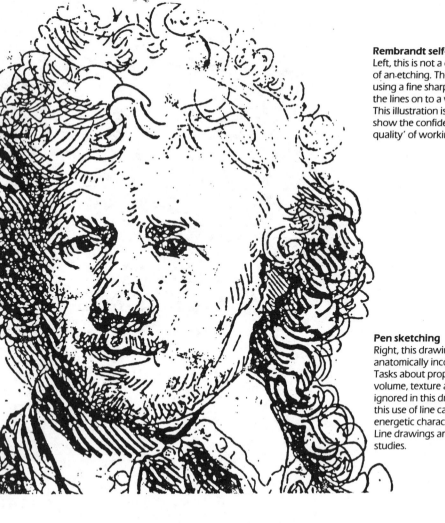

Rembrandt self-portrait
Left, this is not a drawing – it is a print of an etching. The artist drew himself using a fine sharp needle, scratching the lines on to a waxed metal plate. This illustration is an enlargement to show the confident 'handwriting quality' of working in line.

Pen sketching
Right, this drawing by Marcel Janco is anatomically incorrect. All the previous Tasks about proportion, structure, volume, texture and tone have been ignored in this drawing. Nevertheless, this use of line captures the attentive, energetic character very successfully. Line drawings are good for quick studies.

TASK 71
Speed of line
Do a series of quick line drawings from newspaper photographs of a head. Do not worry about accuracy. Work enthusiastically to draw the form and texture, using the minimum number of lines.

TASK 72
Only in line
Another version of tonal drawings. Using your earlier tonal drawings in Tasks 66 and 67, do a copy building up the same effects with an interwoven net of cross-hatched lines.

Precision line drawing
Left, this drawing by Gris is a very careful, very patient, line study. The artist built up the structure in a light line drawing which he then worked up with a single specific line, taking care that he considered all the forms and shapes accurately.

Knitted lines
Above right, a student study greatly reduced to show the tonal effects. Line drawing has traditionally been used to describe tones by building up overlays of knitted parallel lines. These areas, which appear to the eye as tones, are actually thin weavings of lines. Below right, a section actual size.

©DIAGRAM

The surface textures of a drawing are not necessarily similar to those on the subject. The effects of the paper's smoothness or roughness on a drawing can be attractive as qualities of the drawing, especially if it is to be used for reproduction.

When exploring textural surface effects you must always remember that it is the content of the drawing and not its effects that are the most important.

Seamen
Above, these night fishermen were drawn with pen and ink on thin paper – in the open, on a rolling sea, in the rain. The ink, the paper, the fatigue all combine to give the result a roughness and directness suitable for the subject.

Granny
Right, drawing by Anne, aged 11. This is reproduced here smaller than the original, which combined the coarse brown paper surface with the soft lead pencil marks to give the drawing a warm and sympathetic feel.

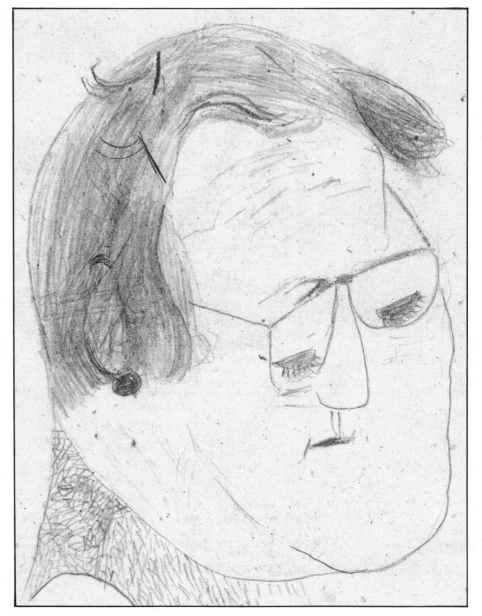

Four tasks to test surface qualities
Draw each picture 3 in x 3 in (7.6cm). Use one of your earlier drawings for reference, or copy a new subject from a photograph or model.

TASK 73
Pencil grades
Collect pencils of varying grades. The B's are soft and the H's hard. Do a drawing with a 3B or softer, and one with a 3H or harder. Compare the differences of quality.

TASK 74
Surface qualities
Repeat the drawing in Task 73 using a 3B or softer and do two drawings: one on very rough surfaced paper, like watercolor papers or 'sugar' paper; the other on glossy, smooth paper. Compare all four drawings.

TASK 75
Absorption
Repeat the drawing with inks, brushes and pens on absorbent paper. A piece of blank newspaper area is good for this exercise. Repeat on glossy paper.

TASK 76
Resistance
Repeat the drawing using a brush and ink on clear plastic. Collect all seven examples of paper, and stick them on a sheet, captioning them with the tool and materials.

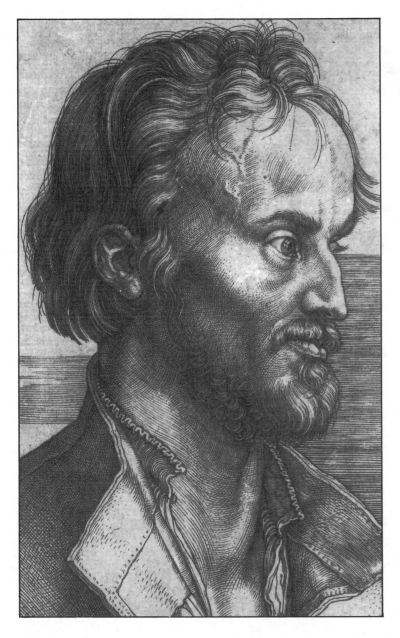

Study by Dürer
Left, this is not a drawing. It is a print of an engraving. The sharp point of the engraving tool cuts very fine lines so that the resulting print is very delicate in its detail. This is a very difficult medium to master.

Che
Right, this was done with Indian ink, an old brush, and on very thin glossy clear plastic (the type used to wrap food). The surface resistance of the material and the nervous energy of the old brush marks created irregular shapes. When the ink was dry, the drawing was crumpled up into a tiny ball, which caused the ink to peel.

©DIAGRAM

The technique

This chapter was not about drawing, it was about how drawings are produced – the technique of drawing. Never be fooled into believing that technique is preferable to seeing or understanding. Nevertheless, you can achieve wonderful results by exploring the possibilities of using the marks made by drawing tools.

Marlene

Left, this drawing was produced by Marlene placing a thin sheet of plastic over her earlier pencil drawing on page 210, and building up the tones to represent the lighting effects of the earlier drawing. She used a technical drawing instrument that produces a regular dot or line. The drawing (right), reduced, was achieved by sketching in ink and brush on the first drawing.

TASK 77

Recording the technique

Mark in the corner in a soft pencil the method by which you have drawn the previous 76 tasks. If most are in pencil, consider using other tools, and now you have a little more experience, even re-doing tasks in pen, brush or technical drawing tools.

TASK 78

Convert a previous drawing

Convert a previous drawing to a new and unfamiliar drawing with a technical tool.

TASK 79

Convert to pen dots

Using Task 2 (your self-portrait), redraw, using a dot-to-dot technique like Marlene's drawing on this page.

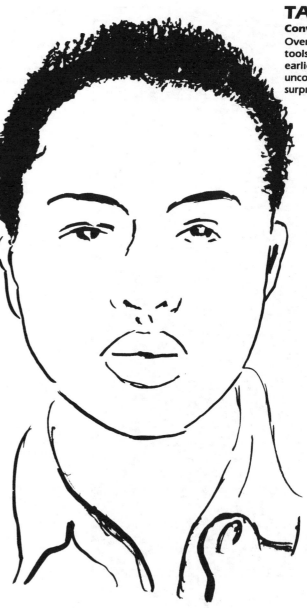

TASK 80

Convert to your least-happy tool

Overcome your fears of unfamiliar tools by copying a photograph or earlier drawing with a tool you feel uncomfortable with. This is surprisingly rewarding.

CONSIDERING DESIGN CHAPTER 4

This chapter is concerned with seeing the drawing as independent of the subject, and how to enjoy the graphic qualities of a portrait drawing. There are twenty Tasks to help you explore the style of drawing, the view of the subject in relation to the picture's shape, the composition of the picture, and the way we bring prejudgements of what a face should look like to the study.

- The first two pages, 230 and 231, compare the different ways artists make marks on the paper – their handwriting.
- Pages 232 and 233 suggest that by selecting a different and sometimes difficult view your drawing can have a new visual interest.
- The aspect least considered when beginning a portrait is its position on the page. Pages 234 and 235 look at the composition of drawings. By exploring new ways to frame your work you bring new dynamics to your work.

- Pages 236 and 237 move away from the subject and consider our prejudgements of what we think the face is like. These pages contain a Task – drawing yourself from the side – which, if drawn with accuracy, can be of great help when doing later self-portraits from the front.
- Finally, page 238 invites you to explore new pattern-making ways of producing a drawing.

Handwriting

One unconscious influence working on your drawing is your own handwriting style. It is the natural way you make marks on the paper. Never let this be a conscious part of the drawing – let it be the result of the tool, the surface, the circumstances and the subject. Doing what comes naturally is always best.

TASK 81
Copying

Try to obtain a copy from a book of an original drawing reproduced the same size. Working with the same tools as the original artist, try to copy his work, studying how he produced the drawing.

TASK 82
Imitating

Redraw Task 2 (your self-portrait), using the style of an artist you admire.

TASK 83
Handicap

Redraw Task 2 (your self-portrait), using the hand other than the one normally used for drawing.

Parallel lines
Left, a detail from a 19th-century drawing. Thicks and thins create the optical effect of lights and darks.

Agitated lines
Right, Vincent Van Gogh's drawing reveals his nervous state as he 'pecks' out the tones on the background and face.

TASK 84
Styling

This is great fun. Redraw Task 2 (your self-portrait) or others in as wide a variety of styles as you can invent. Explore techniques and ways of looking at the drawing – experiment. Do not be afraid of failures. Successful drawings are well worth all the failures.

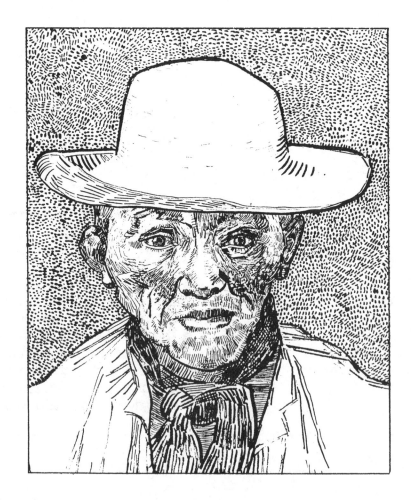

Drawing unnaturally
Below, Graham's self-portrait on page 237 was drawn with his right hand, the one used normally for writing. This is a drawing with his left hand. Compare the difference in line quality.

Exploration
Right, five drawings made from the photograph using a variety of styles and techniques. Can you guess how they were drawn?

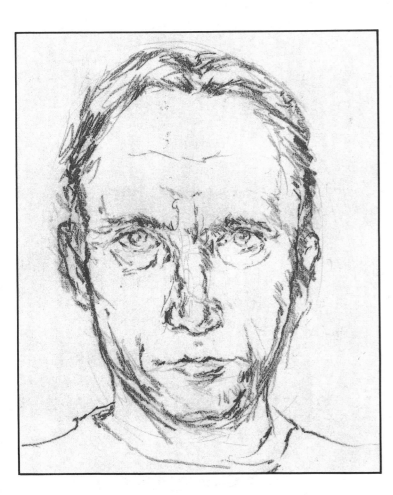

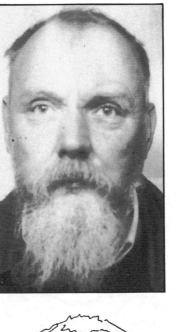

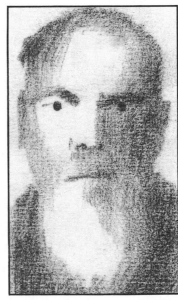

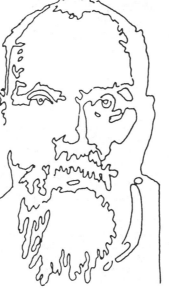

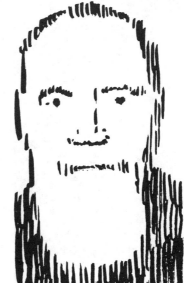

©DIAGRAM

When you are beginning your drawing you should take into account your eye level. This is the imaginary horizon opposite your eyes when you view the subject. The head, when viewed from above, is longer than it is wide; when viewing it from below, the ear will appear lower on your drawing than the model's eyes.

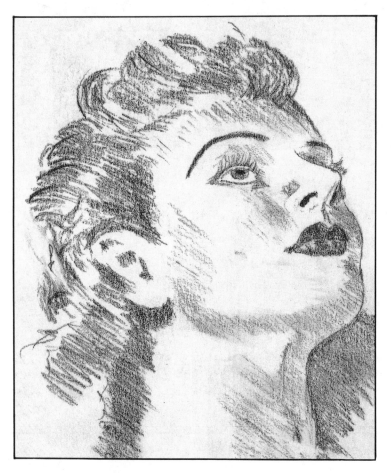

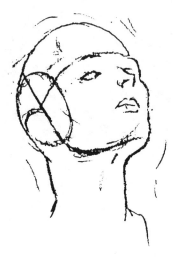

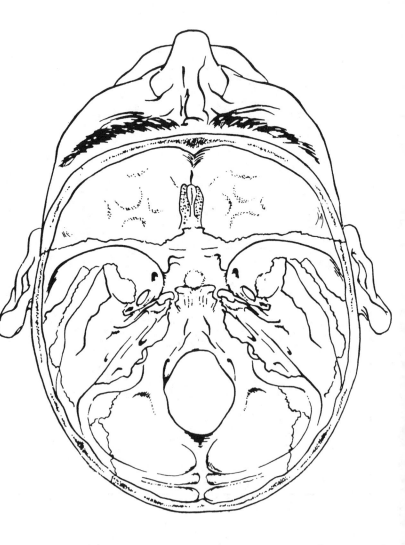

The underview
Above, when beginning a drawing from any unfamiliar viewpoint, first sketch out the basic elements using the bucket and ball technique from page 207. This abstract construct should not appear in your final drawing (left).

Thick head
Right, the human brain is deeper from front to back than it is wide. This ratio is seldom remembered by beginners when viewing the head from an unusual angle.

Box-like heads
Above, when considering unusual views, it is advisable to practice by drawing box-like heads. Although these seem childish, artists use these as a quick method for checking the location of the ear to the features.

TASK 87
Boxed views
Explore the variety of views by sketching box-like heads onto which you draw the features and ear.

Changing view
Above, this drawing of a swimmer was first drawn from a study of a model who briefly stood with her arm up and was sketched from a low eye level. The studies were used to reproduce a drawing which was then turned sideways and the sea and bubbles added. Turn the page sideways to see the artist's original view of the model.

TASK 88
Under and over
Collect views in magazines of head views from above or below.

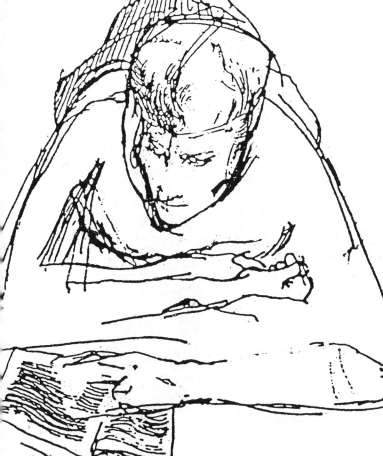

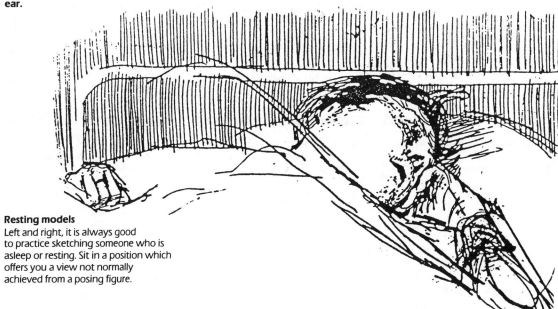

Resting models
Left and right, it is always good to practice sketching someone who is asleep or resting. Sit in a position which offers you a view not normally achieved from a posing figure.

©DIAGRAM

Composition

The position of a drawing on the mounting paper has an influential effect on its appeal. Poor drawings cannot be improved by framing, but those of medium quality, and good drawings, are enhanced by virtue of their position within the rectangle.

TASK 89
Adjustable frame
Make yourself two L shaped frames using card, each side being approximately 12 inches long. Place these over a drawing and move them to form a rectangle whose composition you find attractive.

1a

2a

3a

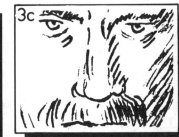
3c

1b

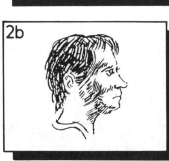
2b

3b

3d

3f

3e

There are three factors influencing the drawing's composition:
1 The subject's spacial relationship to the picture plane.
1a parallel, 1b angled.
2 Its size within the drawing area.
2a small, 2b large.

3 Its position in the frame.
3a and 3b same size but different positions, 3c and 3d same size but different frame sizes, 3e incomplete, 3f protruding and using the picture frame as part of the drawing shapes.

Dynamics
Left, the position of the head in the drawing is enormously enhanced by the dark area of the hair, and the emptiness of the rest of the page. Your attention is directed immediately to the subject's eyes.

TASK 90
Size
Do two drawings, one of which could be a redrawn version of Task 2 (your self portrait). Place both drawings in the center of 2 sheets of paper, approximately 12 inches by 18 inches in size. The first drawing should be positioned 3 inches high, the second approximately 10 inches high. Pin both on the notice board and compare the effects of the surrounding white space.

Space
As well as horizontal and vertical space – the compositional elements – a drawing can use the inner space, moving out from the page like the drawing (right) and the one on page 191. This is not easily achieved as you are required to describe foreshortened forms convincingly.

TASK 91
Cropping
Collect photographs from magazines and cut away their sides until you have an interesting composition.

TASK 92
Composition
Collect postcards and printed examples of famous artists' works and consider their compositional solutions. Degas, the 19th-century painter, had very many exciting figure studies for his compositions.

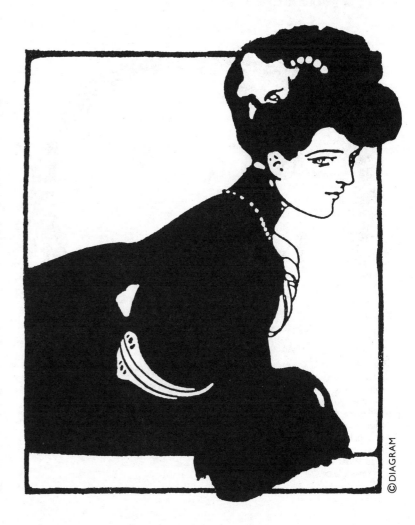

© DIAGRAM

Beginners always express the fear 'I can see it, but I cannot draw it.' They instinctively know what a subject looks like, but cannot capture their impressions on paper. This is because much of what we see we read as generalizations — an impression of reality. The actual world is complex and infinitely variable. Our view of it is transformed into a code of representation.

Visions
Below, 'The man who instructed Mr. Blake in painting in his dreams.' This represents the art teacher of the 19th-century English artist William Blake. No such person existed — Blake dreamed these features. They are an assembly of learned parts — eyes, noses, mouths — remembered bits of his wakeful observations, combined here to represent a fictitious person. We must learn to record our observations and not simply represent them with codes for eyes, noses, mouths, hair and skin. Always draw the particular, never the general.

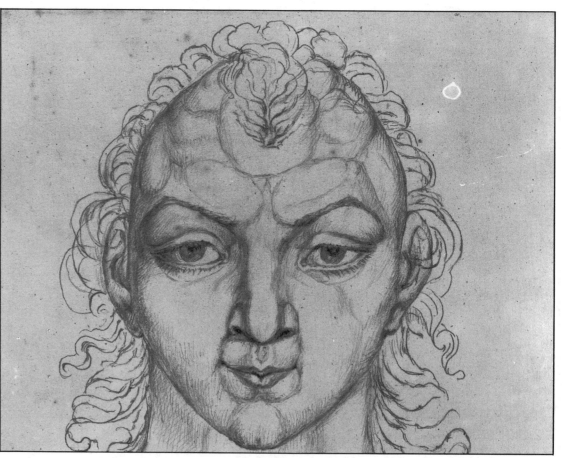

Concepts
Above, a drawing by Zoë, aged 5. It was her first subject study. She knows what she looks like and can recognize herself in photographs. Her drawing, though, does not yet make the connection with concepts and recorded observations. 'This is Zoë' she says. What she is really saying is 'This represents Zoë.'

TASK 93

Memory test 1
Select any picture in this book, then close the book and, without turning back to it, do a simple sketch of it. Now compare your memory of it and the reality.

TASK 94

Memory test 2
Select any of your earlier drawings (but not those of yourself) and from memory re-draw the picture. One consequence of this Task is that the second is usually better than the first. The reason for this is that, having previously drawn a subject, it is somehow committed to our memory more permanently than those just casually examined.

TASK 95

Yourself
This is great fun. Redraw Task 2 (your self-portrait) from memory and compare the two drawings.

Side view
Graham drew his front view by looking in the mirror. He then positioned two large mirrors so that he could study his side view by looking in the front mirror at the reflection.

TASK 96

Self side view
Arrange two large mirrors in positions where the view of the side of your head in one mirror receives the reflection in the other. If you produce a successful study, leave your drawing in a conspicuous place for your friends to comment on. They will be very impressed with your ability to see yourself as they see you.

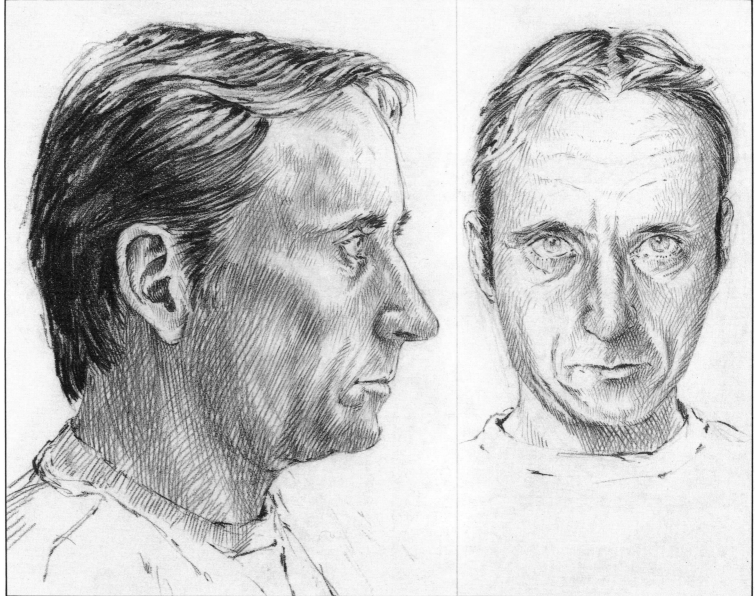

© DIAGRAM

Graphic qualities
The Tasks in this chapter are designed to help you consider the appearance of your drawing – its graphic qualities. Remember that although these topics are visually stimulating, it is the objective of good drawing to portray the solid world on a flat surface.

Below, this drawing is of the same subject as that on page 227. It converts the study into curved, blob-like shapes. The three drawings below right are experiments from page 205.

TASK 97
Graphic variety
Collect examples of artists' extreme graphic styles from newspapers and magazines.

TASK 98
Simplification
Place tracing paper over any illustration in this book and convert it to simple patterns.

TASK 99
Pointillist
Convert a drawing to a built-up dot pattern.

TASK 100
Convert your own portrait
Convert your own portrait to a pattern of shapes and, when complete, ask your friends who the drawing is of.

DRAWING WITH THE HEART

Drawing with your heart is excellent therapy. Like yoga, chess or sailing, the concentration required is rewarded by the inner peace that success brings. It is never a good idea to take Tasks too seriously. They need an element of play to make them enjoyable. These next twenty Tasks assume you have learned how to draw, and now it's time to 'kick the ball about.' Bounce ideas freely off the wall. Enjoyment is what drawing is about. Express your views of what you see.

- The first two pages, 240 and 241, reassure you with the idea that the hardest part of portraiture – capturing likeness – comes automatically if you follow the earlier advice on drawing.
- Then pages 242 and 243 explore what we consider as the total face, the parts and their relationship to the whole.
- On pages 244 and 245 you can have some fun with Tasks that express the emotions of the subject. Try to record the emotional conditions of the person you are drawing – the objective observation.

- On pages 246 and 247 we explore our emotional reactions to the subject we are observing.
- Finally, page 248 gives some good advice – and extracts a promise!

Capturing likeness is probably the hardest part of portrait drawing. Do not be discouraged. Look, observe, and seek to understand what you see. Record and reconsider, then re-check and modify your work. The natural qualities of a face will automatically appear. People with a strong personality often reveal this in their face, so select subjects whose appearance helps you in your search for the uniqueness of a face.

Luther
Below left, I have used this example many times to illustrate the uniqueness of portraits. The 16th-century artist, Cranach, was so observant and honest that he recorded for all time the mole on Luther's brow over his left eye.

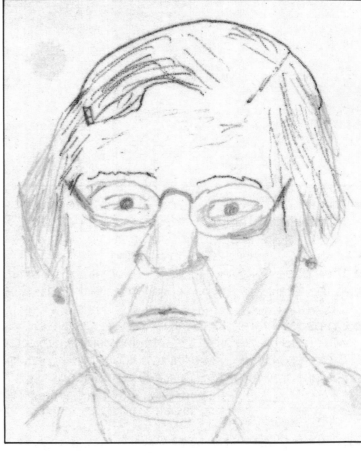

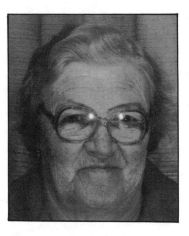

Granny
This is the first-ever observation study by granny, aged 76. As you can see from her photograph, her first attempt captures a little of her features. She is also the model for a study on page 226.

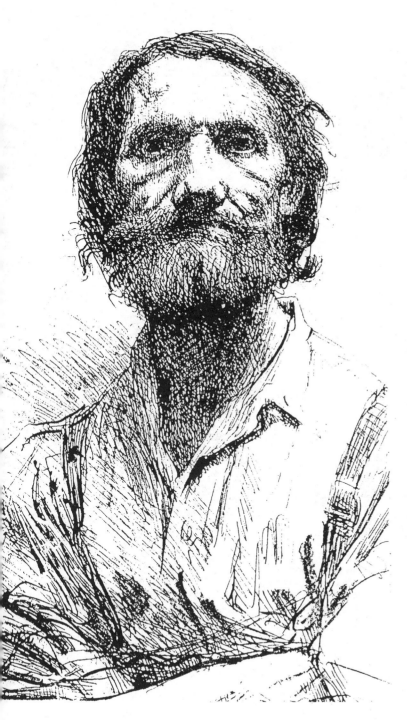

Defiance
Left, the direct stare of the subject in this study is an excellent rendering of his character. He is obviously not a quitter. His lean features describe a hard-working, persistant personality.

Self-portrait
Below, Rembrandt never failed to discover new aspects of his own face. For over thirty years he continued to draw himself. Compare this with his earlier self-portrait on page 224. This example is a copy by a present-day student. You should copy great artists' drawings whenever possible.

TASK 101
Dossier
Make a series of notes about your own features, color of hair, eyes, shape of nose, ears, etc. Compare these to your self-portrait (Task 2).

TASK 102
Character study
Draw a person with a strong personality.

TASK 103
Fame
Draw from photos a movie star or pop star, a person everyone recognizes. Then show the drawing to your friends and ask who it is.

TASK 104
The ultimate test
Do a drawing of a friend and show your drawing to others who know the subject and see if they recognize your mutual friend.

Photofit

Police use a method of building up a face from individual parts. Superimposed on a selected basic shape are an infinite variety of combinations of eyes, noses, mouths, hair. These seldom resemble the real person. A face is more than the parts.

Distortion by imagination
Above, a caricature of Louis-Philippe by a 19th-century artist. Cartoonists have a strong influence on how we remember a person's face. Once seen as a pear, Louis's face can never again appear in any other form.

TASK 105
Caricature
Try to do a caricature of your own self-portrait. This is a very difficult task and most of us fail to see the striking features of our own faces.

Distortion by exploration
Above, distortion achieved by cutting up photostats of the drawing on page 228 and playing with the new arrangement of parts.

TASK 106
Distortion by experiment
Cut up newspaper photographs and re-arrange the parts.

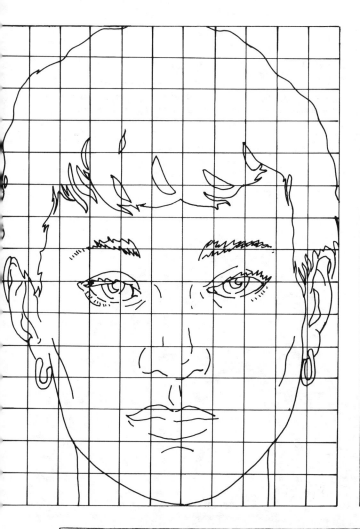

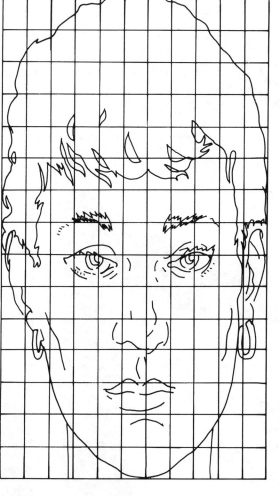

Distortion by geometry
Below left to right, the horizontal and vertical relations of features can be very slightly distorted by widening or narrowing either of the axes, or by bending one axis.

TASK 107

Square-up a photograph
Draw a new, distorted, grid and replot the features.

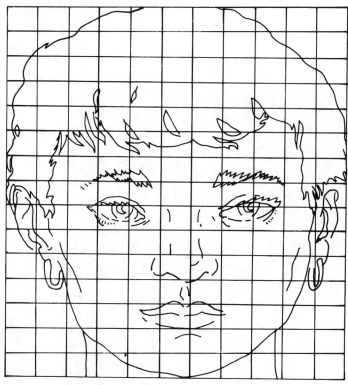

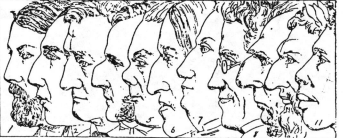

Distortion by tradition
Left, a series of profiles in which a 19th-century artist imagines that intellectuals idiots, workers and others have characteristically different features.

TASK 108

Collect character types

Collect portraits of poets, murderers and politicians and, to disprove the 19th-century idea, ask friends to guess the character of each example.

© DIAGRAM

Facial expressions reveal our thoughts. The muscles of the face are contorted with our emotional responses. Artists enjoy adding expressions to a drawing because they project to the reader the subject's thoughts.

Eternal symbols
The simple picture for joy and misery. These clown-like designs can be applied to more detailed drawings.

TASK 109

Pulling faces
Sit in front of a mirror and express, and then sketch happiness or sadness.

Expressing emotion
Left to right, three artists descriptions of:
Happiness – by the English 18th-century artist William Hogarth.
Anger – by the Japanese 18th-century artist Katsukawa Shunko.
Despair – a drawing study of a stone carving.

TASK 110

Angry photographs
Collect newspaper and magazine examples of people expressing anger.

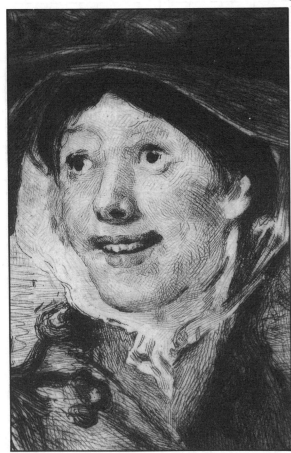

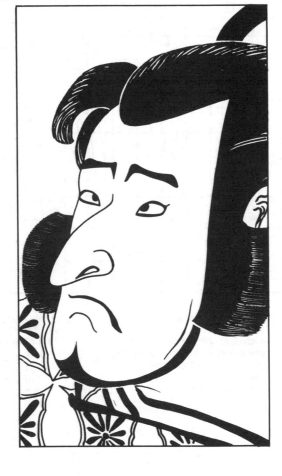

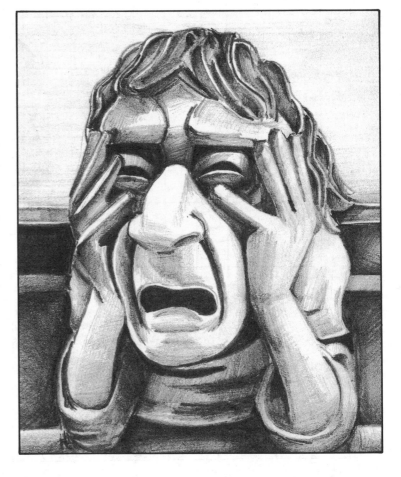

TASK 111

Distortion

Copy a large photograph of a face and, while drawing, try to change the expression on the face.

Facial expressions

Right, twelve drawings of the facial contortions produced to express emotion.

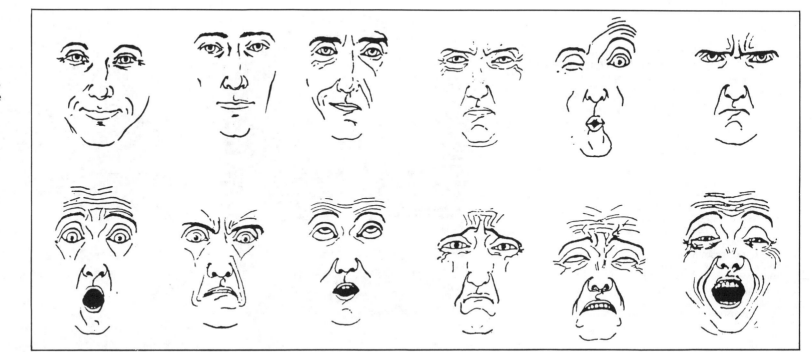

TASK 112

What are they thinking?

Below, these five drawings illustrate some typical responses. What are they?

©DIAGRAM

Mood

The final ingredient within your drawing is your emotional response to the subject model — your subjective responses. This magical element comes naturally and should be the result of the interaction between you and your subject.

Achieving success
Right and opposite, four drawings by masters of the art. The first is by a young man who copied a photograph of a rock musician hero. The second is a self-portrait by Kathy Kollwitz. The third is an emotional response by the 20th-century artist Ben Shahn. The final drawing is by one of the world's greatest portrait draughtsmen, the 16th-century painter, Hans Holbein.

TASK 113
Subjective responses
Collect examples of artists' works which express their emotional responses to their subjects.

TASK 114
Objective/subjective
Re-evaluate your drawings to try to discover whether they contain an element of your emotional responses to the subject.

TASK 115
Emotional response
Copy any picture in this book which you think shows the artist's subjective responses. Another way to do this is to copy the drawing you like best in the book as this reflects your subjective responses.

TASK 116
Admiration
Draw the person you most admire — either from a photograph, or from a personal study of them sitting in your presence.

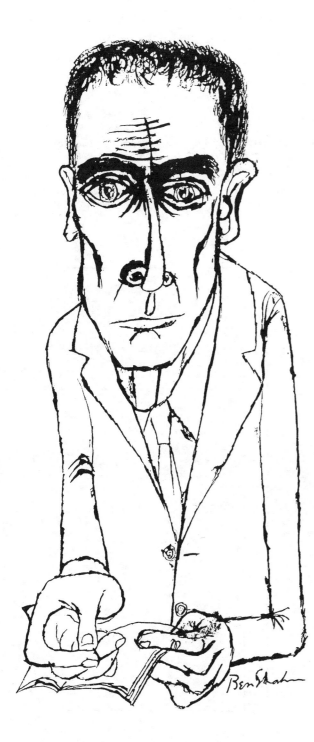

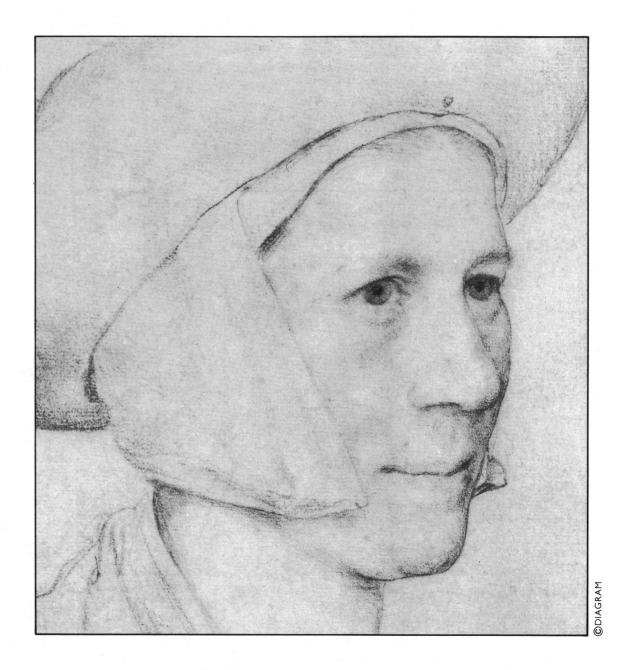

Portraits
These drawings are by Jane, aged 11, 16 and 20.

TASK 117
Review
Collect all your tasks into one portfolio and store safely.

TASK 118
Mount and present
Cut a card mount of one of your better drawings and offer it as a gift to a friend.

TASK 119
Buy a drawing
Buy an artist's drawing or print from an exhibition, gallery or art shop.

TASK 120
Promise
Promise yourself to do a drawing of yourself at least once a year. This task is very good for the Christmas holiday times. During those days you can spend a restful two hours doing a self-portrait.

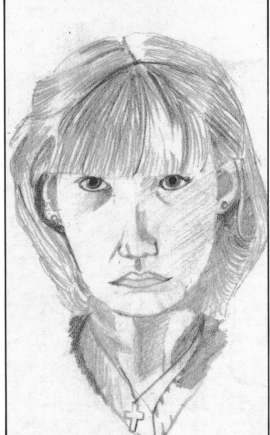

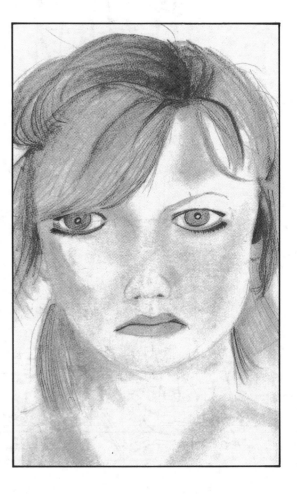

CHECKING YOUR PROGRESS: OBJECTS

You may not do all the tasks in the order they appear in the book. Some require you to research sources of photographs or other artists' works, some direct you to museums and art galleries, and some may be done quickly while others can only be completed when you can devote more time to their study.
To help you keep a record of your completed Tasks, fill in the date against each numbered Task in the space given beside it.

TASK 1	TASK 31	TASK 61	TASK 91	TASK 121
TASK 2	TASK 32	TASK 62	TASK 92	TASK 122
TASK 3	TASK 33	TASK 63	TASK 93	TASK 123
TASK 4	TASK 34	TASK 64	TASK 94	TASK 124
TASK 5	TASK 35	TASK 65	TASK 95	TASK 125
TASK 6	TASK 36	TASK 66	TASK 96	TASK 126
TASK 7	TASK 37	TASK 67	TASK 97	TASK 127
TASK 8	TASK 38	TASK 68	TASK 98	
TASK 9	TASK 39	TASK 69	TASK 99	
TASK 10	TASK 40	TASK 70	TASK 100	
TASK 11	TASK 41	TASK 71	TASK 101	
TASK 12	TASK 42	TASK 72	TASK 102	
TASK 13	TASK 43	TASK 73	TASK 103	
TASK 14	TASK 44	TASK 74	TASK 104	
TASK 15	TASK 45	TASK 75	TASK 105	
TASK 16	TASK 46	TASK 76	TASK 106	
TASK 17	TASK 47	TASK 77	TASK 107	
TASK 18	TASK 48	TASK 78	TASK 108	
TASK 19	TASK 49	TASK 79	TASK 109	
TASK 20	TASK 50	TASK 80	TASK 110	
TASK 21	TASK 51	TASK 81	TASK 111	
TASK 22	TASK 52	TASK 82	TASK 112	
TASK 23	TASK 53	TASK 83	TASK 113	
TASK 24	TASK 54	TASK 84	TASK 114	
TASK 25	TASK 55	TASK 85	TASK 115	
TASK 26	TASK 56	TASK 86	TASK 116	
TASK 27	TASK 57	TASK 87	TASK 117	
TASK 28	TASK 58	TASK 88	TASK 118	
TASK 29	TASK 59	TASK 89	TASK 119	
TASK 30	TASK 60	TASK 90	TASK 120	

CHECKING YOUR PROGRESS: TREES AND PLANTS

TASK 1	TASK 31	TASK 61	TASK 91	TASK 121
TASK 2	TASK 32	TASK 62	TASK 92	
TASK 3	TASK 33	TASK 63	TASK 93	
TASK 4	TASK 34	TASK 64	TASK 94	
TASK 5	TASK 35	TASK 65	TASK 95	
TASK 6	TASK 36	TASK 66	TASK 96	
TASK 7	TASK 37	TASK 67	TASK 97	
TASK 8	TASK 38	TASK 68	TASK 98	
TASK 9	TASK 39	TASK 69	TASK 99	
TASK 10	TASK 40	TASK 70	TASK 100	
TASK 11	TASK 41	TASK 71	TASK 101	
TASK 12	TASK 42	TASK 72	TASK 102	
TASK 13	TASK 43	TASK 73	TASK 103	
TASK 14	TASK 44	TASK 74	TASK 104	
TASK 15	TASK 45	TASK 75	TASK 105	
TASK 16	TASK 46	TASK 76	TASK 106	
TASK 17	TASK 47	TASK 77	TASK 107	
TASK 18	TASK 48	TASK 78	TASK 108	
TASK 19	TASK 49	TASK 79	TASK 109	
TASK 20	TASK 50	TASK 80	TASK 110	
TASK 21	TASK 51	TASK 81	TASK 111	
TASK 22	TASK 52	TASK 82	TASK 112	
TASK 23	TASK 53	TASK 83	TASK 113	
TASK 24	TASK 54	TASK 84	TASK 114	
TASK 25	TASK 55	TASK 85	TASK 115	
TASK 26	TASK 56	TASK 86	TASK 116	
TASK 27	TASK 57	TASK 87	TASK 117	
TASK 28	TASK 58	TASK 88	TASK 118	
TASK 29	TASK 59	TASK 89	TASK 119	
TASK 30	TASK 60	TASK 90	TASK 120	

TASK 1	TASK 31	TASK 61	TASK 91	TASK 121
TASK 2	TASK 32	TASK 62	TASK 92	TASK 122
TASK 3	TASK 33	TASK 63	TASK 93	TASK 123
TASK 4	TASK 34	TASK 64	TASK 94	
TASK 5	TASK 35	TASK 65	TASK 95	
TASK 6	TASK 36	TASK 66	TASK 96	
TASK 7	TASK 37	TASK 67	TASK 97	
TASK 8	TASK 38	TASK 68	TASK 98	
TASK 9	TASK 39	TASK 69	TASK 99	
TASK 10	TASK 40	TASK 70	TASK 100	
TASK 11	TASK 41	TASK 71	TASK 101	
TASK 12	TASK 42	TASK 72	TASK 102	
TASK 13	TASK 43	TASK 73	TASK 103	
TASK 14	TASK 44	TASK 74	TASK 104	
TASK 15	TASK 45	TASK 75	TASK 105	
TASK 16	TASK 46	TASK 76	TASK 106	
TASK 17	TASK 47	TASK 77	TASK 107	
TASK 18	TASK 48	TASK 78	TASK 108	
TASK 19	TASK 49	TASK 79	TASK 109	
TASK 20	TASK 50	TASK 80	TASK 110	
TASK 21	TASK 51	TASK 81	TASK 111	
TASK 22	TASK 52	TASK 82	TASK 112	
TASK 23	TASK 53	TASK 83	TASK 113	
TASK 24	TASK 54	TASK 84	TASK 114	
TASK 25	TASK 55	TASK 85	TASK 115	
TASK 26	TASK 56	TASK 86	TASK 116	
TASK 27	TASK 57	TASK 87	TASK 117	
TASK 28	TASK 58	TASK 88	TASK 118	
TASK 29	TASK 59	TASK 89	TASK 119	
TASK 30	TASK 60	TASK 90	TASK 120	

CHECKING YOUR PROGRESS: PEOPLE

TASK 1	TASK 31	TASK 61	TASK 91
TASK 2	TASK 32	TASK 62	TASK 92
TASK 3	TASK 33	TASK 63	TASK 93
TASK 4	TASK 34	TASK 64	TASK 94
TASK 5	TASK 35	TASK 65	TASK 95
TASK 6	TASK 36	TASK 66	TASK 96
TASK 7	TASK 37	TASK 67	TASK 97
TASK 8	TASK 38	TASK 68	TASK 98
TASK 9	TASK 39	TASK 69	TASK 99
TASK 10	TASK 40	TASK 70	TASK 100
TASK 11	TASK 41	TASK 71	TASK 101
TASK 12	TASK 42	TASK 72	TASK 102
TASK 13	TASK 43	TASK 73	TASK 103
TASK 14	TASK 44	TASK 74	TASK 104
TASK 15	TASK 45	TASK 75	TASK 105
TASK 16	TASK 46	TASK 76	TASK 106
TASK 17	TASK 47	TASK 77	TASK 107
TASK 18	TASK 48	TASK 78	TASK 108
TASK 19	TASK 49	TASK 79	TASK 109
TASK 20	TASK 50	TASK 80	TASK 110
TASK 21	TASK 51	TASK 81	TASK 111
TASK 22	TASK 52	TASK 82	TASK 112
TASK 23	TASK 53	TASK 83	TASK 113
TASK 24	TASK 54	TASK 84	TASK 114
TASK 25	TASK 55	TASK 85	TASK 115
TASK 26	TASK 56	TASK 86	TASK 116
TASK 27	TASK 57	TASK 87	TASK 117
TASK 28	TASK 58	TASK 88	TASK 118
TASK 29	TASK 59	TASK 89	TASK 119
TASK 30	TASK 60	TASK 90	TASK 120

TOPIC FINDER INDEX